THE

WHITE MOUNTAINS

PLACE AND PERCEPTIONS

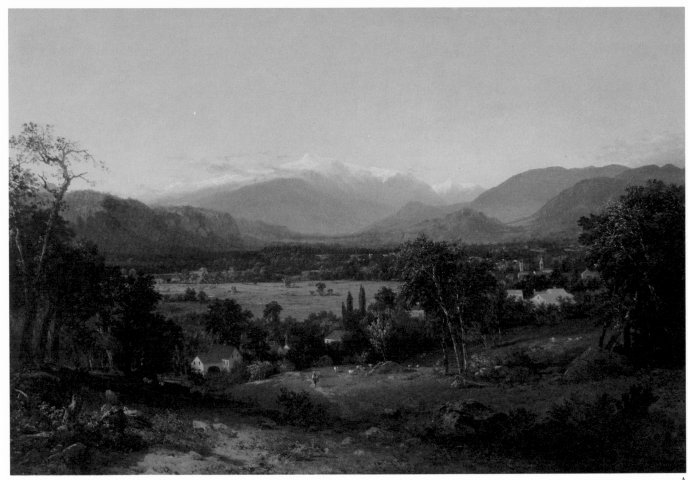

A

THE
WHITE MOUNTAINS
PLACE AND PERCEPTIONS

EXHIBITION CURATOR
Donald D. Keyes

CONTRIBUTING AUTHORS
Catherine H. Campbell
Donald D. Keyes
Robert L. McGrath
R. Stuart Wallace

Published for the University Art Galleries, University of New Hampshire, Durham, by the University Press of New England,
Hanover, New Hampshire, and London, England.

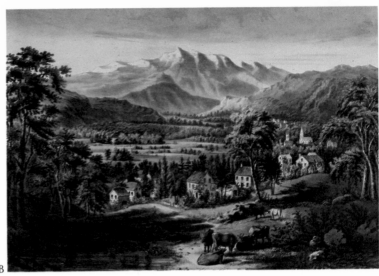

B

Published for the University Art Galleries by the University Press of New England, Hanover, New Hampshire 03755
Printed in the United States of America

Library of Congress Catalog Card Number 80-68935
International Standard Book Number 0-87451-190-9

This publication is produced in conjunction with an exhibition organized by the University Art Galleries, University of New Hampshire. The project is supported in part by a grant from the National Endowment for the Humanities, a federal agency.

EXHIBITION SCHEDULE

September 8 through October 29, 1980
University Art Galleries, Durham

December 1 through January 30, 1981
The New-York Historical Society,
New York

March 6 through April 19, 1981
Dartmouth College
Museum & Galleries, Hanover

COLOR PLATES

A. John Frederick Kensett, *The White Mountains, Mount Washington,* 1869. The Wellesley College Museum, Gift of Mr. and Mrs. James B. Munn (Ruth C. Hanford, '09) in the name of the class of 1909

B. *Mount Washington and the White Mountains from the Valley of Conway,* Frances Flora Bond (Fanny) Palmer, lithographer, after a sketch by Fanny Palmer; published by Currier and Ives, New York, N.Y., ca. 1860. Lent by Mr. and Mrs. Charles O. Vogel

C. Thomas Cole, *Lake Winnipesaukee,* 1827 or 1828. Collection of Albany Institute of History and Art, Gift of Mrs. Ledyard Cogswell, Jr.

D. Jasper F. Cropsey, *Indian Summer Morning in the White Mountains,* 1857. Collection of The Currier Gallery of Art

E. Sanford Robinson Gifford, *Mount Washington from the Saco,* ca. 1854. Lent anonymously

F. *Bird's Eye View of Whitefield, Coös County,* A. F. Poole, 1883. Collection of New Hampshire Historical Society

G. Benjamin Champney, *Moat Mountain from Intervale,* ca. 1870. Lent by White Mountain National Bank, North Conway, N.H.

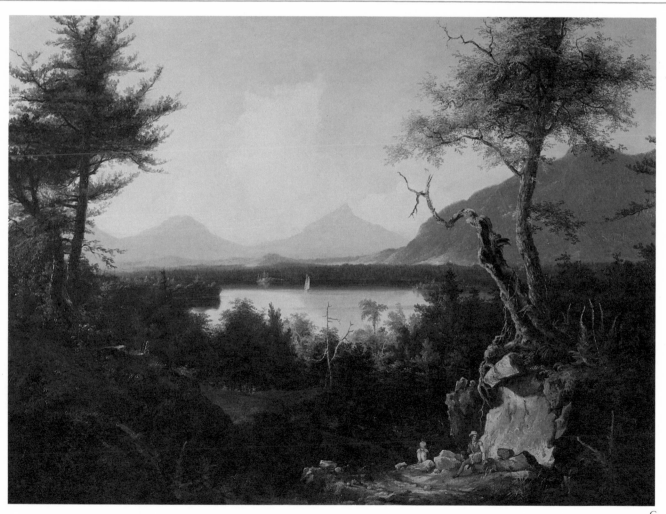

C

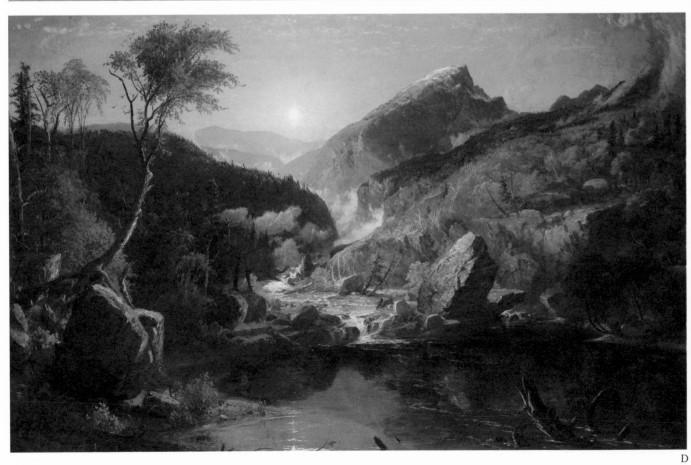

D

CONTENTS

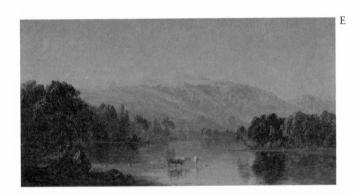

E

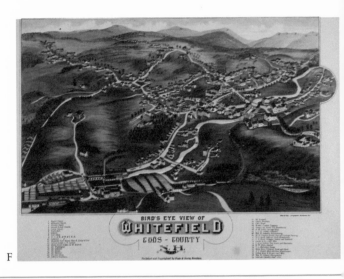

F

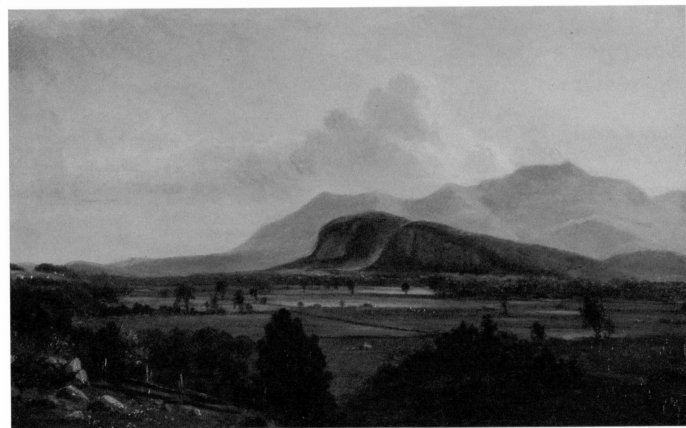

G

LENDERS
TO THE
EXHIBITION

ix

Albany Institute of History and Art

Allen Memorial Art Museum,
Oberlin College

Austin Arts Center, Trinity College

Boston Public Library, Print Department

The Brooklyn Museum

The Art Institute of Chicago

Cooper-Hewitt Museum,
Smithsonian Institution

The Corcoran Gallery of Art

The Currier Gallery of Art

Dartmouth College Library

Dartmouth College Museum & Galleries

Davis & Long Company, New York

Diplomatic Reception Rooms,
Department of State

International Museum of Photography at
George Eastman House

Katherine S. Emigh

Henry Melville Fuller

Mr. and Mrs. Robert A. Goldberg

Mrs. L. Hamlin Greene

Greene County Historical Society

Hirshhorn Museum and Sculpture
Garden, Smithsonian Institution

Kennedy Galleries, New York

Littleton Public Library

The University of Michigan
Museum of Art

Museum of Fine Arts, Boston

The Newark Museum

New Hampshire Historical Society

The New-York Historical Society

North Carolina Museum of Art

Douglas Philbrook

Portland Museum of Art, Maine

The Art Museum, Princeton University

Oswaldo Rodrigues Roque

Stephen T. Rose

Mr. and Mrs. Walter H. Rubin

John H. Sanders

Shelburne Museum, Inc.

Special Collections, Dimond Library,
University of New Hampshire

University of Vermont Library

Vassar College Art Gallery

Mr. and Mrs. Charles O. Vogel

Wadsworth Atheneum

The Wellesley College Museum

White Mountain National Bank

and several anonymous lenders

1. *A Map of the Most Inhabited Part of New England,* Carington Bowles, 1771. Lent by Wilbur Collection, University of Vermont Library

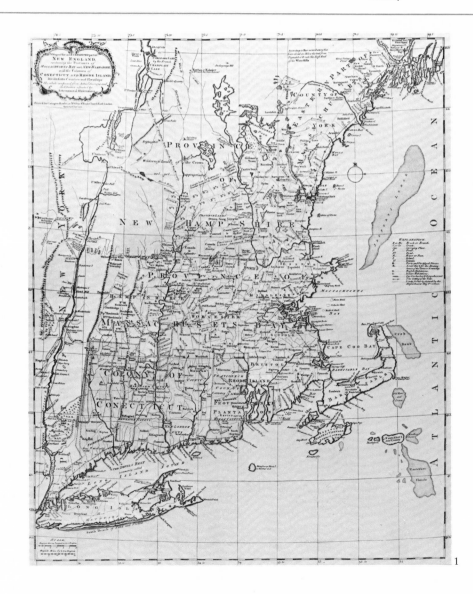

INTRODUCTION
AND
ACKNOWLEDGEMENTS

The White Mountains: Place and Perceptions is the second in a series of exhibitions presented by the University Art Galleries that focus on the culture and history of New Hampshire and its contribution to American cultural history. The first exhibition, *A Stern and Lovely Scene*, dealt with the long and remarkable history of the Isles of Shoals, a group of islands lying off the coast of New Hampshire. In this exhibition, we turn from the seacoast to the rugged heart of the state, the White Mountains. We turn also to the people who were there: the settlers who found a living in farming, logging, guiding, or innkeeping; the artists, writers, and scientists who sought inspiration and information; the tourists who relaxed and played in the healthful air. These groups of people participated in the profound demographic and cultural changes that occurred in the nineteenth century in this region. The images included here document the rich history to which these people contributed and provide insight into their varying perceptions of the mountains of New Hampshire.

The White Mountains lie in the center of the state, forming a huge spine. Part of the Appalachian Mountain system, they contain the highest peaks in the Northeast. They are subject to a wide range of climatic variations. Mount Washington, the highest peak of the range, has arctic conditions most of the year. The valleys foster lush, verdant growth during the summer months and catch the deep snows of winter.

The mountains have created a barrier to exploration as well as a challenge. By 1642, Darby Field had ventured into the mountains to climb Mount Washington. He was followed by a small trickle of courageous explorers in the eighteenth century, but it was not until the nineteenth century, the period of our study, that the mountains were systematically visited and explored.

In 1784, a group of men that included Jeremy Belknap climbed Mount Washington to collect scientific data, leading the way for numerous amateur scientists who traveled into the mountains in the early nineteenth century. Trekking along paths of earlier explorers or along routes known previously only to native Americans, they came to study the terrain, the climate, or the flora as well as to admire the dramatic landscape. By the second quarter of the century, the mountains drew more serious scientists, such as geologist Benjamin Silliman, botanists James W. Robbins and Edward Tuckerman, and State Geologist Dr. Charles T. Jackson. A state survey ordered in 1868, the study of arctic conditions on Mount Washington, and numerous scholarly articles and publications grew out of these earlier explorations.

Early images, such as Abel Bowen's pictures for Philip Carrigain's map of 1816, as well as written records of the mountains such as Jeremy Belknap's accounts of 1784, emphasized the rugged mountain terrain. Artists in the early decades of the century were drawn by this naturally "Sublime" landscape, finding delight in the terrible jagged peaks and deep valleys and the danger and adventure the mountains afforded. Thomas Cole and Henry Cheever Pratt, who visited in 1827–1828, were followed by mid-century by Alvan Fisher, Jasper Cropsey, Asher B. Durand, John F. Kensett, Albert Bierstadt, and Benjamin Champney. By this time, most of the artists sought the tranquil, pastoral landscape—a terrain shaped by the hand of man. Prints and photographs, with a few exceptions, presented this kind of idealized view of the White Mountains to a broad audience. Through these visions, the general public came to know the picturesque aspects of the mountains and not the difficult climate and harshness of daily life.

The local residents, on the other hand, were constantly aware of the rigors of life in the mountains. Most of those who settled in the region after the Revolution turned to farming. But in many cases, they found the trials too great and their farms were abandoned. A number found a more profitable livelihood catering to the writers, artists, and travelers who discovered the wild beauty of the mountains.

2

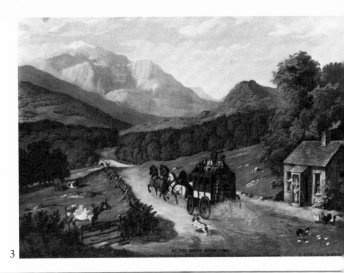

3

From the personalized and simple hospitality available at the inns of the Thompson and the Crawford families in the early decades, tourist accommodations grew both in size and number. Old inns were expanded and new structures built. The growth of tourism was accelerated by the railroads, which expanded north in midcentury. With the mountains readily accessible to large numbers of visitors, owners were prompted to build even larger hotels. Hotels and railroads worked together to publicize the advantages of a White Mountains vacation through a wide range of souvenirs, guidebooks, maps, and advertisements.

But tourism wasn't the only livelihood. Early in the century, road building, guiding, or logging occupied some residents. By the 1870s and '80s, small-scale logging activity had given way to an extensive logging industry, made possible by the consolidation of large tracts of timber land and the building of logging railroad spurs. Logging camps sprang up in remote areas; towns developed around sawmills and papermills.

The two major industries of the last part of the century, logging and tourism, found themselves at odds with each other. The very untrampled land sought by tourists to the mountains was the source of lumber for the loggers. Numerous painters, photographers, and printmakers were portraying wooded hills which in actuality were being clear-cut by lumbering.

At the same time, there was inevitable dependence. Railroads were an essential ingredient for bringing tourists to the mountains and timber out of the region. Hotels and artists worked in concert to bring tourists to the region—tourists who provided an important source of revenue for each. In the end, each person, whether a permanent resident, a summer guest, or a day-tripper, contributed to the development of the White Mountains.

This exhibition and publication recognizes the contributions of the people of the White Mountains. Objects have been chosen to illustrate the physical form of the mountain landscape and to reflect the changing perceptions of the people through the nineteenth century. Essays contained here deal with the social, economic, and cultural development of the region. R. Stuart Wallace discusses early explorations, settlement of towns, and the growth of industries. Donald D. Keyes's essay presents a survey of the different visions of artists, photographers, and printmakers in the nineteenth century, examining how these visions reflect changing sensibilities and helped to shape America's response to this region. Robert L. McGrath's essay focuses on popular images of the mountains and the way they reflect ideals of imagemakers and their public. The catalogue by Catherine H. Campbell documents each work in the exhibition.

With this exhibition and publication we wish to acknowledge our debt to all those who have been fascinated by the history of the White Mountains. The years of study by many of these people have formed the basis for our work. In this sense the project is truly a cooperative effort.

The four scholars involved in this project each have contributed time and energy far beyond the call. The Galleries' special thanks goes to them. Donald D. Keyes, professor of art history at Smith College, has acted as principal consultant throughout the planning phases. He has traveled many miles to talk with collectors and scholars. He has sifted through the vast amount of visual material on the subject to choose the objects in the exhibition, a task which is the culmination of over two years of work. In the process he has compiled an exhaustive archive of White Mountain paintings done before 1900. Keyes will continue this archive and he welcomes information on pertinent works, while respecting confidentiality of owners. Upon completion, this archive will be deposited in the Dartmouth College Library with a copy at the Dimond Library of the University of New Hampshire for use of future scholars.

Robert L. McGrath, professor at Dartmouth College

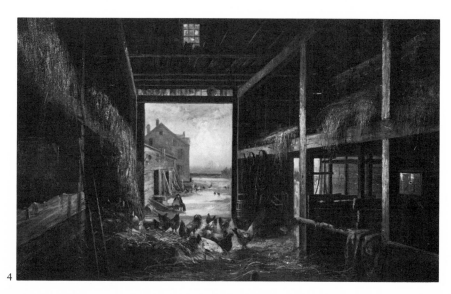

2. Thomas Doughty, *Tuckerman's Ravine,*
ca. 1840. Allen Memorial Art Museum,
Oberlin College, Ohio. Gift of C. F. Olney

3. *At the White Mountains,* F. Gleason,
1875 (?). Collection of New Hampshire
Historical Society

4. Harrison Bird Brown, *Barn Interior,* ca.
1880. Collection of the Portland Museum of
Art, Me.: Gift of the Reverend George
Monks, Commander John P. Monks, and
Mrs. Constantine Pertzoff, 1944 4

and author of the essay, *The Real and the Ideal,* included herein, has devoted many years of study to the paintings of the White Mountains. Long interested in fostering an exhibition of these works, he has generously shared his extensive and invaluable research with us. His own institution's involvement with the exhibition is a tribute to his interest and enthusiasm for this area of New Hampshire.

Through his own research and through his work as editor of *Historical New Hampshire,* a publication of the New Hampshire Historical Society, R. Stuart Wallace has gained a wide knowledge of New Hampshire history. His contributions to this project go beyond the essay included in this publication. He has lent his practiced editorial eye to proposals, lectured to docents, consulted on the film which is part of our project, and tirelessly checked facts and offered information.

The catalogue section written by Catherine H. Campbell is the result of years of personal study of White Mountain paintings. Her files on the subject are formidable, and her willingness to share this information has given this project added dimension. Her enthusiasm for the subject has been infectious; her knowledge of painters and places invaluable.

Collectively the four authors wish to thank those institutions and individuals who have generously offered their resources. Their acknowledgements are as follows—

Catherine H. Campbell: Albany Institute of History and Art; Boston Athenaeum; Boston Public Library, Department of Fine Arts; Boston Public Library, Print Department; Crawford J. Campbell; William Culp Darrah; Frick Art Reference Library; Phyllis Greene; George Gurney; Kennedy Galleries, New York; George Kent; The New-York Historical Society; Douglas Philbrook; S. Morton Vose; Vose Galleries, Boston; and Walter W. Wright.

R. Stuart Wallace: New Hampshire Historical Society; and Charles E. Clark.

Robert L. McGrath: Walter W. Wright, Dartmouth College Library, Special Collections.

Donald D. Keyes: John Page and his very cooperative staff at the New Hampshire Historical Society; Robert Goldberg; Lee Hanshaw; Gabriella London; Faith Bushby; Ann Reynolds; Marianne Regan; Carolyn P. Adams; Margaret Moody; Nan Hopkin; Theodore Stebbins; Smith College, both for a small grant for photographs and for use of its facilities; as well as the many collectors who allowed free access to their collections—collections often gathered with extraordinary love and devotion to ideals that can never be measured monetarily.

The University Art Galleries extends special thanks to the following: The National Endowment for the Humanities for both the planning grant and the implementation grant which have made the project financially feasible; Dartmouth College Museum & Galleries and The New-York Historical Society for sharing the exhibition with us; the many institutions and private collectors lending to this exhibition, whose very real generosity has enriched our endeavor; John Bardwell, director, Evelyn Pearson, researcher, and the staff of the University of New Hampshire Media Services for the production of the introductory film accompanying the exhibition; Robert C. Gilmore and the late Lewis Goffe of the University of New Hampshire for offering suggestions and information during the planning phases of the project; Eva Roberts, a designer in the University of New Hampshire Publications Office, for designing the rich and imaginative exhibition installation at this university and the traveling display fabrications; University of New Hampshire Publications Office senior editor Shirley Ramsay, and senior designer Lisa Douglis, for long hours molding the disparate parts into the elegant and cogent publication presented here; the Galleries' Educational Project docents, Helen Reid, coordinator, for help in organizing the flood of information; Shirley Michael and Paula Volent for editorial assistance; Arthur Balderacchi, chairman of the Department of the Arts, for his continuing support of the Galleries' program; the Board

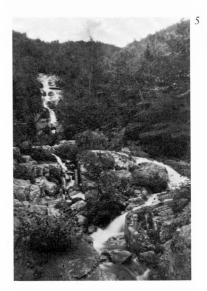
5

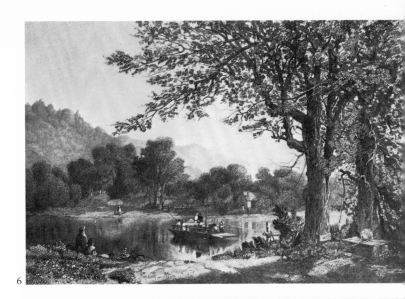
6

of Advisors to the University Art Galleries for dedication, interest, and support of all aspects of the Galleries' activities and for their particular encouragement of this exhibition; and Effie Malley, assistant to the Galleries, whose dedication and hard work have pulled the project together. It would not have been possible without her.

Susan Faxon Olney
Director, University Art Galleries
University of New Hampshire

5. Unknown photographer, *Silver Cascade,* ca. 1900. Collection of New Hampshire Historical Society

6. *The Ferry (On the Androscoggin River),* William Wellstood, engraver, after a painting by Albert Fitch Bellows; engraved for the *Ladies Repository.* Lent by Douglas Philbrook

7. William Hart, *Moonlight on Mount Carter, Gorham,* 1859. Collection of the Vassar College Art Gallery

8. David Johnson, *Study, Franconia Mountains from West Campton, N.H.,* ca. 1860–1865. Wadsworth Atheneum, Hartford; Bequest of Mrs. Clara Hinton Gould

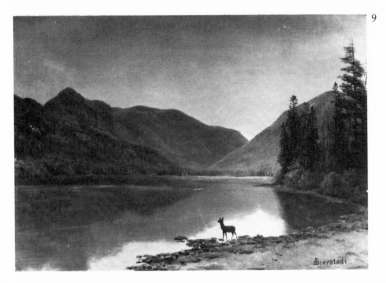

9

9. Albert Bierstadt, *Lake at Franconia Notch, White Mountains,* n.d. Collection of The Newark Museum

10. Thomas Cole, *Autumn Twilight, View of Corway* [Mount Chocorua] *Peak*, 1834. Collection of The New-York Historical Society

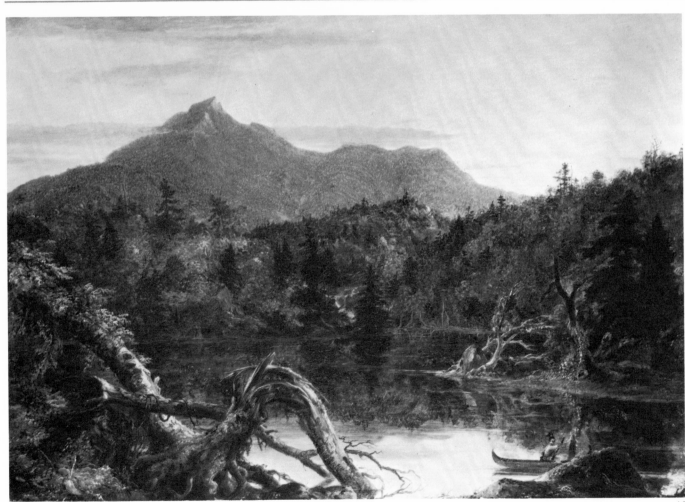

10

A SOCIAL HISTORY
OF THE
WHITE MOUNTAINS

R. Stuart Wallace

New Hampshire's White Mountains have meant different things to different people over time. A tiny corner in an expanding country, these mountains have represented America's rural challenge. To farmers, loggers, and townspeople living in New Hampshire's North Country, the White Mountains have been a home and a source of livelihood. To scientists, the mountains have been an arctic laboratory, while to artists and writers, they have been a source of inspiration. And to urban Americans, the White Mountains have been more than just another pretty place to visit; they have represented America's vanishing wilderness and all of the good qualities of life associated with the nation's natural landscape.

It has not been easy for the White Mountains to be all things to all people. The interests of loggers, artists, and tourists were frequently incompatible. As one group or another pushed its perception of the White Mountains to the brink of overwhelming reality, others reacted to restore the balance. As a result, the character of the region is both parochial and urbane; its natural resources have been exploited as they have been venerated; and the strains of vying interests have led to perceptions of the White Mountains that do not reflect the reality of the place.

EXPLORATION

The discovery and early exploration of the White Mountains is partially shrouded in mystery. Since, on a clear day, the mountains may be seen from the sea, it is impossible to say which of the early sixteenth century European explorers actually saw them first. Verrazano reported having seen "high mountains" as he sailed along the New England coast in 1524, but these may not have been the White Mountains. Mountains appear on several sixteenth century European maps, but once again, their identity is uncertain. In 1605, Samuel de Champlain reported having seen high mountains west of what is now Portland,

Maine—almost certainly the White Mountains. During his visit to New England in 1623 and 1624, Englishman Christopher Levett was told by Indians in the Casco Bay area of a great "Cristall hill" located about one hundred miles inland.[1]

The earliest attempt to explore the White Mountains came in 1642, when Darby Field climbed to the top of Mount Washington. Field, a resident of New Hampshire's seacoast region, ascended to great "Cristall hill" with the aid of Indian guides. His motives for making the climb are unknown, but, once on the summit, he gathered some shining stones that he mistook for diamonds. His accounts of shining stones prompted others to venture into the White Mountains, including an expedition sponsored by Maine's proprietor, Sir Ferdinando Gorges. None found any diamonds.[2]

By 1677, the mountains were apparently being designated "White Mountains," for they appear as such on John Foster's map of New England that year. But further exploration was interrupted when the frontier areas of Maine, New Hampshire, and Massachusetts began experiencing a period of turmoil and bloodshed, which continued intermittently for some ninety years. The French living along the St. Lawrence River and their Indian allies fought bitterly to retard English settlement in northern New England. In the end, they failed, but not until both sides had suffered heavy losses.

In the eighteenth century, as English settlement pushed northward and westward, the White Mountains took on increased strategic importance. During Queen Anne's War (1702–1713) and Lovewell's War (1723–1725), several Massachusetts and New Hampshire militia units entered the White Mountains. In 1725, the same year that one of these groups was defeated in a skirmish at Lovewell Pond, another "ranging party" climbed to the top of Mount Washington.[3]

In the twenty-year period following the end of Queen

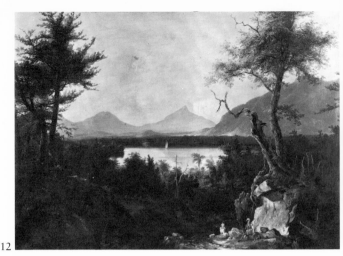

Anne's War, there was an uneasy peace along the frontier regions of northern New England. While some English settlers broke out of the seacoast area of New Hampshire to begin farms in the towns of Rochester, Barrington, Nottingham, and Chester, others, primarily from Massachusetts, moved north along the Merrimack and Connecticut Rivers. Scotch-Irish immigrants from Ulster swarmed into southern New Hampshire and, before long, had settled much of the land between the Connecticut and Merrimack.

Both King George's War (1743–1748) and the French and Indian War (1755–1763) diminished this flow toward the White Mountains. Once again, activity in the vicinity of the White Mountains was related to warfare between the French and Indians on the one hand and English settlers on the other.[4] However, by the 1740s, English settlement had reached the southern regions of the White Mountains. The townships of Gilmanton, Meredith, Sanbornton, Tuftonboro, Wakefield, and Holderness had been granted by 1750. Although some of these early grants bore little or no fruit, interest in New Hampshire's North Country was evident. In 1752, the provincial government of New Hampshire took such an interest in the upper reaches of the Connecticut River, then called "Cohos," that they made preliminary plans to survey the area as well as to build a road leading to the region.[5]

With the conquest of French Canada by English and American units in 1760, the northern frontier of New England was safe for English settlement for the first time. New Hampshire Governor Benning Wentworth wasted no time granting townships on both sides of the Connecticut River. The land to the west of the Connecticut River became known as the "New Hampshire Grants," though the status of this region was not officially determined until it was recognized as the state of Vermont in 1791. At least one firsthand account of the laying out of township boundaries survives with Matthew Patten's 1765 diary descrip-

tion of surveying lots in Piermont.[6]

In the period roughly between the end of the French and Indian War in 1763 and the end of the Revolutionary War in 1782, exploration and settlement complemented one another. As settlers began farms in the White Mountains, the intensity of exploration and the rate of discovery accelerated. In turn, each new discovery enhanced settlement.

EARLY SETTLEMENT

"Settlement" was not necessarily synonymous with agriculture. The White Mountains of Maine and New Hampshire have experienced a variety of land uses over time. In the late eighteenth century, some people recognized the potential value of the region's forests, while others hoped to discover mineral wealth. Yet most of those settling in the mountains or speculating in White Mountain real estate were interested in farming. From the end of the Revolutionary War through 1820, hundreds of small farms were started within the White Mountains. Some were abandoned in a few short years; others proved successful, and in some cases the farmhouses stand today.

The White Mountain region was one of the last settled in New England, and this settlement represents the last and most desperate attempt to push an agricultural economy to its limit. In the end, the attempt failed. Most White Mountain farms were abandoned and reclaimed by the forest prior to the massive logging operations of the late nineteenth century.

To understand the pattern of White Mountain settlement in the late eighteenth and early nineteenth centuries, it is necessary to look at the changing process of granting townships in provincial New Hampshire. In the seventeenth and very early eighteenth centuries, a New England town began when a group of settlers received permission from a provincial government both to own and to live on a tract of land. Hence, the original settlers were also the

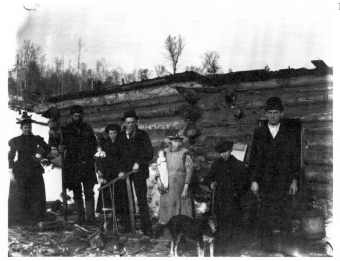

*Illustrations marked with an asterisk are of works not in the exhibition.

11. *Chocorua's Curse,* George W. Hatch, engraver, after the painting by Thomas Cole, 1830. Collection of Dartmouth College Library

12. Thomas Cole, *Lake Winnipesaukee,* 1827 or 1828. Collection of Albany Institute of History and Art, Gift of Mrs. Ledyard Cogswell, Jr.

13. Unknown photographer, *New Hampshire Homestead,* ca. 1890. Lent anonymously

"proprietors." The proprietors hired a surveyor who prepared a "proprietors' map" of the new town. An original "village" was laid out with home lots generally located near a town meetinghouse. Individuals received strips of land, sometimes located behind their homes. As more land was cleared, a new "range" of strips, or "lots," was surveyed and fenced. The proprietors would then draw for their new lots, drawing in proportion to the number of shares they owned. Pasture and woodlots were usually held in common.[7]

This system resulted in a settlement pattern whereby a town had distinct urban and rural components. The urban component was the village where people lived. The rural component consisted of ranges of privately owned lots, common pastures and woodlots, and wasteland—swamps, lakes, mountains, and such.

This practice worked well at a time when people were migrating as large groups and when a centralized village provided some defense against Indian attack. The Indian threat also prompted provincial governments to avoid isolated towns and to lay out towns in contiguous fashion in "chains."[8]

Changing circumstances in the eighteenth century altered this form of settlement. One reason behind the change was the reduced Indian threat from 1725 to 1744. Another reason was land speculation. A final reason for the breakdown of the old system of settlement was the boundary controversy between Massachusetts and New Hampshire from 1720 to 1740. Both provinces claimed the land between the Connecticut and Merrimack rivers, and investors in both provinces wanted to buy land in the disputed territory. As a result, both provincial governments frantically granted townships on paper to anyone wishing to be a proprietor. The resulting "paper townships" were created at a much faster rate than they could be settled.[9]

The essential difference between the old and new methods of settlement, therefore, was the separate identity of "proprietors" and "inhabitants" in the eighteenth century. Under the new system, a group of proprietors, some wealthy and some not, would petition either the New Hampshire or Massachusetts provincial government to be granted a "township." Many had no desire to be inhabitants, however, but sought to settle others in their townships.

The emergence of "absentee" proprietors created a new situation in eighteenth century settlement. Since most of the new proprietors were not going to be inhabitants of their townships, quality of life within the new community was not of utmost importance; the sale of real estate was. They were not interested in the advantages to be gained by living in a centralized village, nor were they much concerned about the uneven topographical makeup of land they would never see.

Proprietors' maps of the middle and late eighteenth century reflect this change. Instead of laying out a nucleated village and waiting for ranges to be surveyed before more lots were sold, proprietors simply cut their townships into a grid pattern. Topographical features were ignored, and no plans were made for a village. This grid pattern of township land sales, or a slightly modified grid, was universally used by New Hampshire proprietors by the end of the French and Indian War in 1763.

Although much of the land within the mountains had been granted in the form of townships by the time of the Revolutionary War, a mere handful of settlers had come to this area. The war further discouraged settlement, as settlers constantly feared a British and Indian invasion from Canada.

Several "gateway" towns to the White Mountains had made tentative headway prior to the Revolution, however. Conway, New Hampshire, and Fryeburg, Maine, had been settled in the 1760s—largely by settlers from Concord, New Hampshire. Plymouth, New Hampshire, was settled

14

15

in 1764 and ten years later was the shire town of Grafton County, complete with a courthouse. The neighboring towns of Rumney, Campton, and Thornton also had permanent populations by the outbreak of the Revolution. Even north of the mountains, the township of Jefferson, or Dartmouth, as it was then called, had been settled by Col. Joseph Whipple in 1773. Whipple was the first to take advantage of the "notch" through the mountains discovered by Timothy Nash in 1771. Although the township was not incorporated until 1796, Whipple realized that a road through the notch, later known as Crawford Notch, would make it possible for people living north of the mountains to reach coastal markets.[10]

With the end of the Revolutionary War in 1783, the situation changed. New Hampshire's North Country began growing at a much faster rate than the state as a whole.[11]

It is interesting to note that most accounts of early White Mountain settlement tend to follow the lead of Lucy Crawford by concentrating on the Crawfords, Rosebrooks, and Willeys of Crawford Notch.[12] While these families form a viable part of both the history and lore of the White Mountains, their story does not stand alone. Hundreds of families were starting small White Mountain hill farms in the very late eighteenth and early nineteenth centuries. Town maps of the early nineteenth century show roads in mountainous areas where none exist today.

AGRICULTURE

Settlement and agricultural prosperity did not go hand in hand. The process of clearing the land did result in ashes that would be made into potash; wheat apparently grew well in the early nineteenth century on the region's limited intervale lands; and a substantial quantity of potatoes was grown in the 1850s. Sheep farming also provided some prosperity in the mountains early in the century but de-

clined throughout northern New England by the Civil War. The turn to dairying later in the century came too late to save most of the hill farms in the White Mountains.[13]

The hill farms of northern New Hampshire also suffered because of their distance from substantial markets. Rivers in the White Mountains were shallow and unnavigable, while "roads" were poorly maintained and frequently were nothing more than paths. The road through Crawford Notch washed out at least once each year. Efforts to bring northern New Hampshire closer to markets in Portland, Portsmouth, and Boston had a limited effect. Locks and canals improved transportation in the southern part of the state but did little for the North Country. Privately chartered turnpikes, begun in the closing years of the eighteenth century, were more successful. The Tenth New Hampshire Turnpike ran through Crawford Notch and was a vital link between the Littleton area and Portland. Yet overland travel in New Hampshire was never dependable until the arrival of the railroad. In some respects, however, the railroad was a matter of "too little, too late" for all but the most fortunate of White Mountain farms. Only a few farms were within easy reach of the main lines, and these main lines were not completed until roughly 1870—by which time many hill farms had already folded.[14]

In order to survive, farmers in the North Country had to practice diversified, family farming, raising a wide variety of crops and animals. This practice is reflected in the rambling, multipurpose, connected farm buildings that came into being in the late nineteenth century.[15] These farmers also had to turn to hunting in the fall, lumbering in the winter, and maple sugaring in the spring. In short, New England hill farms were a diverse economic operation, with crops and livestock producing only a portion of the farmers' total product.

Evidence suggests that many of the most remote White Mountain farms were abandoned shortly after they were

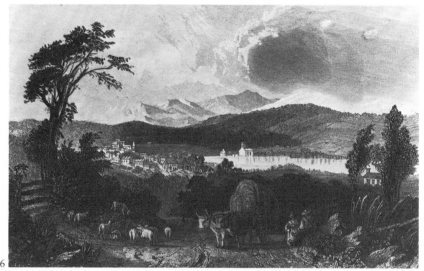

14. Jasper F. Cropsey, *Eagle Cliff, Franconia,* 1858. Collection of North Carolina Museum of Art

15. Russell Smith, *Mount Franklin,* September 17, 1848. Collection of Kennedy Galleries, New York

16. *Harvest Scene: Meredith, N.H.,* after William Bartlett; ca. 1850. Lent anonymously

17. Samuel Bemis, *Crawford Notch,* ca. 1840. Collection of International Museum of Photography at George Eastman House

16

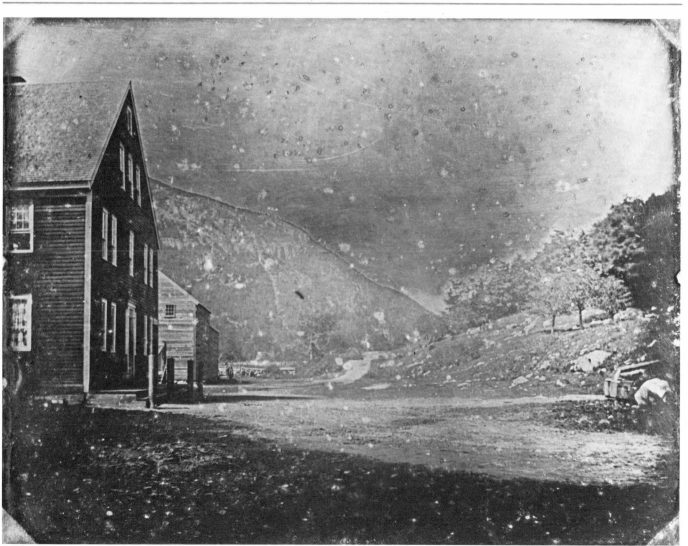

17

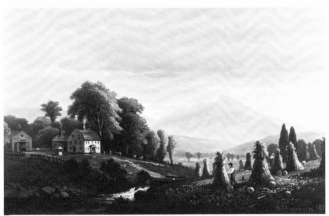

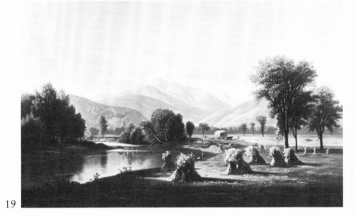

begun. In the town of Woodstock, two entire farming villages had been abandoned by the Civil War.[16]

The White Mountain farm towns in Grafton and Carroll counties followed roughly the general population trends of hill towns to the south. By the 1830s, most of the good farmland had been taken, and immigration to these towns slowed. Population growth tended to be from within, and increases in improved land resulted from the development of existing farms. Although settled later than the hill towns in southern New Hampshire, Carroll and Grafton county hill towns began losing population in the mid-nineteenth century.

Towns in Coos County took a somewhat different course than those of Grafton and Carroll. From the start, farming was so limited in the Coos County towns that they experienced neither the rapid rise nor the slow decline of the other White Mountain towns. Harold Fisher Wilson has correctly pointed out that northern towns peaked at a later date than southern towns.[17] This phenomenon probably had little to do with the area's very limited farming, but rather resulted from the impact of the railroad, the corresponding increase in scale of logging operations, and, to a lesser extent, the arrival of growing numbers of tourists.

A substantial number of White Mountain towns continued to lose population in the late nineteenth and early twentieth centuries. A comparison of county maps made in the 1860s and town maps published in 1892 shows hill farms to have disappeared from the later maps, and small farm roads that had been "thrown up" are gone as well. The process accelerated early in the twentieth century, as the population of the White Mountain towns began to move literally "downhill" to a limited number of village centers.[18] Many abandoned and struggling farms were purchased by land speculators and lumber companies, whereupon they were allowed to return to the forest.

SCIENTIFIC EXPLORATION

If the White Mountains were a source of hardship and frustration for thousands of hill farmers, they were also a source of wonder to scientists throughout the nineteenth century. The earliest effort to get away from simple *exploration* to a more detailed *study* of the mountains is generally thought to have begun as early as 1784. It was in this year that a party of New Hampshire and Massachusetts men, including historian Jeremy Belknap, climbed Mount Washington. The group carried some scientific apparatus in the hope of measuring the height of the mountain. Belknap was unable to complete the climb, while those who did reach the summit were frustrated by inclement weather and could not use their instruments.[19]

The expedition of 1784 was typical of efforts to study the White Mountains in the late eighteenth and early nineteenth centuries. The "scientists" who traveled into the mountains were frequently amateurs; they traveled in small groups, were lightly equipped, and came with a wide variety of vague goals. Excursions into the Presidential Range and vicinity were usually not purely scientific ventures, but tourist jaunts as well, where the grandeur of the region and its various curiosities were studied, admired, and described. Some of these excursions were never recorded, while some that were are filled with disjointed and incorrect observations.

Manasseh Cutler, a companion on the earlier Belknap expedition, returned to Mount Washington in 1804, this time accompanied by William D. Peck and Nathaniel Bowditch, two of the most eminent American scientists of the early nineteenth century. This group estimated the height of Washington to be 7,055 feet, a much more realistic figure than Belknap's guess of 10,000 feet. While near the summit, Peck also observed various unusual alpine plants. Three years later, in July, 1807, George Shattuck, a doctor

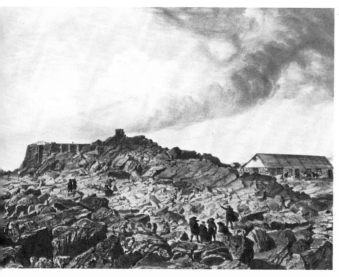

18. *Pumpkin Time,* after Benjamin Champney; published by L. Prang & Co., Boston, after 1871. Collection of the Boston Public Library, Print Department

19. *North Conway Meadows,* after Benjamin Champney; published by L. Prang & Co., Boston, after 1870. Collection of the Boston Public Library, Print Department

20. *Summit of Mount Washington,* after Benjamin Bellows Grant Stone, 1857–1858. Lent by Douglas Philbrook

from Boston, led a six-man party to the summit of Washington, where he recorded a number of general scientific observations.[20]

Botanist Jacob Bigelow, accompanied by fellow botanist Francis Boott and others, climbed Mount Washington in the summer of 1816. Not only did this group arrive at a reasonably accurate estimate of Washington's altitude (6,225 feet), but Bigelow also kept a journal of the expedition and recorded the names of various plants collected. This was then published in the *New England Journal of Medicine and Surgery.*[21] During the summer of 1825, botanist William Oakes spent the first of his many summers in the White Mountains. Oakes probably called upon the services of Ethan Allen Crawford to help him find his way about in 1825. Although his primary interest was collecting samples of White Mountain plant life, Oakes is best remembered today for his book, *Scenery of the White Mountains.*[22]

As the United States moved into the so-called "Age of Jackson" (c. 1828–1845), some subtle changes occurred in American science. For one thing, scientists not only became more specialized but also sought a separate professional identity by forming scientific organizations and academies. They improved communication within the growing scientific community through a number of scientific journals, albeit poorly funded and usually short lived.[23] These changes were reflected in scientific study of the White Mountains in the years prior to the Civil War. In 1828, Professor Benjamin Silliman of Yale made the first of at least two trips to the White Mountains. Silliman was one of the most distinguished chemists and geologists of his time, as well as the founder and editor of the prestigious *American Journal of Science and Arts.* Botanist James W. Robbins also visited the White Mountains during this period (1829) and collected a number of plants on Mount Washington. Finally, in 1837, botanist Edward Tuckerman began his long association with the White

Mountains. He collected plants over several summers, wrote numerous scholarly articles, and culminated his career as a professor of botany at Amherst College from 1858 to 1886.[24]

By the late 1830s, the state of New Hampshire had decided to enter the scientific quest. In 1839, Dr. Charles T. Jackson was appointed state geologist. His job was to prepare a geological survey of the state. Jackson was one of America's leading experts in geology, chemistry, and mineralogy, and he conducted state geological surveys for Maine and Rhode Island as well as New Hampshire. The methods used by Jackson and his assistants, one of whom was Edward Everett Hale, were crude by later standards and necessitated another survey shortly after the Civil War. Yet, the Jackson *Final Report* was a major pioneering effort in its own right.[25]

A number of European scientists also felt obligated to explore the American wilderness in the years prior to the Civil War, and some of these men came to the White Mountains. English geologist and botanist Sir Charles Lyell visited the White Mountains in 1845. In 1847, Swiss geologist Louis Agassiz spent part of his first summer in the United States traveling through the White Mountains, although his most significant White Mountain paper was not published until 1871, after a much-delayed second visit. Agassiz's Swiss friend Arnold Guyot made the first of four summer trips to the White Mountains in 1849. Guyot, a geologist and Princeton professor, was most interested in ascertaining mountain heights through barometric readings, and in 1851 concluded that Mount Washington had an altitude of 6,291 feet.[26]

By mid-nineteenth century, American and European scholars had begun to assemble accurate scientific data about the White Mountains. In the years after the Civil War, this information started coming together, resulting in detailed guidebooks, accurate topographical maps and geological surveys, and both popular and scholarly articles.

21

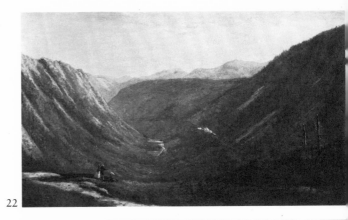

22

Perhaps the single most important step toward scientific exploration of the White Mountains began in 1868 when the New Hampshire General Court passed an act authorizing another state geological survey. Ironically, this came the year after the state had sold the White Mountain region to private interests. Charles H. Hitchcock was appointed to the post of state geologist, and his assistants were J. H. Huntington of Hanover, New Hampshire, and George L. Vose of Paris, Maine.[27]

The published geological survey is only one of several results stemming from this scientific endeavor. In an effort to understand better the White Mountain weather in the winter, Huntington and photographer A. F. Clough spent the winter of 1869–70 in the Mount Moosilauke Summit House.[28] Having accomplished this, Huntington finally gained permission to try a winter on the summit of Mount Washington. He headed the five-man group that spent the winter in the Mount Washington Railway Company station. They took meteorological readings throughout the winter and reported regularly by telegraph to Hitchcock at Dartmouth College.[29] The winter outing proved so successful that the United States Signal Service set up a weather observatory in 1871 on the summit of Washington. They built a separate signal station in 1874, which they maintained year-round until 1887 and during summers until 1892.[30]

While Huntington and friends performed their heroics, the state geological survey continued.[31] The three-volume study, *The Geology of New Hampshire,* was published between 1874 and 1878, with Volumes I and II containing the most White Mountain material. In addition Hitchcock and H. F. Walling prepared the best atlas of New Hampshire to that time.[32]

In addition to geological surveys, zoologists and botanists became increasingly fascinated by White Mountain plant and animal life in the late nineteenth century, and their articles appeared in dozens of journals. Many, for instance, were intrigued by White Mountain insects, particularly the hardy breeds of butterflies that lived near the summit of Mount Washington. Entomologists Samuel H. Scudder and H. K. Morrison and writer/entomologist Annie Trumbull Slosson collected specimens in the White Mountains and wrote numerous articles in both scholarly and popular journals.[33] Nature writer Bradford Torrey wrote extensively of White Mountain birds and, along with Slosson and popular writers like William C. Prime and Frank Bolles, wrote books and articles of a semiscientific nature. This blend of science and literature became very popular in the late nineteenth century, as readers in urban America became increasingly aware of the nation's vanishing wilderness and longed to understand it before it disappeared.[34]

TOURISM IN THE WHITE MOUNTAINS

All of the early visitors to the White Mountains, whether they styled themselves scientists, painters, photographers, or poets, were to some degree "tourists." Their hosts, in spite of making part of their living as farmers and road builders, were also innkeepers. Many early nineteenth century visitors to the White Mountains mixed business with pleasure, and scientists, writers, and artists continue to come to the mountains to this day. By the 1850s, however, thousands were pouring into the region for pleasure only. By the last quarter of the nineteenth century, the era of the grand hotel had brought unprecedented prosperity to the White Mountains. The once remote mountains in northern New Hampshire became a playground for wealthy, urban Americans and, as such, a significant chapter in American history. With the coming of the automobile in the twentieth century, however, American attitudes toward work and play changed. The hotel owners who initially welcomed these four-wheeled curiosities into the

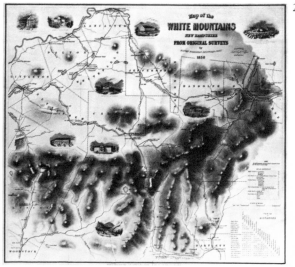

21. Albert Bierstadt, *Shady Pool, White Mountains,* ca. 1869. Collection of Hirshorn Museum and Sculpture Garden, Smithsonian Institution

22. Frank Henry Shapleigh, *Crawford Notch from Mount Willard,* 1877. Lent by Mr. and Mrs. Walter H. Rubin

23. *Map of the White Mountains from Original Surveys,* Harvey Boardman, 1858. Collection of New Hampshire Historical Society

24. Winslow Homer, *Summit of Mount Washington,* 1869. Collection of The Art Institute of Chicago, Gift of Mrs. Richard E. Danielson and Mrs. Chauncey McCormick

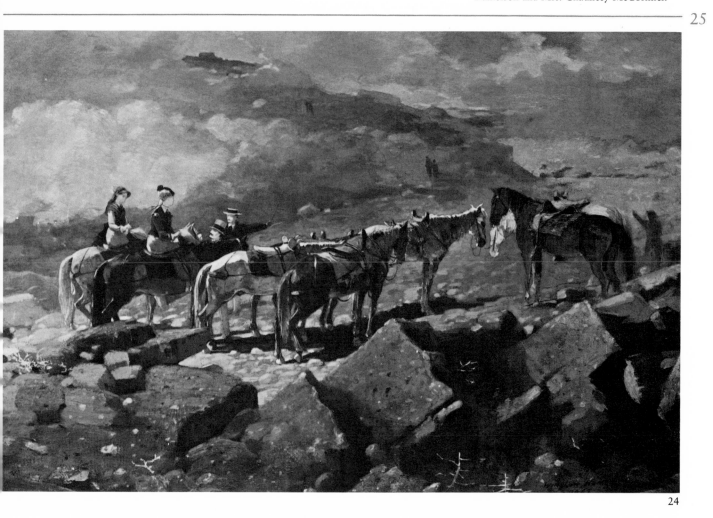

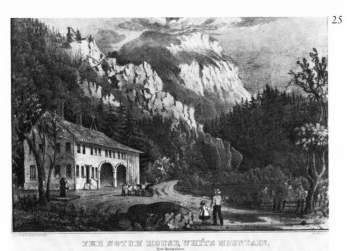

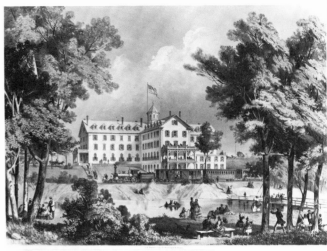

THE NOTCH HOUSE, WHITE MOUNTAIN,
New Hampshire.

PEMIGEWASSET HOUSE, PLYMOUTH, N.H.

White Mountains learned to regret their actions. A totally new form of White Mountain tourism developed—one that threatened the grand hotels with extinction.

White Mountain tourism can be thought of in a number of recognizable stages. Prior to the 1840s, tourism was conducted on a limited scale. Writers, scientists, artists, and a few curious and daring souls visited the White Mountains to experience firsthand the wonders of a little-known region. They reached the mountains on rugged and sometimes nearly impassable roads and by a number of interesting routes. They stayed in small, simple country inns and taverns, sharing their rustic lodgings with the innkeeper, his family and servants, and any number of cart and wagon drivers bringing produce and goods through the mountains. Their stay was usually brief—a couple of days to perhaps one or two weeks—and their intriguing travel accounts are the best single source of information we have of early White Mountain tourism.[35]

Certainly the most famous of the early nineteenth century innkeepers were members of the Crawford family, whose three inns serviced those traveling through what became known as Crawford Notch.[36] Abel Crawford, "the Patriarch of the Mountains," first came to the White Mountains in the 1790s and eventually established himself at the southern end of the notch near Bemis. Two of his sons went on to become innkeepers in the area: Thomas J. Crawford ran the Notch House, while Ethan Allen Crawford, "the Giant of the Mountains," operated an inn near Fabyan.

The Crawfords were best known, both to contemporaries and to future generations, as pathbuilders, mountain guides, and innkeepers. In the last two of these roles, tourists expected them to be as dramatic and original as the surrounding mountain scenery. In this, the Crawfords were remarkably successful. For the tourists' benefit, both Abel and Ethan Allen Crawford made pets of wild animals, including deer, wolves, bears, a peacock, and even a moose. Ethan Allen Crawford used to fire a cannon near his inn so tourists could hear the spectacular echo. Abel Crawford was known for his wit and personality, shared at times with tourists around his well-stocked bar.[37]

Yet these were men of many parts. Abel Crawford may have been a rugged mountain pioneer, but he also served in the state legislature. The same Ethan Allen Crawford who captured live bear and deer had the botanical knowledge to collect specimens for botanist William Oakes and the gracious manners to impress even the very critical British visitor, Mrs. Frances Trollope, who found most Americans socially backward.[38] Among the tourists entertained by one or more members of the Crawford family were Daniel Webster, Ralph Waldo Emerson, Nathaniel Hawthorne, Washington Irving, and Thomas Cole. To travelers of this sort, the Crawfords themselves were as much a part of the trip as the mountains.

This first generation of innkeepers did more than simply entertain tourists, however. To make a living, they had to carry out a wide variety of tasks. The Crawfords not only kept working farms, but also earned much of their money working on roads and managing White Mountain property owned by Portsmouth proprietors.[39] When the Tenth New Hampshire Turnpike was incorporated in 1803, providing transportation through Crawford Notch, the Crawfords were key figures in keeping the road open as much of the time as possible.[40] The hundreds of wagons and "Portland pungs" that bounced and clattered past the various Crawford inns in the notch during the 1820s were a crucial factor in developing Portland's economy. It was so important for Portland to keep a good road open to Littleton and beyond that in 1831 the Maine legislature appropriated and spent $3,000 to repair the road between Fabyan and Littleton, with private citizens in Portland adding another $2,000.[41]

By the 1840s, the trickle of White Mountain tourists was becoming a steady stream. Wealthy city people, fre-

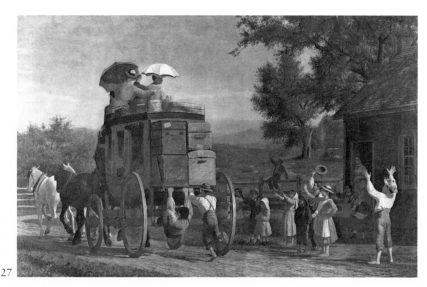

25. *The Notch House, White Mountains,* after William H. Bartlett; published by Currier and Ives, after 1857. Lent anonymously

26. *Pemigewasset House, Plymouth, N.H.,* J. H. Bufford, lithographer, ca. 1855. Collection of New Hampshire Historical Society

27. Enoch Wood Perry, Jr., *The Pemigewasset Coach,* ca. 1899. Collection of Shelburne Museum Inc.

27

quently from the Boston area, were taking advantage of improved transportation in New Hampshire and southern Maine to spend increasingly longer vacations in the White Mountains.

Prior to the coming of the railroad to the mountains, the best means of travel north of Concord or west of Portland was by coach. There were a number of popular routes to the White Mountains. Perhaps the most popular was the route up the Merrimack River to Laconia. After a night in Laconia, perhaps at the Senter House, the traveler could go by coach to Conway, or, after 1833, could break up the coach ride by taking a steamboat across Lake Winnipesaukee. An alternative on the Merrimack route was to go directly to Plymouth. After a night in Plymouth, the traveler would proceed north through Franconia Notch. Although the roads were quite good through Franconia Notch, the Winnipesaukee route was considered more scenic. Another route from Boston to the White Mountains took one through Portsmouth, Dover, and finally Alton Bay. A steamboat would then take the traveler to Center Harbor, and from there it was a twenty-mile coach ride to Conway. Finally, one could get to the White Mountains from Boston by taking a coastal vessel to Portland and then a fifty-seven-mile coach ride to Conway. For those traveling to the White Mountains from Connecticut, New York, and other parts of the eastern United States, the Connecticut River route might be preferable. It was approximately 190 miles from Hartford to Littleton, and part of the trip could be made by boat.[42] From 1830 to 1850, road conditions and overland coaches were improved along all of these routes to the White Mountains.

As it became more convenient to travel to and from the White Mountains, it became necessary to provide more conveniences within the mountains. The rustic inns of the first generation of White Mountain innkeepers could cater to neither the numbers nor the sensibilities of this new wave of tourists. A number of investors, many of whom lived in Portland, were quick to respond to the need for better tourist facilities. In the 1830s and 1840s, several substantial "hotels" were constructed in the White Mountains and staffed with professional managers.

In some cases, old inns were simply expanded into more commodious hotels. All three Crawford inns were expanded, as was the Willey House in Crawford Notch, a house made famous by an 1826 avalanche that killed members of the Willey family but left the house untouched. However, most of this expansion was carried out by the "second generation" of White Mountain innkeepers, with Horace Fabyan being a prime example.

Unlike the first generation of White Mountain innkeepers, Horace Fabyan and most others of the second generation came from urban areas—some of the same urban areas from which the tourists came. Hence, while urban tourists viewed the Crawfords as quaint, rugged, and at times legendary, they saw nothing very unusual about the innkeepers of midcentury.

Horace Fabyan was born just outside of Portland and was a provisions dealer in the city during the 1830s. He then moved to Conway, where he worked as an innkeeper. When a Concord bank took over Ethan Allen Crawford's debt-ridden property in 1837, Fabyan rented Crawford's inn from the bank and became the inn's manager. Soon thereafter, he purchased the property. In 1844, Fabyan purchased the Willey House further down the notch and immediately constructed a two-and-a-half story hotel on the south side of the house. He sold this structure the very next year and immediately began construction of a large addition to Ethan Allen Crawford's old inn. The resulting three-story structure was renamed the Mount Washington House. It contained approximately one hundred rooms, including a sixty-foot-long, carpeted dining room, and was probably the largest hotel in the White Mountains when completed in 1848.[43]

Elsewhere in the White Mountains, other hotels were

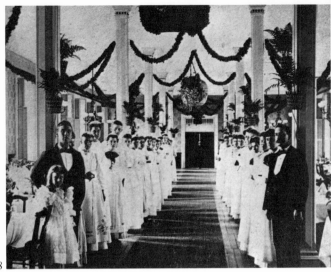

28. Benjamin West Kilburn, *Fabyan House Dining Hall*, ca. 1890. Collection of New Hampshire Historical Society

29. *Jacob's Ladder*, published by Robinson Engraving Company, Boston, 1887. Collection of Dartmouth College Library

30. Benjamin West Kilburn, *Frankenstein Trestle and Train*, ca. 1890. Collection of New Hampshire Historical Society

28

being enlarged and constructed, including the Flume House and the Lafayette House in Franconia Notch.

Both the new hotels of the 1840s and the men running them were forerunners of the era of the "grand hotel." The buildings themselves generally cost around $25,000 to build, were frequently financed by outside interests, and, if lacking architectural distinction, at least had the necessary space for large numbers of tourists.[44] Yet the second generation of White Mountain innkeepers may also be thought of as transitional figures. They operated White Mountain hotels at a time when the railroad first began to make its way into the mountains. The impact was dramatic.

Throughout the 1840s, a number of railroads began to approach the White Mountain region. By 1842, Boston and Portland were connected by rail. Another line had moved up the Merrimack to Concord in the same year. From Portland, tourists could take a daily stage to Conway, or they could take a more interesting land-and-water route that included a twenty-mile ride in the Lake Sebago area on the little steamboat "Fawn."[45] By 1851, however, all of this was unnecessary, as the Atlantic and St. Lawrence Railroad (later, the Grand Trunk) had finally reached Gorham from Portland. It was now possible to travel to within eight miles of Mount Washington by rail.

Railroad construction in the White Mountains continued throughout the century. During this time, the various small and sometimes local railroads were generally absorbed by larger, out-of-state corporations. By 1895, virtually all of the White Mountain lines, as well as the rail lines throughout the state of New Hampshire, fell under the control of the Boston and Maine Railroad.

The railroad made the biggest difference yet in White Mountain tourism; it literally put the White Mountains at Boston's back door. Railroads made it possible for more people to come to the White Mountains from greater distances. Bostonians in 1887 could leave at 7:30 in the morning and be at the elegant Profile House in time for supper—unless they took the more direct stage route through Franconia Notch—in which case they could leave Boston after breakfast and be boating on Echo Lake by late afternoon. New York was not much farther away by train in 1887. It took about eleven hours to get from Manhattan to the front porch of the Crawford House.[46]

An intimate relationship developed between the railroads and the hotels. The hotels needed the railroads to bring tourists, supplies, and the mail. They responded by building their own railroad stations, where hotel employees would meet incoming guests in elegant hotel coaches. Railroads, for their part, printed White Mountain maps, guidebooks, and collections of scenic photographs of favorite tourist attractions. In some cases, railroads directly invested in White Mountain tourism by building hotels.

The era of the grand White Mountain hotel developed along two lines. First, there was the construction of larger hotels. Second, there was the creation of activities and programs for the tourist's entertainment.

One of the first areas affected by the coming of the railroad was Gorham and Pinkham notches to the south. In 1851, the year the Atlantic and St. Lawrence Railroad reached Gorham from Portland, Gorham's 165-room Alpine House was built for a total of $30,000.[47] Between 1850 and 1860, Gorham's population increased fourfold, and the road through Pinkham Notch connecting Gorham and Conway became a much traveled highway. By 1853, Joseph M. "Landlord" Thompson was operating a hotel along this road with a capacity of two hundred guests. One obvious reason for the popularity of Thompson's "Glen House" was its proximity to Mount Washington. Between 1853 and 1861, a road was completed from the Glen House to the summit of Washington, necessitating the construction of hotel facilities there as well.[48] The Glen House remained one of the great resort hotels in northern New England until destroyed by fire in 1884, whereupon

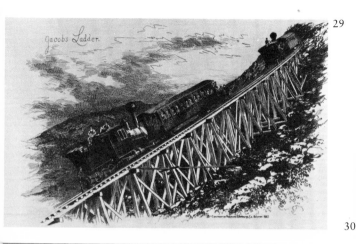

Jacobs Ladder.

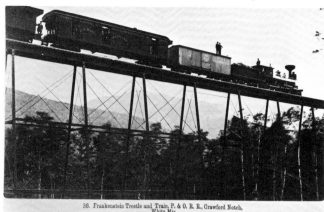

36. Frankenstein Trestle and Train, P. & O. R. R., Crawford Notch, White Mts.

it was replaced by another equally grand Glen House.[49]

Dozens of other hotels were built or enlarged throughout the White Mountains as a result of the railroad. The Crawford House, the Fabyan House, and the Mount Pleasant House all had their own railroad stations, and the Profile House had its own narrow-gage railroad. The Pemigewasset House in Plymouth was built by the Boston, Concord, and Montreal Railroad. The towns of Conway and Bethlehem became major resort centers. In Bethlehem, the climate proved comfortable for people with hay fever, and the town became headquarters of the American Hay-Fever Association. By 1879, Bethlehem's twenty-four hotels could handle a total of 1,450 guests at one time.[50]

The era of the grand hotel in the White Mountains is best epitomized by the magnificent hotels located in the southeastern tip of Carroll, just north of the gate of Crawford Notch. The second Crawford House, built hastily in 1859, was the first of these structures. It was followed by the Fabyan House (1873), the Mount Pleasant House (1876, 1881), and the Twin Mountain House (1869–1870). The area became the undisputed center of White Mountain tourism when work began at Bretton Woods on the Mount Washington Hotel in 1901. The massive, Y-shaped, Spanish Renaissance building, complete with two five-story, octagonal towers, was built at a cost of one and one-half million dollars. It was the last of the truly grand hotels built in the White Mountains and is the only one of the Crawford Notch area hotels still standing. It incorporated not only all of the architectural excellence that lesser grand hotels strove for, but all of the modern conveniences as well.

Yet tourists wanted more than conveniences. Like others before them, tourists of the late nineteenth century expected to be entertained. They were no longer satisfied with a few pet animals and the echo of a cannon; they were wealthy Americans of refined tastes. They came to the White Mountain resorts for extended periods of time—

perhaps for the entire summer—and they sought a lifestyle, not a few thrills. The White Mountain region and its grand hotels had become the playground for the urban elite of America, and, as such, it had to perform according to their cosmopolitan tastes.

The most spectacular treat for urban American tourists was the "railway to the moon."[51] When Sylvester Marsh asked the state of New Hampshire for permission to build a cog railway to the summit of Mount Washington in 1858, the legislators were amused. One is reported to have suggested that Marsh be allowed to continue the railway to the moon. Marsh received permission to go ahead, however, and he chose a path on the western side of Mount Washington that had been used previously as a footpath by both Ethan Allen Crawford and Horace Fabyan. Construction was delayed by the Civil War, but between 1865 and 1869, Marsh's Mount Washington Steam Railway Company laid tracks to the summit of Washington. The Cog Railway was a major tourist attraction from the start, carrying sixty thousand fares in its first eight years of operation. It continues to be a major tourist attraction to this day.[52]

While the Cog Railway was a popular attraction for the White Mountain area in general, individual hotels were still left with the problem of how to attract and entertain guests. Improved rail service throughout the country meant that wealthy tourists were coming to the White Mountains from all over the country, not just from the Northeast. The fashionable city people who came to spend the summer in the White Mountains wanted lots of fresh air and grand scenery, but without giving up the comforts of home. Hence, it became necessary for hotels to provide good meals, comfortable beds, and excellent service. Guests not only needed assistance in seeing the natural wonders of the area, but wanted more frivolous entertainment, as well, in order to round out the social life of a grand hotel.

31

31. *Tourists at the Mount Kearsarge Summit House*, late 1800s. Collection of New Hampshire Historical Society*

32. Edward Hill, *Lumbering Camp in Winter*, 1882. Collection of New Hampshire Historical Society

33. Frank Henry Shapleigh, *Old Mill, Jackson, N.H. (Goodrich Falls)*, 1877. Collection of Mr. and Mrs. Robert Goldberg

30

Providing luxury and good service within the hotels was costly but necessary. Employees of the summer resorts frequently were well-mannered college students from Dartmouth, Bates, and some of the teacher colleges and seminaries in New Hampshire and Maine. Much of the food came from the local area, with some hotels owning their own farms. The remainder of the food came by train, and invoices from some of the hotels indicate that exotic foods were not uncommon. Along with good food and service, hotels often had their own post office, a barber shop, and a hotel store. The effort was to make the hotel a small city unto itself.

Providing comfort and luxury also meant keeping up with technological advances. The hotels that bragged of gas lighting in the 1870s were proud of their electric lights at the turn of the century. No hotel could survive without a good livery in the late nineteenth century, but the smart owners quickly built automobile garages and service areas in the early twentieth century. In the late nineteenth century, hotels first boasted of having a telegraph; later they listed the number of telephones available. Finally, it became necessary in the closing years of the nineteenth century to include in the hotel's spring literature the number of waterclosets that had been added since the last season. Thousands of photographs, advertisements, guidebooks, and newspapers survive that reveal much about the era of the grand hotel in the White Mountains. There are photographs of people boating, hiking, riding in coaches, riding burros to the summit of Mount Washington or some lesser peak, playing tennis, strolling about hotel lawns or sitting on hotel piazzas, and, in the 1890s, playing golf and riding bicycles. In the evening there were dances, card parties, lectures, concerts, and plays.

Much of the social life of the White Mountain hotels was recorded in the pages of the area's tourist newspapers. The best known of these are *Among the Clouds*, published on the summit of Mount Washington by members of the

Burt family from 1877 to 1909, and the *White Mountain Echo and Tourist Register*, first published in Bethlehem in 1878. Both newspapers not only carried accounts of daily events, from weather conditions to baseball scores, but also recorded the names of prominent guests as they arrived for the season.

Among the many events reported in local newspapers was the 1899 ascent of Mount Washington made by a Stanley "locomobile."[53] The steam-powered car of F. O. and F. E. Stanley was only the first of many to climb the old carriage road. In fact, Mount Washington became a testing ground for many of America's early automobiles.

The coming of the automobile created changes in White Mountain tourism as dramatic as the coming of the railroad fifty years before. Yet few people realized that in 1900. The automobile was seen at first as a curiosity, not an alternate form of transportation. The only real problem created by the first automobiles in the White Mountains was that they scared horses.

By 1920, if not a few years earlier, it was obvious to all that the automobile was no mere toy that scared horses; it was creating major changes in White Mountain travel and tourism. The automobile brought a kind of freedom unavailable by train—the freedom for individuals and families to travel anywhere they wanted, and at great speeds. In the first two decades of the twentieth century, the automobile also brought a new generation of Americans into the White Mountains: a generation who, in the spirit of Theodore Roosevelt, wished to get "back to nature" and seek a rugged yet personal experience in America's vanishing open spaces. Nor were these new tourists as wealthy as those of the late nineteenth century; they might be anyone with a week or two of free time and the three hundred dollars it took to buy one of Henry Ford's cars.[5]

The result of all this was improved roads, automobile garages and service areas, the tourist camp, the motor court, and tourist cottages. By the 1930s, next to the time

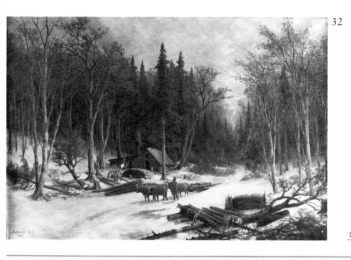

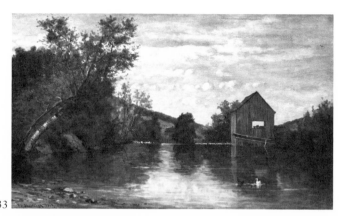

honored names of the Crawford House, the Alpine House, and Thayer's Hotel, we find advertisements for Cozy Corner Camp and the U-Auto-Rest Hotel.[55] Increasing numbers of private homes and farms also took in boarders.

More people than ever before began pouring through notches that one hundred years earlier had sometimes been impassable on foot. Ironically, as improved roads and inexpensive cars made it easier than ever before to get to the White Mountains, people began spending less time there. By the First World War, it became fashionable to "do" the White Mountains and then move on. Accelerated speeds meant accelerated pace.[56]

The White Mountains had passed through a series of stages—from a hauntingly beautiful area explored by a few, to a rural playground for the nation's rich, to a vacation area enjoyed by the nation as a whole. Some lamented the passing of the old order, when wealthy guests spent long weeks enjoying a lifestyle transported to elegant White Mountain hotels. Yet others praised the twentieth century trend. One traveler boasted in 1913, "where one pilgrim discovered the White Mountains then, a hundred enjoy them now. The region has ceased to be a New England monopoly and is a national possession."[57]

LOGGING IN THE WHITE MOUNTAINS

The development of the White Mountain tourist trade in the late nineteenth century, while providing recreation for urban Americans, also served to bolster the sagging economy of rural New Hampshire. Ironically, at the very time tourists were flocking to White Mountain forests in unprecedented numbers, logging operations were leveling the forests as never before.

In the late eighteenth and early nineteenth centuries, logging in the White Mountains had been on a very limited scale. While local logging operations helped White Moun-

tain farmers supplement meager farm incomes, the sawmills constructed within the towns were technologically unfit for anything but a local market. Since the rivers and streams within the White Mountains are shallow and rocky, attempts to get large quantities of logs out of the area were greatly hindered. Of these small-scale operations, the largest was that of Nicholas Norcross along the Pemigewasset River.[58]

There was, however, a need for lumber to the south. Southern New Hampshire towns, which had cleared much of their land during the turn toward sheep farming in the 1830s and 1840s, now required wood from the outside. Hence, sparsely populated White Mountain towns began sending logs and sawn boards south. By the 1850s, the need for wood increased even more as railroads approached the southern and eastern White Mountain area. Not only did the railroads mean a better way of transporting timber, but also they meant a demand for hardwoods, since the early steam locomotives were wood burners.[59]

Yet the greater demand for wood from the White Mountains did not immediately mean a turn to large-scale logging operations. Until the 1890s, land in White Mountain towns was usually owned by private individuals as relatively modest farms. The farmers themselves did much of the logging in the fall and winter, taking their logs to locally owned sawmills. While these small sawmills began converting from up-and-down to circular blades, water power was still the norm and steam power a rarity until the 1890s in the White Mountains. Small tote roads and old farm roads helped loggers get timber out of inaccessible places, while some operations tried getting logs down from the hills by using flumes and sluices.[60] Even with the completion of main railroad lines around and through the White Mountains in the 1870s, few could contemplate the expensive construction of logging railroads in the 1870s and 1880s.

34. Dixville Notch, illustration by J. D. Whitney, for Charles T. Jackson, *Final Report on the Geology and Mineralogy of the State of New Hampshire,* 1844. Lent by Special Collections, Dimond Library, University of New Hampshire

35. The Hall Studio, *Profile House and Lake,* ca. 1885 (?). Collection of New Hampshire Historical Society

36. Henry Cheever Pratt, *On the Ammonoosuc,* ca. 1866. Lent by Museum of Fine Arts, Boston; M. and M. Karolik Collection

32

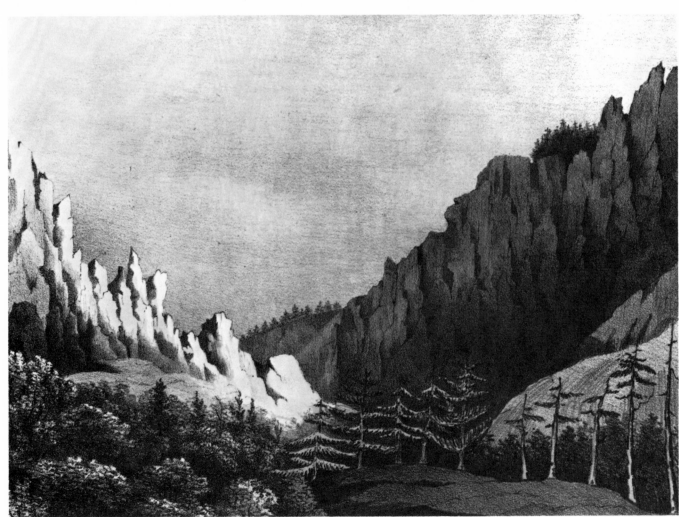

34

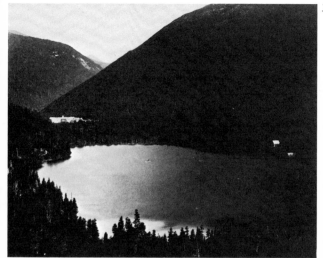

35

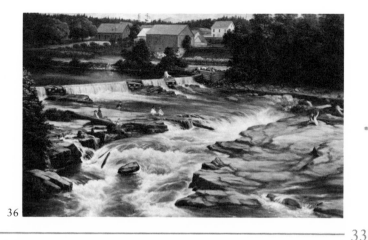

36

The situation changed dramatically in the last quarter of the nineteenth century. In 1867, the state of New Hampshire sold its land holdings in the White Mountains, approximately 172,000 acres, for the sum of $25,000 to both local landowners and land speculators. Within a few years of the sale, two important developments occurred. First, the major rail lines were completed through and around the White Mountains, greatly facilitating travel and transport between the mountains and the port cities of Boston and Portland. Statistics indicate the importance of railroads to logging, as the value of New Hampshire's cut timber went from $1,208,629 in 1860, to $5,641,445 in 1880, to $9,218,310 in 1890.[61]

The second development was equally important for the logging history of the White Mountains. With the introduction in the 1880s of the sulfite process of reducing wood to pulp, a process that generally works best with softwoods, the conifers in the White Mountains took on new importance by the turn of the century.[62]

Those aware of the immense future profits to be made by cutting the timber of the White Mountains moved quickly. First, the various small, scattered plots of privately owned land were consolidated by private investors during the 1880s. Some of this land was purchased directly by logging company owners, such as J. E. Henry, the Saunders family, and, further north in Coos County, George Van Dyke. In the western regions of the White Mountains, land was consolidated by private concerns that did not seek to log the land directly but sought to lease or sell to logging companies. Both a shrewd local investor named Ira Whitcher and the New Hampshire Land Company, directed by Bostonian George B. James, consolidated much of the forest and farm land in Benton, Easton, Ellsworth, Woodstock, Warren, and Lincoln. James was particularly ruthless in buying up farms in Thornton, and was responsible for depopulating the entire farming village of Thornton Gore. Once he had made his purchase, his policy was

never to sell or lease land to farmers or tourists, but only to logging and paper companies in lots of ten thousand acres or more.[63]

The consolidation of large tracts of land was a necessary prerequisite to the next big step toward cutting in the White Mountains—the construction of logging railroads. With few exceptions, logging railroads were constructed after 1880, with their greatest impact coming after 1890. They were generally standard-gage railroads, the components of which were leased from the main commercial railroads. Lumber companies would begin their logging railroads at some point on a commercial line, then lay track along a convenient river or stream into the heart of their land holdings. A typical White Mountain logging railroad might be only five or ten miles long, with numerous feeders and branches stretching into previously inaccessible areas. Yet, these logging railroads did not last very long. With a few key exceptions, most lasted between five to fifteen years. Floods frequently damaged roadbeds and the wooden trestles. Usually, however, the railroads were either destroyed in forest fires or taken up after an area had been cleared.[64]

At least seventeen logging railroads operated within the White Mountains, and these have been described in detail by C. Francis Belcher.[65] There were also a number of spurs and branches that never acquired a name and of which little is known today. Eleven of these logging railroads were begun between 1877 and 1895, while six additional logging railroads were incorporated between 1906 and 1917. Owners of these railroads were a mixed lot, from the respectable Saunders family of Boston (Sawyer River Railroad), to Gilded Age "timber baron" J. E. Henry (Zealand Valley Railroad and the East Branch and Lincoln Railroad), to the legendary river logger George Van Dyke (Little River Railroad). None of the nineteenth century railroads were originally involved in pulp operations, but instead took logs to company-owned sawmills. Some, such

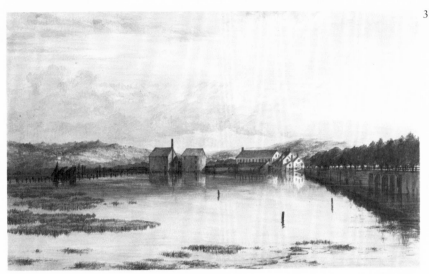

37. Unknown, *Mill on Lake Winnipesaukee.* Lent by Museum of Fine Arts, Boston; M. and M. Karolik Collection

38. *Town and City Views of New Hampshire: Bartlett, Carroll Co.,* D. H. Hurd and Company, 1892. Collection of New Hampshire Historical Society

39. W. C. Hunton, *Laconia Box Factory,* ca. 1880. Collection of New Hampshire Historical Society

as the Bartlett & Albany Railroad (1887–1894) and the Saco River Railroad (1892–1898), had a very limited existence, while the Sawyer River Railroad (1877–1937) and the East Branch and Lincoln Railroad (1893–1948) did much better.

The logging railroads made possible large-scale logging operations in remote areas of the White Mountains. The woods were filled with countless numbers of logging camps and logging roads, and whole mill villages were created in short order to maintain the railroad and saw the logs.

Logging roads supplemented the railroads and were an integral part of White Mountain logging operations. The better and more permanent ones, sometimes called "dugway roads," were well-made dirt roads, still evident and sometimes still used today. Many of these form part of the present Appalachian Mountain Club trail system. These better roads branched off from the logging railroads and led to the more crudely-made "upper" roads. The upper roads were temporary expedients essential for getting logs down from steep slopes.[66] They might literally ring a mountain, appearing almost as a series of contour lines on a mountain that had been logged.

Like the logging roads, logging camps were scattered throughout the White Mountains, although most seem to have been located along the railroads.[67] Usually designated by a number, these camps varied in size and duration. Some were regarded as permanent, while others were temporary camps allowing loggers to live closer to a particular operation. Some camps housed only 20 or 30 men, while others contained 100 to 150. Although each camp might have its own peculiarities, certain elements were common to all. Each was under the supervision of a camp boss, whose job it was to get men and horses out to work on time, supervise the actual cutting, enforce company rules, and see that the men were paid. Assisting him would be a clerk. Other important figures were the cook, the scaler, and the blacksmith. Some camps also had a separate car-

penter. The loggers were grouped by basic functions: there were road builders, choppers, binders, loaders, and teamsters.[68] The camps included a wide variety of nationalities. In addition to many native Americans and French-Canadians, there were Irish, Italians, Russians, Swedes, Poles, Norwegians, and others.

There are many photographs and first-hand accounts describing the buildings that made up the early logging camps.[69] Each camp had a cook shack and a dining room, a bunk house, a blacksmith shop, a stable for the horses, an outhouse, probably an office, and possibly a filer's shack for sharpening saws and axes. Camps at the turn of the century were usually described as rustic at best. Buildings were most often made of logs, although some of J. E. Henry's camps were frame buildings that could be taken apart and moved by rail to a new location. Bunk houses generally were poorly ventilated affairs where loggers slept in close quarters.[70]

Important as these camps were to the White Mountain logging operations, they represented only the first stage of the process. Once cut and brought to a logging railroad, logs were transported to the company's mills, usually located near the juncture of the logging railroad and a commercial line. Whole villages developed around these mills, housing people who worked in the mills or for the railroad. Lincoln is the best example of a mill village that survived. Zealand, in the town of Carroll, included not only the J. E. Henry sawmill, but also a railroad station handling as many as five trains a day, a school, a company store, a post office, several houses, some car shops, an engine shop, and charcoal kilns.[71] Yet Zealand lasted only from 1881 to 1904, when it fell victim to forest fires in the Zealand Valley. Today, villages like Zealand, along with Livermore, Johnson, Carrigain, and Hastings (Maine), have virtually disappeared; they lasted for as long as a particular logging operation survived. If the forest area reached by the logging railroad was cleared or burned, or if the mill

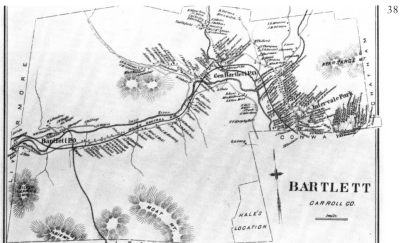

BARTLETT

CARROLL CO.

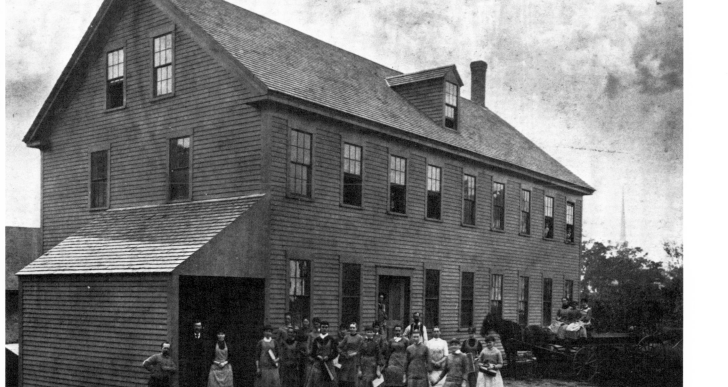

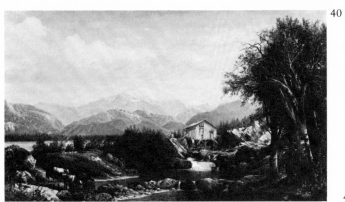

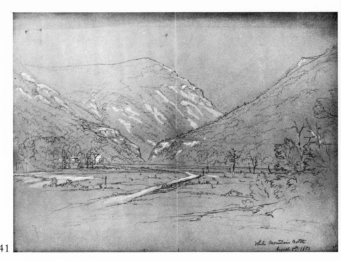

40

41

itself burned, the whole village might disappear within a year or two.

Logging operations, paper manufacturing, and subsidiary mills and factories formed the core of the North Country economy at the turn of the century. Yet it was the very success of the timber economy that brought it under close scrutiny. Wasteful cutting practices on a large scale endangered the existence of White Mountain forests and streams. Throughout New England, concerned citizens took the position that the White Mountains had to be saved from their own prosperity.

SAVING THE FORESTS

In 1893, historian Frederick Jackson Turner first expounded his famous "Frontier Thesis." This thesis stated that the United States was a great nation because of the positive effect the frontier had had upon successive waves of hardy pioneers. But what would happen once the last of America's open spaces had been civilized? According to Turner, the frontier was gone in 1893, and he feared for America's moral health.[72]

As Americans began equating the frontier with moral strength, and as they recognized and accepted the morally uplifting benefits of their nation's natural beauty, it was logical that they would want to preserve some of their frontier. A genuine "back-to-nature" movement evolved during the last quarter of the nineteenth century. Advocates of this movement formed a wide variety of institutions and developed an extensive body of literature to help Americans appreciate their nation's natural beauty. They also fought to save America's remaining rural and wilderness areas.

This back-to-nature movement was urban in character. Those who seemed most appreciative of nature lived in cities. The movement was also a middle class, "elitist" movement. Those advocating a return to nature were men

of education—ministers, educators, writers, artists, and others. Knowing this helps us to understand the kind of "nature" these people wished to return to. They sought neither the working farm nor a primitive wilderness, but instead the spiritual regeneration of a well-manicured garden. These people were neither farmers nor woodsmen and had no desire to be either. As historian Peter Schmitt has aptly stated, "they tried to make rural America the playground of an urban society." Hence they were little concerned about the economic potential of the countryside; they were more interested in how it shaped an individual's character. If anything, the conservationists looked down upon those already enjoying rural life, and one noted nature lover complained that the movement had "failed to teach farmers 'to hoe potatoes and to hear the birds sing at the same time.'"[73]

Advocates of this spiritual sojourn to nature expressed and organized themselves in a variety of ways. Nature writers had become the most popular authors in the country by the turn of the century. Magazines like *Atlantic Monthly, Saturday Review, Colliers,* and *Cosmopolitan* provided their urban readers with a barrage of nature-related articles. While nature writers like Dallas Sharp, John Burroughs, and Walter Prichard Evans became popular through nonfiction, fiction lovers turned in large numbers to novelists like Jack London. Legitimate ornithologists like Edith Patch wrote tirelessly of birds, while Ernest Thompson Seton, Thornton Burgess ("Peter Rabbit"), and Felix Salten (*Bambi*) created animal characters with human personalities. Following the lead of G. Stanley Hall, urban school authorities tried to bring nature into the classroom, and a number of nature texts were written for this purpose. For the urban dweller who might never see many of the nation's natural beauties, books of photographs were published revealing the scenic wonders of Yosemite, Yellowstone, and the Smoky or the White Mountains. For those who wanted to bring nature into the

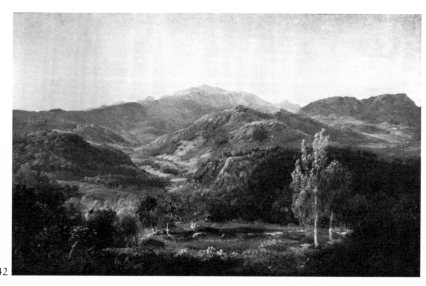

40. Harrison Bird Brown, *View of Mt. Washington,* 1866. Collection of the Portland Museum of Art, Me.; Gift of Mrs. Louis L. Hills, Jr., in memory of Mrs. Louis L. Hills, Sr., and Mr. Louis L. Hills, Sr., 1973

41. John Frederick Kensett, *White Mountain Notch,* August 5, 1851. Lent by The Art Museum, Princeton University (Mather Collection)

42. Aaron Draper Shattuck, *Mount Washington—Autumn Glory,* 1864. Lent by John H. Sanders

42

city, there were the writings and plans of the landscape artists who had studied under Frederick Law Olmstead.[74]

It was inevitable that words be put into practice. The various Fresh Air charities of the nineteenth century spawned a totally new movement for children—the youth summer camp. Yet the summer camps that became commonplace in the early twentieth century catered more to the children of the well-to-do, not the urban poor. Here, in these summer retreats unique to America, boys and girls were given a chance to imitate Daniel Boone—studying nature and learning a wide variety of camping skills.[75] For those who wanted year-round contact with nature, there were the Boy Scouts, the Girl Scouts, the Campfire Girls, or the Woodcraft Indians. For adults, one need only examine the early Appalachian Mountain Club White Mountain Guide Books to see the proliferation of local and college outing clubs—some of which built and maintained trails and shelters throughout the White Mountains.[76] The Randolph Outing Club became one of the most active of the local New Hampshire groups, thanks to its proximity to the Presidential Range, while the Appalachian Mountain Club built its first hut, the Madison Spring Hut, as early as 1888.[77] To understand efforts to save the White Mountains from the excesses of logging operations, it is important to keep this back-to-nature movement in mind.

Efforts to save and properly manage the forests of the White Mountain region developed slowly and at various levels. Little concern was given to "saving" forests prior to the Civil War, as forests in the United States seemed inexhaustible. New Hampshire's modest, locally controlled logging operations seemed to pose no threat to the White Mountain forests prior to 1870, and no voices of conservation protested the 1867 sale of the state-owned region. Yet this casual attitude began to change throughout the 1870s.

In 1881, the New Hampshire state legislature appointed a temporary committee to study the problem of forest depletion. By 1885, the state had a permanent Forestry Commission which in that year issued a landmark study of forest conditions in New Hampshire. In spite of this and subsequent reports, however, the state remained unsure throughout the 1890s of what measures should be taken to protect its forests.[78]

Circumstances intervened to force the action, however. Forest fires, particularly those in the Zealand area, alarmed conservationists. They gained a valuable ally when T. Jefferson Coolidge, treasurer of Manchester's Amoskeag Manufacturing Company, the world's largest textile manufacturer, publicly blamed clear-cutting in the White Mountains for the damaging spring floods along the Merrimack in 1895 and 1896. These had forced the company mills to close temporarily, putting six thousand people out of work.[79] Other manufacturing interests located along major waterways in New Hampshire shared Coolidge's concern.

Some advocates of the back-to-nature movement did not welcome support from allies whose interests were less than purely spiritual. However, most conservationists sought a broad-based coalition—one that included naturalists, railroad interests, hotel owners, manufacturers, and even the paper and lumber companies—to bring about the necessary action to save the White Mountains. This would mean compromising with people whose interests in the White Mountains was more economic than spiritual.

The broad-based coalition became a formal organization in 1901 with the formation of the Society for the Protection of New Hampshire Forests (SPNHF). A year later, the society hired Philip W. Ayres as its executive forester. The goals of the society included the protection of forests and scenic areas, the creation of a nursery and a demonstration forest, development of an educational program to teach principles of wise forestry, and, finally, the origination and support of good forest legislation. In addition, Ayres took his position with the understanding that the society would

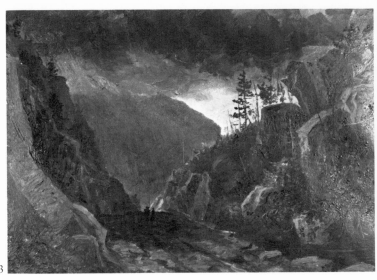

43. Benjamin Bellows Grant Stone, *Gate of the Notch*, 1858–1859. Lent by Catherine Decker Memorial Collection, Greene County Historical Society, N.Y.

44. *Mount Washington Road,* illustration by Harry Fenn, for William Cullen Bryant, ed., *Picturesque America,* vol. 1. Lent anonymously

45. Albert Bierstadt, *Maple Leaves, New Hampshire,* 1862. Lent anonymously

43

push for a federal reservation in the White Mountains.[80]

For the next ten years, the Society for the Protection of New Hampshire Forests, the State Forestry Commission, and several key political leaders in New Hampshire and Massachusetts worked for the creation of this federal reservation. They overcame certain regional problems by linking their efforts to a movement to create a federal reservation in the southern Appalachians. One argument against federal involvement stated that since most of the White Mountains are located within one state, the land should be purchased by New Hampshire, not the federal government. Proponents of the various bills to save the forests argued that New Hampshire was too poor to buy the necessary land. In any case, the White Mountains were enjoyed by people from all over the country and were not solely the concern of one state.[81]

Finally, after overcoming a series of political obstacles, efforts of the conservationists became law in 1911. The resulting Weeks Act authorized the purchase of much of the land within the White Mountains and the creation of the White Mountain National Forest.

The creation of the White Mountain National Forest was an attempt to reconcile differences between the White Mountains as they were perceived and as they existed. Through federal management, the Forest Service could balance the vying interests of tourists, local residents, logging companies, artists, and anyone else wishing to appreciate the area. Yet the White Mountains will continue to be an abstruse statement of America's rural heritage—a heritage filled with farmers and explorers, mountain guides and scientists, loggers and tourists. The mountains have been a meeting place of local and urbane interests over the years, and the imperfect blend has been as intriguing to watch as the mountains, streams, and notches that make up the White Mountains.

44

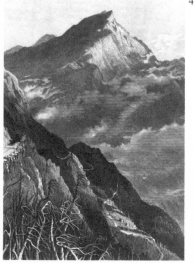

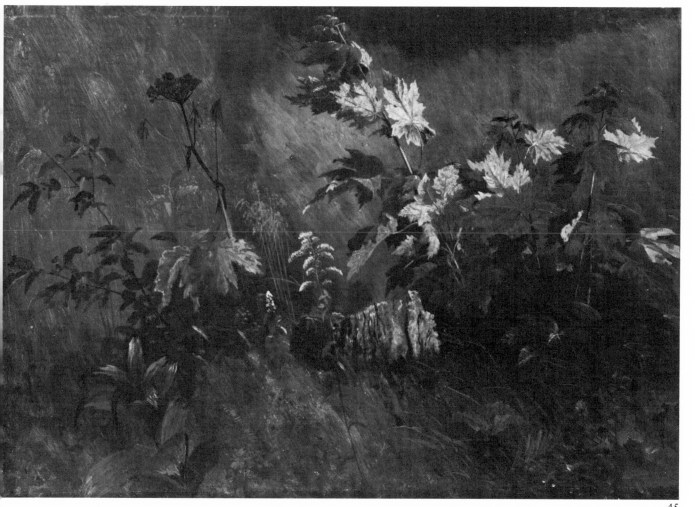

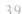

45

46. Frederic Edwin Church, *Intervale at North Conway*, ca. 1856. Lent anonymously

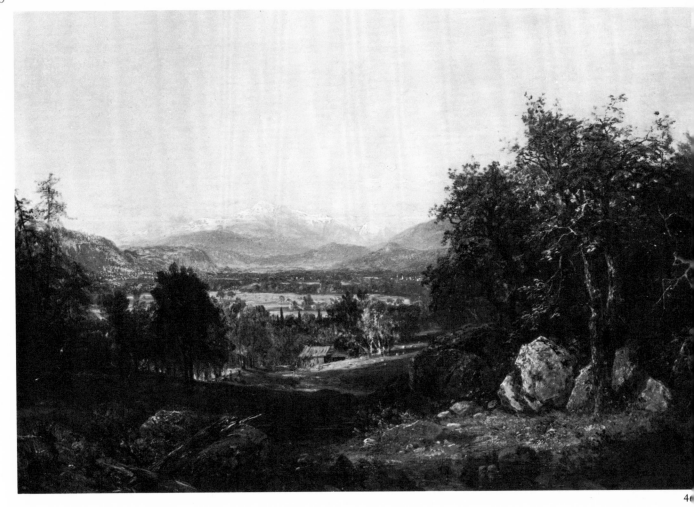

PERCEPTIONS OF THE WHITE MOUNTAINS: A GENERAL SURVEY

Donald D. Keyes

Beginning in the early nineteenth century and for nearly four generations thereafter, artists travelled to the White Mountains to relax, paint and sketch, and photograph. As the region changed over time, the work of these artists changed. However, the perceptions of these artists also influenced how the region was to change and certainly determined how the rest of America perceived the region. The artists were an important part of the making of the White Mountains as a symbol of American tastes and values throughout the century.

To show this process more clearly, this exhibition is organized in an unusual way. Traditional investigations of American art are generally confined by parameters of media, chronology, or style. In order to break down these restrictions, the present exhibition's focus is limited only by place—the White Mountains of New Hampshire—and time—prior to 1900—without regard to style or visual media. Through this organization of the material we will see how the viewer was misled by artists who spoke of fidelity to nature but who, in fact, practiced a subtle idealism that made critical adjustments in that truth.[1] These adjustments began very early and, at one time or another, affected all producers of visual images.

This essay explores four phases of White Mountain art, from the early romantic period of the pioneering artists, through those first regular visitors in the mid-nineteenth century who were searching for an arcadia, to the flood of artists after the Civil War—artists who can properly be identified as the White Mountain School, and ending with those artists who were drawn to the area only to reject its traditions in favor of an imagery that was unsuited to the mountains. Americans knew the White Mountains through these images. Each kind of image contained truth, but each vision also was mixed with unique variations from the reality of the situation.

EARLY ROMANTIC PHASE

The White Mountains encompass the highest mountains in the Northeast, some of the most rugged terrain known to Americans in the eighteenth century, and one peak whose weather almost matches the Arctic. Their wilderness has been their allure from the earliest settlers to the present, and in the nineteenth century they sometimes seemed like the last accessible frontier. These mountains stood between the East Coast ports and the farms of the interior of northern New England and Canada. Hence, the White Mountains were a barrier to man and a challenge to his ingenuity, as well as an area of great scenic beauty. For years they represented the archetypal American wilderness.

Early accounts of the region, particularly Jeremy Belknap's description of 1784,[2] stress the fabulous and rough terrain that contains both riches ("precious stones") and danger. Early pictures of the region, such as Abel Bowen's simplistic inserts in Philip Carrigain's 1816 map (ill. 70), also stress the towering heights and treacherous terrain of the mountains. The early accounts and pictures of the area are perfect examples of the kind of landscape described in the mid-eighteenth century English treatises on the Sublime, particularly Edmund Burke's essay of 1757.[3] The keystone of Burke's aesthetic is emotion, and the foundation of his theory of Sublimity is the emotion of terror. He introduced imagination as a significant factor in the arts, and with imagination came the importance of individuality and individual emotions. The Sublime was represented by contrasts in scale, sharp jumps in space, and irregular objects; in short, through rough and rugged forms that are often great in size. In the early nineteenth century, the concept of the Sublime was firmly rooted in American art through the work of Benjamin West and Washington Allston, and it constituted the fundamental

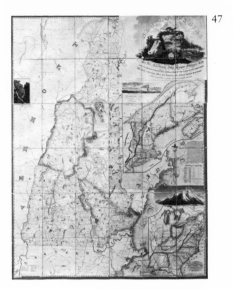

47

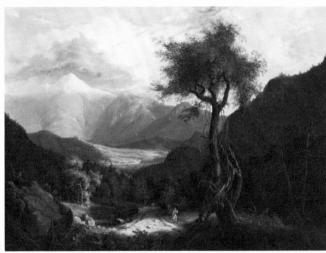

48

aesthetic in most American art during the period before the Civil War.

The growing number of accounts of the region, of which Carrigain's map was one, drew adventurers to the White Mountains. Men such as the cultural benefactor and amateur Daniel Wadsworth, as well as scientists in search of botanical and geological specimens, made sketches of the landscape, plant life, and other natural phenomena. Wadsworth visited the region in 1826 and urged his friend, the young painter Thomas Cole, to visit the White Mountains. Cole did just that the next year, accompanied by Henry Cheever Pratt.[4] The two trips they made—in 1827 and 1828—resulted in diaries and sketchbooks by both artists.

From his sketches, Cole produced numerous paintings of specific White Mountain locations. *View of the White Mountains* (Wadsworth Atheneum, Hartford, Conn.; 1827: ill. 48), made for Daniel Wadsworth, appears to be a precise rendering from accurate drawings (now in the Detroit Art Institute).[5] However, Cole completed the finished painting well after his visit to the site, working up the composition in an oil sketch (now at Yale University). In the transition between the drawings and the painting, Cole adjusted elements in order to produce an ideal vision that conformed to the Burkeian concept of the Sublime. In a well-known letter to his friend Asher B. Durand he explained his method:

> Have you not found?—I have—that I never succeed in painting scenes . . . immediately on returning from them. I must wait for time to draw a veil over the common details, the unessential parts, which shall leave the great features . . . dominant in the mind.[6]

The resultant work shows a topographic adjustment, particularly in the extension of the foreground and the deepening of the space, in search of "a union of the picturesque, the sublime, and the magnificent."[7] In the case of *Autumn*

Twilight, View of Corway Peak, N.H. (ill. 10), this increased magnificence is augmented by the lightning-blasted tree at the left and the canoeing Indian at the right, both of which were the artist's inventions. Cole's pictures "reform natural scenery into pictorial order" to suggest the Burkeian concept of "the savage tempered by the magnificent."[8]

Another example of this Sublime vision is seen in Alvan Fisher's painting of *The Notch* (Fruitlands Museum, Harvard, Mass.; 1834: ill. 49)[9] done seven years after Cole's picture. His scene, from the south end of the notch, shows the Willey House surrounded by swirling clouds and mountains. It has little of the rich coloration and brilliant execution of Cole's paintings, as Fisher never rose above the stiff, flat style of provincial early American art.[10] It is simpler in style, yet still full of the grand, sublime, and magnificent mountains sweeping up from the valley. Man is shown as very small and almost helpless, overcome by the awesome elements of nature.

Cole returned to the White Mountains in the fall of 1839 and produced the well-known *The Notch of the White Mountains* (National Gallery of Art, Washington, D.C.; 1839: ill. 51).[11] In this painting, the savage elements are balanced by objects of civilization; he has recognized the changing landscape that resulted from the increasing commerce at Ethan Allen Crawford's Inn, which served as a stage and tourist stop. Tree stumps suggest the presence of mankind,[12] with his need to clear the land, while storm clouds continue to threaten this order that is being imposed on the wilderness. This contrast is also suggested in the opposition of the blasted trees in the foreground to the warmly colored, cleared land around Crawford's house. By the time of Cole's return to the White Mountains, the land had acquired a history, the history of the survival of Ethan Allen Crawford and his family in the wilderness, a history that embued Cole's scene with an almost mythological overtone.

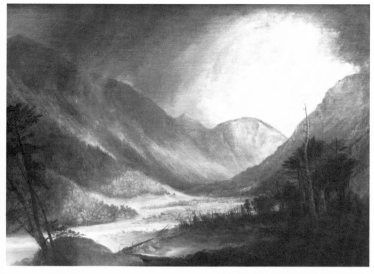

49

*Illustrations marked with an asterisk are of works not in the exhibition.

47. *New Hampshire by Recent Survey,* Philip Carrigain, 1816. Collection of Dartmouth College Library

48. Thomas Cole, *View of the White Mountains,* 1827. Collection of Wadsworth Atheneum*

49. Alvan Fisher, *The Notch,* 1834. Collection of Fruitlands Museum*

In literature as well as the visual arts, the pioneers of the region were being turned into legends by writers such as Nathaniel Hawthorne, who wrote four very popular romantic tales of the area between 1835 and 1850.[13] Also material for legends was the pre-nineteenth century struggle with the indigenous population, the Abnaki or Algonquian Indians. *Chocorua's Curse* (ill. 11), after Cole's design, represents such a legend. The interest in the tribal chief Chocorua, who cursed the white man and for whom the most spectacular mountain in the Sandwich Range was named,[14] increased the fascination that the area carried, even though few Indians remained there in the nineteenth century. These stories helped to create a richly romantic aura of savagery subdued and of order wrested from the wilderness by these heroic pioneers.

The settling of the White Mountains during the Jacksonian Era, which we see reflected in the sequence of paintings by Thomas Cole from 1827 to 1839, mirrored a broader change. As America grew, the concern with carving order out of the wilderness came to be balanced by a new, opposing concern, that of preserving nature unmolested by industrial development.[15] The clearest popular expression of this attitude can be seen in the engravings (ill. 145) based on the Englishman William Bartlett's drawings, published the year before Cole painted *The Notch of the White Mountains*. These engravings were published in London by George Virtue in 1838 under the title *American Scenery* and were accompanied by a written account by the New York writer Nathaniel P. Willis. In the two volumes, one finds twelve prints of the White Mountains, often with great mountains separated by unmeasurable chasms, which broadly adhere to the basic guidelines of the Sublime. Yet, some of the prints exhibit a quaintness, as was beginning to appear in Cole's 1839 painting, with people pursuing their everyday lives and calmly observing the mountains. These images stress the accessible magnificence rather than the terrifying diminu-

tion of mankind in the presence of awesome nature. The Sublime is still expressed in exaggerated topography, but it has been balanced through a more ordered composition, fewer spatial leaps, and more harmonious forms.

In short, the pure Sublime has been tempered by the aesthetic of the Picturesque, as best known in America through the essays of Uvedale Price and Robert Payne Knight.[16] These eighteenth century British writers were concerned with the ordering of nature, particularly in gardens, and the production of a harmony that grows from feelings and senses, in contrast to pure reasoning. These writers were attuned to painting—the picture-ness of a scene—as a transmission of harmonies of light and color in nature. The result of these aesthetic ideas was a change to a land in which the presence of man was more openly felt, but not to the point where the land was spoiled.

JEFFERSONIAN PICTURESQUE

During the 1840s and 1850s, the White Mountain region changed. The land was put to greater use, more people moved in as residents, and towns grew up. The fruits of technology appeared in the form of industry, railroads, and tourist accommodations. As a result, the region took on a more civilized and ordered look. The area, therefore, presented different facts. Moreover, the aesthetics of the time were also changing, with less emphasis placed on the Sublime and more on fact—"realism." This decreased emphasis on the Sublime, however, was also accompanied by a new idealization: the Jeffersonian exemplar of an agrarian arcadia based on Christian and democratic principles. The wilderness and the savagery of nature were replaced by ordered fields and small towns that still preserved the land's beauty. The artists' pictures reflected this harmony and domestication and, in turn, became the standard for the future, as the land was developed along lines that were picture-like. Thus the artist was given a new, critical role

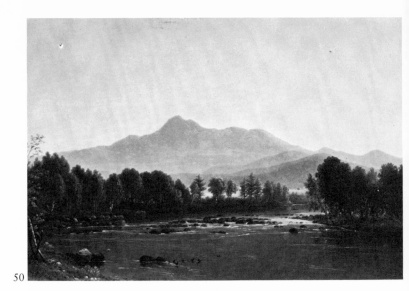

50

in the development of America.

The story told by Samuel W. Thompson to his son demonstrates this economic influence of the artist. In about 1840 the elder Thompson became an innkeeper for teamsters coming through Crawford and Pinkham notches. However, with the advent of the railroads, this source of income dwindled for the Thompsons because the railroads carried goods and people directly from the coast to their destinations further north. Unable to survive on their farm income without the money from travelers and teamsters, they were considering abandoning the region when a stranger came unexpectedly to the tavern. Intending to stay for only one night, his "stay was extended into days, weeks and months and the summer was gone and autumn came before he could think of going to his city home." This stranger provided

> that small beginning [with which] came the start which has grown into its present [ca. 1853] dimensions. Yes, to the landscape artist [the stranger] more than to any other one influence is due the present prosperity of North Conway. This one man was enthusiastic, others saw his pictures or heard of them and came to this wonderfully beautiful place. Not many years after that Champney and Kensett found our beautiful valley.[17]

During the 1850s, not only did artists come, but also the number of tourists greatly multiplied as the fame of the region's beauty spread. The tourists brought with them previously unheard-of demands for transportation—met by the completion of the Atlantic and St. Lawrence Railroad's route to Gorham in 1851 and the Boston, Concord and Montreal Railroad in 1853—and for lodging—met by the expansion of existing hotels and the building of new ones, such as the Crawford House in 1851, the Glen House in 1852, and the Profile House in 1853.[18]

The first artists whose work attracted the tourists were in turn joined by other artists who were drawn by the growing reputation of the region's scenery. Whether they stopped briefly, as Frederic Church did, or spent every summer for the remainder of the century, as Benjamin Champney did, these artists made the sites—the notches, mountains, and intervales—well known throughout the Northeast. The gathering spot for many of these artists was Thompson's Tavern (later called the Kearsarge House) in North Conway.[19]

Champney and John F. Kensett stayed at Thompson's inn during the summer of 1850 on their way back from Maine. By 1853, some forty artists were summering in North Conway alone.[20] Many of the most important Hudson River School painters came to the White Mountains: Kensett; Jasper Cropsey, one of the closest followers of Thomas Cole; Asher B. Durand, one of the founders of the Hudson River School along with Cole; and Albert Bierstadt, who developed his principal reputation in the Far West, are among the most prominent who worked in the region during the 1850s.

In contrast to Cole, most of these artists were drawn to a cultivated, cleared, and ordered land. They

> were delighted with the surrounding scenery, the wide stretch of the intervales, broken with well-tilled farms, the fields just ripening for the harvest, with the noble elms dotted about in pretty groups.[21]

Champney painted this relaxed, contemplative scenery in his *Mt. Chocorua, New Hampshire* (Museum of Fine Arts, Boston; 1858: ill. 50). In contrast to Cole's *Autumn Twilight* or *Crawford Notch*, Champney's composition is more static, because of the crisper forms, smooth transitions in color and shading, and more harmonious spatial constructions.[22] His work depicts distant fields and farm houses and nicely thinned trees. Champney's landscape

50. Benjamin Champney, *Mt. Chocorua, New Hampshire,* n.d. Collection of Museum of Fine Arts, Boston; Bequest of Maxim Karolik*

51. Thomas Cole, *The Notch of the White Mountains (Crawford Notch)*, 1839. Collection of the National Gallery of Art*

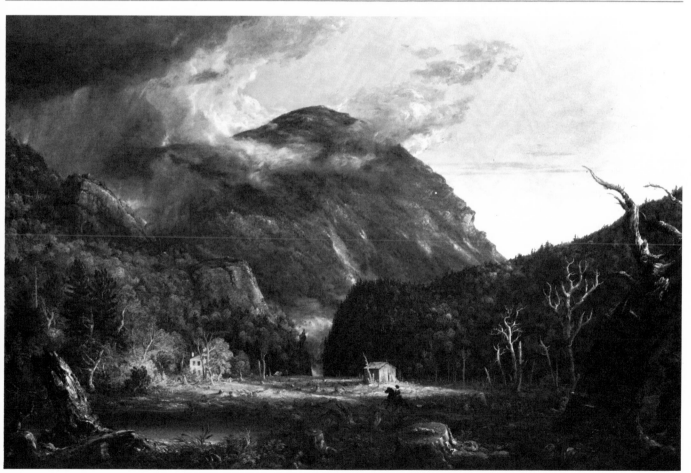

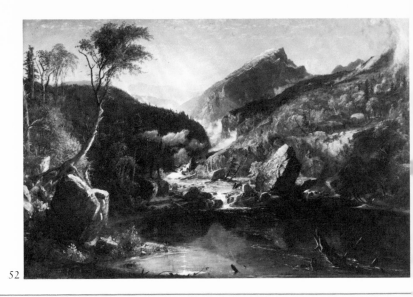

52. Jasper F. Cropsey, *Indian Summer Morning in the White Mountains*, 1857. Collection of The Currier Gallery of Art

53. Samuel L. Gerry, *Landscape with Cows and Ploughman*, 1852. Collection of The High Museum of Art*

54. *The Lower Cascade in the Notch of the White Mountains*, illustration by Isaac Sprague, for William Oakes, *Scenery of the White Mountains*, 1848. Lent by Douglas Philbrook

52

does not have blasted trees or swirling clouds. His is a scene of pastoral peace that shows

> something of human interest [that] must be associated with a scene in nature to render it picturesque in the highest degree. A rude scene, without qualifying accompaniments, reminds us only of waste and discomfort.[23]

Not all the artists at this time saw the White Mountains this way. Some painters still sought the Sublime in the wondrous wilderness of the region. Jasper Cropsey often pictured the region as a still-primitive one, or at least one in which pioneers struggled against a powerful and unyielding wilderness. This grandly wild aspect of the White Mountains is shown in *Indian Summer Morning* (ill. 52), which exhibits many of the traits of Cole's earliest pictures.[24] Stressing expressive forms, richly contrasting colors, and major spatial shifts, the picture embodies the Sublime. In *Eagle Cliff, Franconia* (ill. 14) the pioneer family is dwarfed, even threatened, by nature, especially the twisted, gnarled trees and looming cliffs. Yet, even in this picture we see some of the more peaceful, pastoral qualities in the sunflowers, the grazing animals, and the sunlight. In Cropsey's later paintings (e.g., ill. 101), the White Mountains appeared more harmonious although still richly colored and bathed in light.

The other principal artists of this decade, Kensett, Bierstadt, and Durand in particular, responded as Champney did. These artists, especially Durand, used the facts of nature in the service of a moral and religious vision. As formulated by the Transcendentalists, the contemplation of nature worked to unlock the secrets of the universe: through the contemplation and compilation of details of nature, one transcends mere detail and reaches toward a greater truth.[25] Thus, these painters stressed precise observation while at the same time allowing for an adjustment of certain elements—the wild forest; harsh, rocky land;

and inclement weather—to fit the spiritual vision of the arcadian ideal.

These artists, as well as Champney and others, sought in their paintings a mixture of the magnificent mountains with the simple pleasures of man as he worked and thrived on the land. Such a view of man in this grand setting can be seen in Samuel Lancaster Gerry's *Landscape with Cows and Ploughman* (High Museum of Art, Atlanta, Georgia; 1852: ill. 53). We look from the cool, shaded interior of the forest, with the peacefully drinking cattle and sheep, across the fertile fields bathed in sunlight at the town of North Conway, with the prominent steeple of the Congregational church, and finally to the majestic North Kearsarge Mountain, which dwarfs all else.

The Transcendentalist concern for accuracy complemented the increasing interest in the systematic study of the natural sciences. The White Mountains attracted a growing number of scientists as its untouched regions grew more accessible. Charles Jackson's *Final Report on the Geology and Mineralogy of the State of New Hampshire* of 1844 (ill. 34) was an early and impressive study of the region's riches. Jackson's work was accompanied by illustrations, as was increasingly common in the 1840s. In the case of the work of the botanist William Oakes, *Scenery of the White Mountains* of 1848 (ill. 54), the two artists Godfrey Frankenstein and Isaac Sprague were hired to do the designs. The result is a set of pictures with precise delineation of plants in the foreground and, in the background, smooth transitions from form to form: images that in their overall character conform to the Picturesque.

An exception to the prevailing aesthetic, an exception born of the concern for accurate reportage and made possible by greater scientific skills, was photography. The earliest form of photography in America was the daguerreotype, and perhaps the first daguerreotype landscapes in this country were the three done by the Boston dentist Samuel Bemis of Crawford Notch in about 1840 (ill. 17).

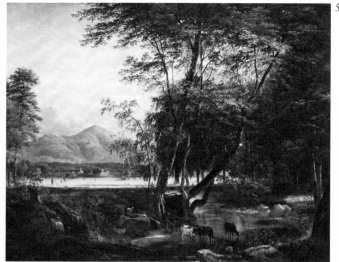

54 THE LOWER CASCADE OF THE NORTH ...

As with most daguerreotypes, the picture is a mirror image, laterally reversed. In these images we see equipment and farm houses worn from use, with no apparent idealized organization. At this time, photography was crude and simple, and the state of the art was concerned with the mechanics of making a picture and not with composition or content selection. As a result, we have a special and short-lived occurrence. Most photographers in subsequent years trained their lenses on more picturesque objects in line with current aesthetic precepts.

Prints were an especially effective way to transmit the idealization of this period to a large public. During this time, the number of prints increased dramatically, paralleling in style the Picturesque mode of contemporary paintings. In fact, many of these prints were made after compositions by well-known painters. In 1851 the American Art-Union, one of the centers of a growing American school of art,[26] published as one of the annual subscription series an engraving of *Mt. Washington from the Valley of Conway* (ill. 134) after a painting (now lost) by John F. Kensett. A later version (ill. 116) is owned by Wellesley College.[27] The print, very close to and surely related to the insert by Kensett's close friend Champney in George Bond's map of New Hampshire of 1853 (ill. 157), is highly structured, using strips of dark and light gently placed in ever lighter bands until one's eye reaches the background, from which the mountain rises in serene majesty. A few people look out from Sunset Hill over the modulated harmony of well-kept fields and houses. Prints such as this reached many households in all parts of the country, convincing people that the Jeffersonian ideal existed in an actual place where they could spend the summer enjoying and observing this natural setting, still beautiful and unspoiled. As the individual sites became better known, there developed a tradition of images that were based on artistic conventions. Hence, the outside world came to know the White Mountains as picturesque rather than as the place

of harsh climate and terrain that they actually were.

As more and more people were drawn to the region by the popular images, guidebooks made the area seem all the more accessible and inviting. Sylvester Becket's *Guide Book of the Atlantic and St. Lawrence* of 1853,[28] was one of the earliest of these guidebooks; two years later John Spaulding wrote *Historical Relics of the White Mountains*; and in 1856 the most important midcentury guidebook was written by Samuel C. Eastman (ill. 149).

Moreover, histories of the people of the region were appearing, such as Benjamin Willey's *Incidents in White Mountain History* (with illustrations after Benjamin Champney). Here one has, in contrast to other descriptions of the region, accounts of the hardships of life, with the struggle against the elements, the difficulty of farming, and the day-to-day routine. Yet, even Willey succumbed to the vogue for the ideal, dwelling on the picturesque scenery, on the myths about the usual points of interest, and on the early pioneers as folk heroes. In describing the view from North Conway, he approximates Kensett's image in *Mount Washington from the Valley of Conway*:

> One feels, in standing on that green [Conway] plain, with the music of the Saco in his ears, hemmed in by the broken lines of its guardian ridges and looking up to the distant summit of Mount Washington, that he is not in any county of New Hampshire, not in any namable latitude of this rugged earth, but in the world of pure beauty—the *adytum* of the temple where God is to be worshipped, as the infinite Artist, in Joy. (p. 174)

More in keeping with the idealized view of the region, Thomas Starr King, in his *The White Hills; Their Legends, Landscape, and Poetry* (Boston: Crosby, Nichols, and Co., 1859), directed the visitor to make the extra effort to seek out the perfect viewing spot (e.g., pages 66 and 95) in order to find views that are pictures (e.g., page 163). More-

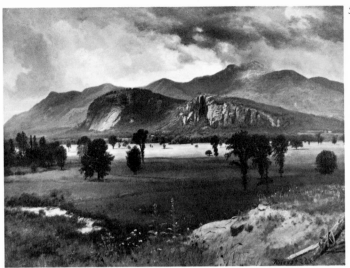

55

55. Albert Bierstadt, *View of Moat Mountain, Intervale*, ca. 1860. Collection of The Currier Gallery of Art*

56. Daniel Huntington, *Chicorua Pond and Mountain*, September 28, 1854. Collection of Cooper-Hewitt Museum, Smithsonian Institution

48

over, when the reader reaches this spot he will have

come to the highest use which mountains serve when we speak of their *beauty*. No farm in Coös county has been a tithe so serviceable as the cone of Mount Washington, with the harvests of color that have been reaped from it for the canvas of artists, or for the joy of visitors. (p. 104)

King's tone is carried by religious-like fervor reinforced by poetry and illustrations.[29] The natural order of which he speaks was sometimes extended into a moral and political context in which one sees not only the glory of God but also the benefits of freedom.[30] Willey went so far as to contrast the liberty that the mountains represented to the disorder and strain of the cities,[31] thus picturing a visit to the White Mountains as a necessity for the growing urban population.

Traditional views of particular sites increasingly became the only accepted ones;[32] and hence, many painters looked at the same place from the standard locations and produced almost the same picture. Two such examples are Bierstadt's *View of Moat Mountain, Intervale* (Currier Gallery of Art, Manchester, N.H.; ca. 1860: ill. 55) and Champney's painting of the same subject (ill. 99). Both stress the comfortable location of the observer in the foreground with the view of the Conway Intervale neatly set against the hazy mountains and sky. The colors are harmonious greens, blues, and browns bathed in the warm, midday sun.

Both artists, as did most painters who were working after midcentury, created a highly idealized pastoral beauty, stressing carefully selected details to give a documentary, realistic appearance to the work. Bierstadt's interest in detail was the result partly of his study in Düsseldorf in the mid-fifties and partly his making of photographs, both on his own and with his brother Charles.[33]

His paintings show the influence of photographic concepts: the frame cutting off foreground and lateral forms, the cloudless sky (from orthochromatic film), and the detailed objects in the background as well as the foreground. He might have known the stereograph of the intervale by the Boston photographer John F. Soule of about the same time;[34] certainly his training with a stereo camera in 1859 and 1860 in preparation for the publication of his *Views Among the Hills of New Hampshire* in 1862 was significant.

Another artist who stressed details while idealizing nature was Asher B. Durand. He first visited the White Mountains with his friend Thomas Cole in 1839.[35] His paintings of the area, however, were done later, after his three trips of 1855, 1856, and 1857, when he sometimes stayed at Thompson's while in the North Conway area. Influenced by his year in Europe with Kensett and John Casilear and by the growing interest in the ideas of Sir John Ruskin,[36] he made precisely drawn sketches from nature of motifs that he then combined in his studio. Through this working method, he sought motifs that worked together to transcend individual form in search of a pantheistic vision.[37] In one of several versions of Franconia Notch (private collection: ill. 58) we see not only the peacefully grazing livestock, the well-ordered fields and farms, and the beautiful view, but also, as in the Samuel Gerry (ill. 53), the church at the left. Framed by the trees and accented by the brilliant light on the steeple set against the neutral mountains, the church balances the notch (Franconia) and the peak (probably Liberty Mountain) at the right. The Pemigewasset River and the open intervale at North Woodstock serve as the neutral plain between the two forces, nature and religion, that guide and order human life.

Durand's 1855 painting of *Chocorua Peak* (Rhode Island School of Design, Providence, R.I.: ill. 57) is a watershed of the ideals embodied in the Sublime on the one

hand and the Picturesque on the other. Representing the primitive state in which there is no overt view of man or his habitations, nonetheless the cleared land reflects the order man has imposed on a part of nature. The space is grand, with the mountain rising magnificently, and the contrasts of foreground and background along with the sharp light accents on rocks and dead trees add to the romantic energy of the picture. On the other hand, Durand's space is carefully ordered with precisely rendered forms, all of which are set before a serene Lake Chocorua, nestled in the bowl carved out by the dark trees and rocks and the mountain. This is more in line with the Champney (ill. 50) and Kensett vision—as opposed to that of Cole and Fisher.

Durand's interest in the ideas of Ruskin was shared by several other artists who studied nature in minute detail in order to transmit the deeper, spiritual meaning of life. Daniel Huntington, a good friend of Durand, drew a study of Mt. Chocorua (ill. 56) in which all the elements—every rock, tree, and plant—are carefully delineated. The drawing is also carefully dated and sited, as are many of the White Mountain drawings from this period.

Aaron D. Shattuck was a frequent visitor to the region after 1854.[38] His drawings, such as *The Mountain Stream* (ill. 120), show the care with which he observed nature. In contrast to Thomas Cole's drawings, his drawing is not a set of notations for later studies but is a finished record of his immediate experiences. Shattuck includes the observer in the picture by thrusting the foreground rocks into our space and by layering the rocks and trees as one's eye looks deeper into the space.

In many of Shattuck's paintings, such as *Autumnal Snow on Mt. Washington* (Vassar College Art Gallery, Poughkeepsie, N.Y.; 1856: ill. 60) the foreground is similar to Durand's (ill. 58); however, his pictures are more open and have fewer abrupt transitions back into space from the foreground. A comparison of his *Chocorua Lake and Mountain* (Vassar College Art Gallery, Poughkeepsie, N.Y.; 1855: ill. 59) with the same scene by Durand (ill. 57) demonstrates this difference. There is a greater openness in Shattuck's space; his brushwork is broader; his drawing is looser; and his distant forms lack the tight precision of Durand's trees and rocks. These differences notwithstanding, Shattuck stands with Durand, Huntington, Kensett, and Champney as a delineator of pastoral images that transmit through their precious forms, bright colors, and harmonious compositions a pure, moralistic vision of a pastoral arcadia. This vision was no more or less accurate than was the Sublime of Thomas Cole twenty years earlier; rather, it fit a different ideal.

COMMERCIALIZATION AND MAXIMUM GROWTH

After the Civil War, the growth of the White Mountain region increased, and with this growth came extensive development of tourist facilities, as well as light industry. The White Mountains provided a place where Americans could go and, in considerable comfort, experience one of the last unspoiled natural areas in the country. They came in greater and greater numbers. This influx of tourists caused the existing hotels to be enlarged and new ones built. Railroads were extended, replacing the slower and less luxurious coaches.[39] The mountains had become of "more value than the meadow lands on the Connecticut [River]"[40] because tourism brought more revenue than agriculture and manufacturing did to towns such as North Conway, Bethlehem, and Gorham.[41] Rail lines accommodated the needs of the tourists by building spurs to major hotels that in turn provided even more technical improvements and luxurious accommodations: gas lights and then electric lights, private toilets, and elevators; elaborate meals; new games such as croquet, baseball, tennis, and golf; and amusements such as brass bands and grand

57. Asher B. Durand, *Chocorua Peak,* 1855. Collection of Museum of Art, Rhode Island School of Design*

58. Asher B. Durand, *Franconia Range, from the South,* 1857. Private collection*

59. Aaron D. Shattuck, *Chocorua Mountain and Lake,* 1855. Collection of Vassar College Art Gallery*

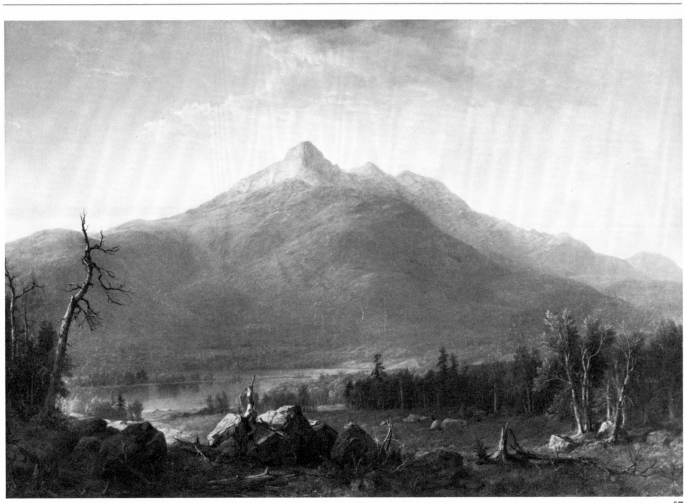

57

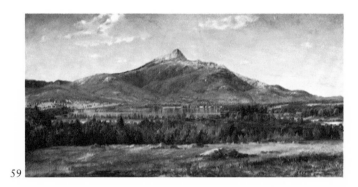

59

coaching parades. The tourist industry also required greater and more sophisticated publicity, which was provided by newspapers such as *The White Mountain Echo and Tourist Register* and *Among the Clouds,* published at the summit of Mt. Washington (ill. 165).[42] Maps and guidebooks, such as Moses F. Sweetser's *The White Mountains: Handbook for Travellers* of 1876 (ill. 150), poured forth. The Appalachian Mountain Club was founded in 1876 to help people explore the mountains.

With this change in the region, art exhibited a similar change. The presence of artists and artistic products became more common. Artists, such as Champney and Shattuck, became regular summer residents,[43] as much a part of the tourist attractions as was Mount Washington.[44] Brochures, broadsides, postcards, and souvenirs abounded throughout this period, particularly after 1875, and paintings and photographs were produced in great quantity to meet the growing demand of tourists. As a result, dedication to aesthetic ideals was overwhelmed by eclecticism and commercialism. Many painters now based their work on traditional representations of the area, using the elements of the landscape that suited their more commercial aims and discarding the rest without regard to the actual despoliation and development that were taking place.

In keeping with the mechanistic spirit of the time, the images of the White Mountains that were being produced showed man and his machines in harmony as they conquered natural obstacles while still leaving the indigenous beauty of the site intact. Photographs abounded of the Frankenstein Trestle (ill. 30), and Jacob's Ladder on the Mount Washington Railway (ill. 162), and the grand hotels (ill. 161) which served as such an important focal point for the economy in the region. These sites now took their place beside the purely pastoral as part of the standard perception of the White Mountains.

While photographs, being produced by a machine, were assumed to present a less manipulated or adjusted picture than a painting, in fact the photographer was as much a subjective perpetrator of this vision as the painter. Like the painter, the photographer composes his photograph, choosing not to depict any element in the landscape that does not fit in with his overall composition and selecting his vantage point to include such elements as rocks and trees as framing devices.

From the Civil War on, because of the growing fascination and acceptance of the machine, because of tremendous advances in technology, and because of the growing demand for impressive yet accurate pictures, the photographer achieved at least equal footing with the painter; hence, he became an important propagator of the image of the White Mountains throughout the country.

Initially, however, the art community did not accept these photographs. A complex and often bitter argument ensued over their artistic value. In general, photographs, while praised for their ability to capture and display the transient aspects of nature, were viewed as inferior because they could not transcend facts; they could not interpret the facts to show the relation of truth to the human intellect and heart.[45] As a result, many of the early photographers of the White Mountains strove to give their work the quality of paintings.

Two marvelous images of the Franconia Notch area by D. W. Butterfield (Littleton Community Center) rival the magnificent pictures by William Henry Jackson and the other pioneering photographers of the Far West who achieved fame after the Civil War. In excellent condition, these two albumen prints are surely contact prints from glass plates, for their detail seems endless. Butterfield's work has a painting-like character. The lights and darks have that richly inked appearance from the collodion negative and albumen emulsion of the paper. The site he has selected for the photograph has much of the scale and many of the compositional elements found in, for example, Frank Shapleigh's *Crawford Notch from Mount Willard*

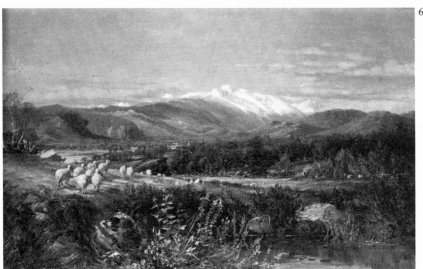

60

60. Aaron D. Shattuck, *Autumnal Snow on Mt. Washington*, 1856. Collection of Vassar College Art Gallery*

61. Unknown photographer, *Littleton, White Mountains, N.H.*, 1900. Lent by Stephen T. Rose

52

(ill. 22). Some smaller photographs also showed this aesthetic concern, as can be seen in the Hall Studio *Profile House and Lake* (ill. 35), in which the mountains close off the space and focus our attention on Echo Lake and the white Profile House. This kind of work brought some artistic recognition to photography. As Oliver Wendell Holmes wrote:

> The first effect of looking at a good photograph through the stereoscope is a surprise such as no painting ever produced. The mind feels its way into the very depths of the picture. . . .[46]

Photographs eventually became a threat to paintings because they were realistic and also because they were cheap and easily accessible. They answered the growing demand for reliable representations to serve as memories of the place. Increasingly, photographs supplanted drawings and paintings as accurate records of the sites tourists visited. The anonymous photograph of *Silver Cascade* (ill. 5) is an example of the kind of work that predominated during the years after the Civil War. This representation of a popular tourist site was inexpensive and also carried with it the mystique of the camera's unadulterated reality. Images such as this one were easily purchased in the White Mountains and in urban outlets; hence, they were available to everyone. By 1870 nearly every sizable White Mountain town had its own stereo photographer. One of the most important, Benjamin Kilburn, along with his brother Edward, opened his studio in Littleton in 1865.[47] Although there were many other photographers in the area, such as John P. Soule and the Bierstadt brothers, the Kilburn brothers dominated the industry, producing 300,000 stereos annually during the eighties. Many of the images were of the Summit House (completed in 1853), the Mount Washington Road (completed in 1861), Jacob's Ladder

and the Cog Railroad (completed in 1869), and the activities of tourists, such as hiking. The photographer looked *at*, not just *from*, the hotels and was less reluctant to record industry and its effects.

Still, the photographer sought subtly idealized images—albeit somewhat different from the ideal the painter had developed. The photographers in the last third of the century strove to integrate a conception of the wonder of nature with the machine and its fascinating industrial products. A few painters had depicted industrial scenes: e.g., Merrill Wheelock's *Logging on the Androscoggin* (New York Art Market) and the anonymous *Mill on Lake Winnipesaukee* (ill. 37), but the light and fluidity of the watercolor medium in these rare pictures make the scene appear more picturesque and less industrial. Some photographers, such as W. C. Hunton in his *Laconia Box Factory* (ill. 39), did depict factories in a direct and unselfconscious manner, but such views of factories did not sell well to tourists who wanted to remember the thrill of Jacob's Ladder or the beauty of the Flume. While these latter photographs document the region as well, the photographer has chosen the elements with care, selecting with an idealizing eye that was trained by the painter. Popular photographers pictured man and his machines in harmony with nature.

The town views that began to appear after the Civil War also reinforced the image of domesticated wilderness, civilized and industrialized but not stripped of its natural beauty. In the unknown painter's *Littleton, N.H.* (ill. 125) we see a train, small farms, and the prominent church as secondary to the mountains and surrounding hills, albeit a cultivated and quiet scene. The Detroit Publishing Company's large photograph of Littleton of 1900 (ill. 61), while showing the racetrack in the foreground, also depicts a town nestled in the beautiful mountains. Other views, such as Poole and Norris's *Littleton, N.H.* of 1883 (ill. 152), demonstrate the commercial nature of towns with

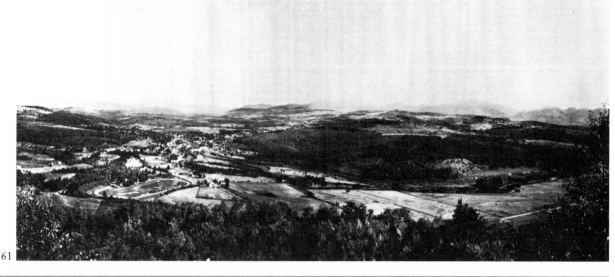

61

factories and extensive architectural development (see also the *Town View of Conway, N.H.*: ill. 160) while still imbuing the scene with a simplicity and clarity that maintains the idealism of the pastoral landscape setting.

Books illustrated with photographs also reflected this ideal. Moses Sweetser in his many publications on the White Mountains avoided views of clear-cut forests, too many railroads, and mundane scenes. Rather he sought the famous sites, whether they were of nature, such as the Old Man of the Mountain, or of man-made forms, such as the Frankenstein Trestle (ill. 91). In his views there is little hint of the difficulty of life in the White Mountains, even for the tourist wet from rain or attacked by flies and mosquitoes.

These idealized views also appeared in widely distributed prints. Currier and Ives, Louis Prang, and the popular press quickly adopted many of the standard images. Currier and Ives commissioned Fannie Palmer to do a large lithograph of *Mt. Washington and the White Mountains from the Valley of Conway* (ill. 132). Fannie Palmer used for this lithograph the American Art-Union engraving after Kensett's painting of nine years earlier. Palmer turned the distant mountains into a romantic Alpine view with huge, exaggerated white mountains in the background and picturesque meadows in the middle and foreground. In prints such as this, Currier and Ives sought to appeal to the taste of the new urban dwellers, reassuring them that the pastoral could still exist in a now predominantly industrial world. Hence, their concern was not with the pastoral ideal but with the already existing perception of that ideal in the consuming public's imagination.

Another important publisher of popular prints was Louis Prang, whose firm printed chromolithographs in Boston from 1860 until 1897. Prang purchased many of the artists' paintings or had copies made of them. He produced views of the Hudson River, the Adirondacks, the White Mountains, and Yosemite, as well as flower and genre pieces. His work, as did that of Currier and Ives, reached far and wide and touched on the sentimental, nostalgic idealism of Victorian America.[48]

In the struggle between the demands of a growing industrial system and a tourist industry that required unspoiled land, these printmakers came down decidedly on the side of the tourists as opposed to the manufacturing, lumbering, and mining industries. The seasons, views of harvest time, and the usual meadows, streams, and mountains were all part of the vision that Prang sold, a vision of the White Mountains untouched by foul weather, industrial development, or poverty. This pastoral goal found support in the ideals of middle-class America, which held an optimistic view of the direction in which the country was developing.

Popular magazines also illustrated scenes from the White Mountains, especially the tourist resorts. These pictures, beginning with the first woodcuts in *Harper's Monthly* in June 1852 and continuing throughout the century, stressed either the vacation-like, relaxed air of the region or the scientific use to be made of it. Prints by well-known artists such as Winslow Homer, as well as by anonymous designers, also touched on the humorous and comical, but in all cases they continued to show the optimism that attracted tourists and, encouraging interest in the region, contributed to its further growth.

Photographers and printmakers did not, however, eclipse painters as propagators of the nostalgic, optimistic vision of the White Mountains. During this period, hundreds of artists flocked to the hotels, producing thousands of images. While several artists stand out, such as Benjamin Champney, many of these artists are little known today, and then only regionally. They did, however, constitute the bulk of the White Mountain School of art, a broad-based, popular school whose aesthetic was embraced by nearly all artists working in all media during the last third of the century.

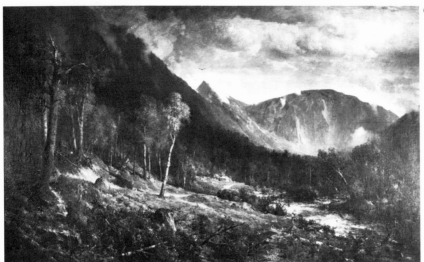

62. Thomas Hill, *Crawford Notch*, 1872. Collection of New Hampshire Historical Society*

63. Sylvester Phelps Hodgdon, *White Mountains in September, North Conway, N.H.*, 1853. Collection of The University of Michigan Museum of Art, Bequest of Henry C. Lewis, 1895

64. George Inness, *Saco Ford: Conway Meadows*, 1876. Collection of Mount Holyoke College Art Museum*

54

THE WHITE MOUNTAIN SCHOOL

These artists, congregating in places like North Conway,[49] looked to the tradition of painting, particularly of native landscape painting, called the Hudson River School.[50] By 1876 this loosely formed national aesthetic had essentially dissipated, having grown from its humble beginnings in the paintings and ideas of the 1830s and 1840s in the work of New York–based artists, such as Cole and Durand.

A school of art flourishes when like-minded artists, in this case painters, work in a similar manner and with related subjects in a recognizably similar style. They exchange ideas and exhibit their work at compatible institutions. The White Mountain School aesthetic was widespread and flourished because people understood and appreciated this traditional aesthetic, because there was a ready market for the pictures, and because the vision of the school reinforced the established social order. The White Mountain School painters continued to work in the waning style established by the Hudson River School artists, a style which stressed the picturesque. The paintings are generally identifiable as to site, which is seen during sunny days from a comfortable vantage point. Seldom are the pictures larger than can be comfortably held in one's hand.[51] The result is a pleasant image of the White Mountains that conforms to traditional beliefs created nearly a quarter of a century earlier by painters such as Champney, Durand, and Kensett. Factors that reinforce our historical perception of this school are: a community of artists, an outlet for their work, and the presence of students.

The most successful of the White Mountain School artists often resided during the summer at the grand hotels as an integral part of the hotels' attractions for tourists. Aaron Shattuck stayed at the Walcott House in North Conway, Frank Shapleigh at the Crawford House, and Alfred Ordway at Kearsarge Hall. These hotels provided a place to work as well as a ready clientele. The tourists probably regarded the pictures as much as souvenirs as anything else, with little concern for the history of ideals that went into their production.

Many of these artists exhibited their work at the Boston Art Club.[52] The availability of an urban exhibition space also contributed to the viability of the White Mountain School. The Club's heyday lasted about twenty years, beginning around 1870, during which time White Mountain painters such as George Loring Brown (ill. 94), Samuel Lancaster Gerry (ill. 107),[53] Samuel Griggs (ill. 112), Edward and Thomas Hill (ill. 62), John Ross Key, Benjamin Nutting, Alfred Ordway, Alexander Pope, and Gabriella White exhibited there. Some of these painters had been to Europe, such as George Loring Brown, while others were northern New England painters, as Samuel Griggs. Edward Hill actually lived in New Hampshire—in Nashua, Lancaster, and Littleton—and worked at the Glen House during the summers.

Whether year-round residents, world travelers, or mediocre painters, these artists all represented through their work the basically reactionary ideals of the White Mountain School. Their work shows us a land of sincere beauty, with quaint towns, verdant fields and meadows, bright sunshine, and sparkling streams. They all generally depict a place of retreat far from the incomprehensible crush of the urban and industrial world. There are exceptions, of course, but on the whole these painters give their numerous patrons the past, in content and in style.

While many of the artists in the White Mountains were summer residents, not all were. Some lived nearby, such as Harrison Bird Brown, who came from Portland, Maine, to paint. Others lived in the region year round, as did Edward Hill, who painted scenes of life in the mountains, logging and maple sugaring, stormy and wintry days. These representations constitute a variant within the

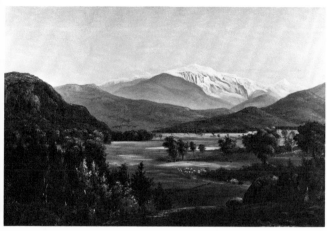

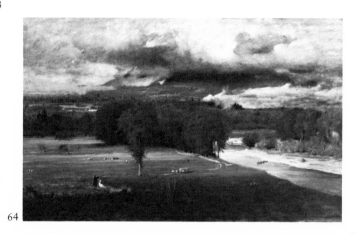

64

school. Unlike that of the usual summer artist, the work of the year-round resident artists showed a sympathy for the harsh life of the indigenous population, especially as experienced during the long winters.

Another contribution to the longevity and unchanging aesthetic of the White Mountain School was the existence of a student-teacher relationship. The most prominent teacher in this instance was Benjamin Champney. Aside from his distinction as a prolific painter in the region, he had a great influence through his many pupils. Sylvester P. Hodgdon (ill. 63) was an early pupil, and later Ann Freeland, Annie MacKay, and Ann Sophia Towne (Mrs. Robert Darrah) worked under Champney's guidance. These artists produced a large number of pictures that continued the picturesque traditions of the White Mountain School, beginning just after the Civil War.

The basic ideals of the White Mountain School artists were geared to popular taste and the pocketbooks of the middle class. There were some exceptions. Thomas Hill's *Crawford Notch* (New Hampshire Historical Society, Concord, N.H.; 1872: ill. 62) is a colossal picture that reverts in some measure to the Sublime of the previous generation and conjures up romantic notions of far-away places, as were being exploited by many painters of exotic locations such as the Arctic, the Andes, and Yosemite. In this picture, exhibited at the Centennial Exposition in Philadelphia, Hill sought to make public art an overwhelming experience, thus embracing a different convention. The peaceful individuality of most White Mountain School pictures, meant for the tourists who bought pleasant memories for their urban homes, is here rejected in favor of Hill's Sublime view of a wilder notch than had existed for more than a quarter of a century. Hill's picture is an exception to the more ordered and developed image of the region that the tourist knew, an image that was both an accessible pleasure and a comfortable reassurance couched in the traditionally picturesque terms of the White Mountain School.

THE DEMISE OF ART IN THE WHITE MOUNTAINS

While the White Mountain School's aesthetic formulae flourished, the seeds had been sown for the demise of the artistic tradition that had developed over the half century since Thomas Cole first came to the White Mountains. These seeds came from the very economic success on which these artists depended. Perhaps this demise is best exemplified in the Centennial Exposition in which Thomas Hill's huge painting was exhibited. Industrial growth with its wealth and cosmopolitanism, its exploitation of natural resources, and its demand for more technology, spawned a fascination with science. At the Centennial Exposition, with the Corliss Steam Engine and the telephone leading the way, unusual machinery and inventions drew large crowds. These interests were being played out in the White Mountains, too. Of particular importance was the Mount Washington Summit House winter observatory which William Halsall painted (ill. 113). However, the subject found a more acceptable format in *Harper's Weekly* (ill. 142), where a print of the scene was accompanied by a detailed description of the observatory and the conditions of the summit during the winter months. More and more the audience had become interested in the unusual, the bizarre, and the unknown, and the focus of subjects shifted from the picturesque to those subjects that lent themselves better to other forms of representation, like writing.

The second force that worked against the White Mountains as an important subject for new art was the changing aesthetics of the last quarter of the nineteenth century. Artists were increasingly investigating light and atmosphere rather than topography. Winckworth Allen Gay and

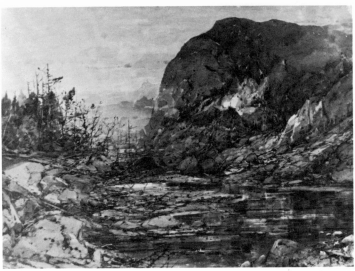

65. William Louis Sonntag, *Carter Dome from Carter Lake*, ca. 1880. Collection of Cooper-Hewitt Museum, Smithsonian Institution

66. Unknown photographer, *Jackson, N.H.*, ca. 1900. Collection of New Hampshire Historical Society

67. Frank Henry Shapleigh, *Mount Washington from Jackson*, 1885. Lent anonymously

68. George Inness, *Mount Washington*, ca. 1875. Collection of Davis & Long Company, New York

56

Frank Shapleigh exemplify this growing interest in light, atmosphere, and color. The concern of these artists lies in the pinks and blues of the sky and of the shadows and not in the physical mass of the land. This interest grew from a study and knowledge of the Barbizon School in France.[54] The color in Shapleigh's work has a lightness and brightness that contrasts with the heaviness found in Champney's work, which stresses the permanence of the masses (rocks, trees, and fields). Shapleigh's brushwork, lack of precisely rendered details, and overall atmosphere point to his affinity with the Barbizon School. On the other hand, Shapleigh did not abandon topography altogether, as a comparison of his *Mount Washington from Jackson* (ill. 67) with the anonymous photograph (ill. 66) attests. Shapleigh's work represents a partial deviation from the picturesque topography of the White Mountain School.

George Inness, on the other hand, gave us views that had never been conceived before and that were contrary to the tradition of pictures of the White Mountains. His view of *Mount Washington* (ill. 68) contains indistinct forms: trees become light accents, space is not delineated, and the mountains are hazy. In his *Saco Ford: Conway Meadows* (Mount Holyoke College Art Collection, South Hadley, Mass.; 1876: ill. 64) we see the mountains enshrouded in clouds—the way they may actually be seen but not the way they were previously painted by Kensett in *The White Mountains, Mount Washington* (ill. 116) or Bierstadt (ill. 55). Inness, who had worked in Barbizon with the French painters there, was interested in the atmospheric conditions not as a depiction of the tangible, harsh life, but as a visual phenomenon, impermanent and not limited to just physical objects. His is the realism of observation of light that led eventually to Impressionism.

Other artists who came to the White Mountains in the 1880s also recorded the common sight of clouds and unusual light effects. Artists such as John Joseph Enneking

(ill. 105), Homer Dodge Martin, Alexander Wyant, and William Louis Sonntag (ill. 65) all produced indistinct paintings in accord with the ideas of the French Barbizon School and later the Impressionists. The mountains were appreciated for unusual colors and were increasingly ignored for the Sublime on the one hand and the Picturesque on the other. Art had evolved as an observation of light, instead of things.

This development, set alongside the commercialization of the region, dealt a death blow to the tradition that had become identified with the White Mountain School. Those artists interested in light turned increasingly to other regions—Long Island and the Isles of Shoals, for example—for motifs that better served their needs. With these painters of atmosphere, we come to the end of an artistic era. The forests had fallen to the tourist with his attendant hotels and railroads (and eventually automobiles), to the lumber industry, and to the realization that the frontier had passed. During the last quarter of the century artists and tourists continued to bring commercial success to the region, but the artists produced little that could form the foundation of a new tradition.

Throughout the century we have seen that every maker of visual images saw as he wanted to, responding to his preconceived ideas and to the demands of his audience. With the change of the region, art changed too. Each artistic change was part of a broader change in how people wanted to see nature and themselves, and each change is echoed in all media, from the finest painting to the simplest souvenir. All these artists, whether painters, photographers, or souvenir designers, took liberties by exaggerating or selecting according to artistic and intellectual traditions or social and economic pressures. These adjustments and liberties form the essence of the lasting perceptions of the White Mountains.

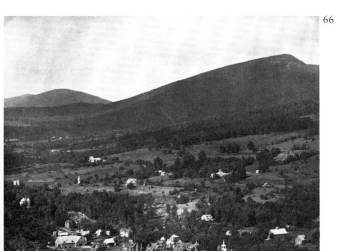

66

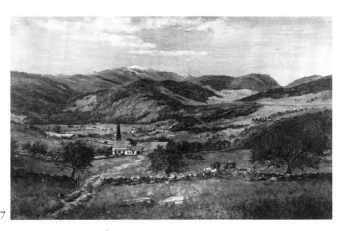

67

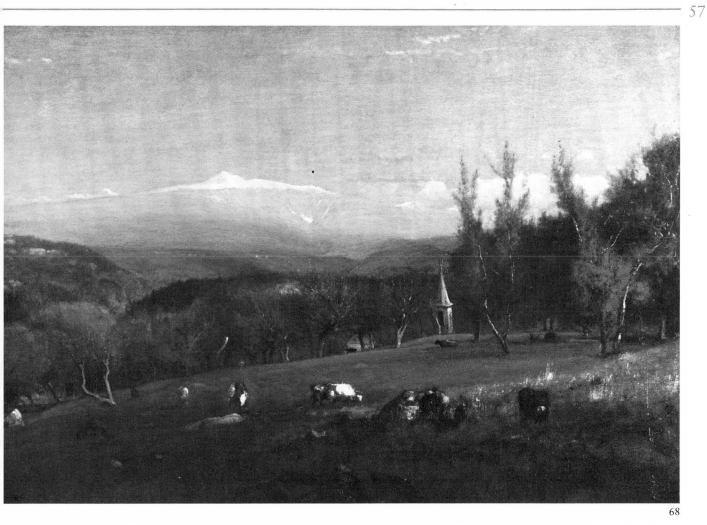

68

69. *The Gap of the White Mountains*, woodcut by Abel Bowen after a drawing by John Kidder, insert for *New Hampshire by Recent Survey*, Philip Carrigain, 1816. Collection of Dartmouth College Library

70. *View of the White Mountains from Shelburne*, woodcut by Abel Bowen after a drawing by John Kidder, insert for *New Hampshire by Recent Survey*, Philip Carrigain, 1816. Collection of Dartmouth College Library

69

70

THE REAL AND THE IDEAL: POPULAR IMAGES OF THE WHITE MOUNTAINS

Robert L. McGrath

For the nineteenth century, the White Mountains were an idea before they were a reality. Popular consciousness of the region was formed by artifacts rather than facts. Images and words rather than experience served to structure the place in the American imagination.

Philip Carrigain's 1816 map of New Hampshire contains the earliest extant images of the White Mountains (ill. 69 and 70), made well before artists and tourists had begun to traverse the area through its great notches. Crude, hand-colored woodcuts, these inserts served to emphasize the idea of soaring height or sharp declivity only dimly suggested by the contours of the map itself. The designer of these prints was free to look up to the spiky, snow-clad peaks of the Presidential Range or down upon a diminutive traveler negotiating a gap formed by sharply rising cliffs and a plunging cascade. Spruce trees, clinging precariously to the incline, form animated patterns against a narrow patch of sky.

Drawn by J. Kidder of Concord and cut by Abel Bowen of Boston, these simple prints are as cartographic as the map itself, reducing the landscape to a few graphic symbols and rendering it subject to ready replication. These woodcuts were often reused in the first half of the century to embellish documentary and didactic writings on New Hampshire. They were employed less to illustrate texts than to denote the chief topographic features of the state and to function as emblems of place.[1] That Kidder had any direct experience of these sites is less likely than that his drawings were based on the verbal descriptions of others, a practice used by many of the early map makers, as well. It is significant that the White Mountains, which form less than one-fifth of New Hampshire, were taken to symbolize the landscape as a whole and to serve as enduring models of consciousness. Emblems of nature rather than products of empirical observation, Kidder's diagrams of the Presidential Range and the White Mountain Notch (later named Crawford Notch) functioned as symbolic

communications rather than simulacra of places perceived and experienced.

In the 1823 *Gazetteer of the State of New-Hampshire,* where the woodcuts were first reused, the author, John Farmer, informs us that the White Mountains are "the loftiest in New-England, and perhaps in the United States." He further claims that they "furnish a rich profusion of the sublime and beautiful," categories derived from European Romantic literary theory and here associated for the first time with the White Mountains. "'Tis true," the writer concludes apologetically, "our majestic hills are not yet adorned with classical recollections . . . like the pass of Saint Bernard."

This associational view of nature—the notion that the landscape is enhanced by the presence of historic man and that grand connections with the past elevate the mind—possesses a venerable pedigree in European artistic theory.[2] Indeed, the lamentable inadequacy of America in this regard was frequently expressed by early writers. Chateaubriand once pithily remarked, "Il n'y a de vieux en Amérique que les bois." (There is nothing old in America except the woods.)

Events occurring in the summer of 1826 conspired to remedy this paucity of "classical recollections" and served, virtually on demand, to satisfy the thirst for humanized "Nature" (the latter generally capitalized by writers). The destruction of the Willey family, pioneer settlers of Crawford Notch, by a massive landslide in August of that year immediately engendered a host of literary and artistic responses, conferring, at the same time, dignity upon the site. Setting off a Romantic *frisson* that reverberated throughout the century, this tragedy both slaked the thirst for association and fed the mounting appetite of the century for "gloom, dread, and fear."

The account of the Willey slide written in 1826 by Theodore Dwight of New Haven in a travelogue significantly entitled the *Northern Traveller* is among the earliest

*Illustrations marked with an asterisk are of works not in the exhibition.

71. *The Site of the Willey Slide*, O. H. Throop, engraver, after a drawing attributed to Daniel Wadsworth, illustration for Theodore Dwight, *The Northern Traveller*, 1826*

72. *Distant View of the Slides That Destroyed the Whilley Family*, Anthony Imbert, lithographer, after a lost painting by Thomas Cole, 1828*

of what was to become a cultural avalanche of quasi-reportorial and fictionalized accounts of the tragedy.[3] Dwight's turgid prose takes a morbid delight in the disaster and alternates between attraction and repulsion before the awesome face of nature. His account is illustrated by a print engraved by O. H. Throop of New York (ill. 71) that represents the heart of the notch together with the Willey homestead. The latter, ironically, had been left standing by the avalanche after being deserted by the family, and thus was capable of being invested with the instantaneous status of a "ruin."[4]

The drawing engraved by Throop was probably executed by Dwight's acknowledged traveling companion and fellow Connecticut wit, Daniel Wadsworth, the New Haven amateur who is best known as Thomas Cole's major early patron. The original sketch attributed to Wadsworth was doubtless made on the site and, as such, was the first view of the White Mountains to be derived from observation rather than imagination. The static and composed view, however, is as much a product of European landscape theory as of experience. In its balanced planar harmonies and carefully resolved symmetries, it conforms to Picturesque modes of landscape representation which had migrated to this country at the beginning of the century. An embodiment of tranquil and beneficent nature, the Picturesque structure of Wadsworth's image forms a marked contrast to Dwight's Sublime ruminations on a "melancholy subject of reflection."

This early and somewhat uneasy alliance of art and letters seen in the *Northern Traveller* was elaborated by the incursion of the first professional academic artists into the White Mountains. Drawn by the published, as well as the informal, accounts of the Willey disaster, Thomas Cole and the New Hampshire–born painter Henry Cheever Pratt visited the notch in October of 1828, guided by the legendary Ethan Allen Crawford. Written records of their experiences have survived, together with the evidence of

their respective attempts to visualize the site.[5]

Cole's now-lost painting entitled *Distant View of the Slides that Destroyed the Whilley Family* is known only in a lithographic copy (ill. 72). Cole's composition eschewed the conventional balanced and frontal views employed by both Wadsworth and Pratt (ill. 78 and 73). Instead he aligned the precipitous slopes of Mount Willey ("the great destroyer") obliquely to the picture plane and eliminated the signs of human habitation. By these means, a series of contrasts between diagonal and frontal, light and dark, foreground and background is created that shifts the spectator's viewpoint from that of observer to participant. Nature and its processes become the core subjects of the work, in which associations are of less importance than the evocation of the undefinable power of natural forces.

For all its apparent immediacy, Cole's scheme also derives from European landscape theory, conforming to the category of the Sublime. A formula for representing the threatening aspects of nature, the Sublime is characterized by jagged and irregular shapes, strong contrasts of light and shade, and forms deployed in tense and dynamic opposition to one another. Mountains, sky, and storm-tossed clouds are the vehicles by which the artist projects his emotions into the landscape. Boulders, stumps, and writhing, humanized trees delineate the foreground plane. As such Cole's work is more consonant with the rhetoric of the written accounts of the disaster, as well as with his own sentiments, which are recorded for us in his diaries and other writings.

Pratt's work (ill. 73), which is contemporaneous with Cole's and also known only in an engraving, is a more static and conventional view. Its softened forms, though dramatically lit and set off by foreground debris, conform in essence to the theory of Picturesque landscape. Only the blasted foreground trees, which derive from Cole, and the fallen branches and boulders serve to exclude the spectator from the pictorial construct and to symbolize hostile forces

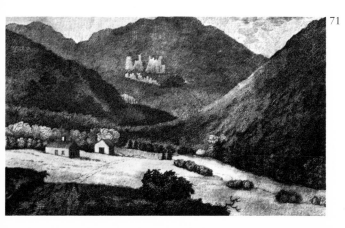

71

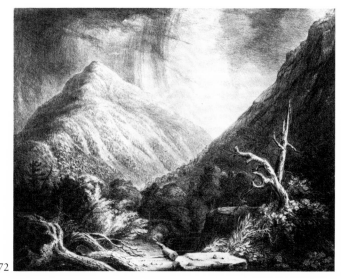

72

of nature. Unlike Cole, Pratt was unable to resolve the respective claims of Picturesque composition and the rhetoric of Sublimity called for by the subject. Cole's work serves as both a powerful evocation of the events and a pictorial critique of his colleague's convention.

In his highly descriptive diary, Cole noted that he and Pratt were made to feel "as worms" by the towering cliffs above the notch. The primacy of painting over prose was asserted since "it's impossible for description to give an adequate idea of this scene of desolation." On a later occasion he wrote of the notch as a battleground for the elements: "There was an awfulness in the deep solitude present up within the great precipes [sic], that was painful." These sentiments were called for by both the spirit of the place and the spirit of the age.

In his 1835 "Essay on American Scenery," Cole further noted the White Mountains as a place where "the savage is tempered by the magnificent." Shifting smoothly from aesthetics to theology, he observed that the wilderness is "yet a fitting place to speak of God."[6] In this latter connection, he was bringing his own convictions into accord with the transcendental view of nature widely held in England and America at the time.

Cole's beliefs were shared by Dwight and Wadsworth, as was the continued fascination with the site of the Willey slide. In another book by Dwight entitled *Sketches of Scenery and Manners in the United States* published in 1829, he noted of the tragedy: "When we see the torrent's path, and the devastation of the avalanche, we regard nature in her more majestic and awful aspect as the enemy of civilization and humanity." This Puritan anxiety in the face of the howling wilderness was tempered, however, by a Romantic exaltation of the beneficent aspect of nature: "But when we reflect again, the broad sheets of untrodden snow that cap the mountains above us, appear like emblems of nature's purity." In a final spasm he confessed that "the feelings of sublimity become painful, after

they have been long excited by the view of vast magnitudes. . . ."

A small, unsigned lithograph (ill. 74) accompanies these reflections on the Willey slide, though Dwight is careful to indicate that it was made solely "for private gratification." The illustration is doubtless a reproduction of one of Daniel Wadsworth's on-site sketches of 1826, though it bears little resemblance formally to the illustrations for Dwight's earlier *Northern Traveller*. (ill. 71)

This novel view of the slide is of special interest since, for the first time, the spectator is afforded admission to the scene by virtue of a small figure at the lower right. Staff in hand, this solitary climber contemplates the spectacle of devastation from the height of a rocky pulpit. Through this device we are made to share the vantage of the artist-preacher from the summit of a mountain peak rather than from the floor of the notch, as in the previous views.

This new panoramic landscape formula, with its aerial perspective, appears here perhaps for the first time in American art.[7] Though derived from European landscape traditions going back to the late eighteenth century, it was only adopted by Cole about 1836 and later by many Hudson River School artists.

As a device for establishing scale and psychological entry into the space of the image, the solitary foreground figure is more than conventional *staffage* of the Picturesque. Rather it functions as a surrogate for the artist and spectator in the elemental encounter with nature, either as rhapsodizing or ruminating witness.

The panoramic perspective further suggests that the view was obtained after climbing the mountain. This being the case, Wadsworth's image and Dwight's prose bear witness to one of the first mountain ascents in America for artistic rather than pragmatic purposes and antedate the more celebrated climbs of Chocorua in New Hampshire by Cole and Emerson, those quintessential American Petrarchs. According to Dwight, the illustration "affords a correct

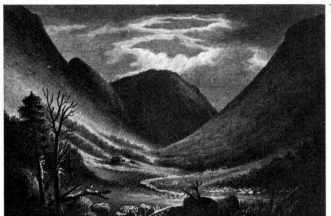

73

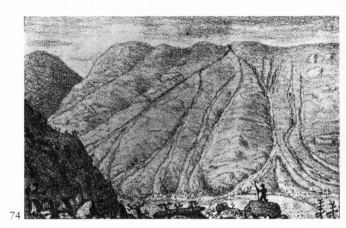

74

idea of the singular appearance of the avalanches and was made by a gentleman distinguished for his taste and accuracy who visited the spot a few months after the catastrophe. The observer stands among the avalanches which fall behind the Notch House."

For a modern reader the idea of "taste" and "accuracy" as collaterals, or in some sense synonyms, appears strained. For the Romantic age, however, Dwight's comments are testimony to an alliance between art and science whereby the sentimental and practical instincts of the age were brought into accord. This perceived consonance of the real and the ideal—which for Thoreau permitted fact to flower into truth—caused emotions to be projected into nature, as Barbara Novak has recently remarked, "under the guise of observation."[8] Thus mountains, like sky and water, could be made to embody moral visions as well as scientific truths.

The Romantic penchant for transforming experience into manageable formulas is encountered at all levels of culture. John Farmer's *A Catechism of the History of New-Hampshire* (Concord, 1829)—in itself a provocative title—elevates the Willey tragedy to the realm of near hagiography. A text for the instruction and edification of school children, it reduces the events to a few memorable, or memorizable, phrases:

"**Q**: What remarkable event happened on the 28th of August, 1826?

"**A**: A remarkable *slide* of earth, trees and rocks from the White Mountains, which buried beneath the mass, the whole family of Mr. Samuel Willey."

Illustrated by a delightfully lurid woodcut (ill. 77), Farmer's *Catechism* served to entrench these events in the popular imagination and to foster youthful anxiety of the terrible visage of nature.

From the foregoing, it appears certain that not only the wider public, but artists as well, largely formed their perceptions of the White Mountains from these various strata of popular thought and imagery. Illustrated travel, literary, and school books all served to formulate a conception of the place and to prescribe those aspects of White Mountain nature deemed worthy of reflection and representation (i.e., those invested with dignity by virtue of association with man). Further evidence of this cultural phenomenon lies in a comparison of an anonymous woodcut (doubtless based on another drawing by Wadsworth) illustrating yet another of Theodore Dwight's copious writings, *Things as They Are; Notes of a Traveller* (New York, 1834), and Thomas Cole's magistral view of Crawford Notch of 1839 (ill. 78 and 51). In both instances, small mounted figures are arrested before the northern entrance of the notch, with steep cliffs forming a proscenium to enframe the exalted spectacle of nature. Though formally unrelated, the two works respond to a common landscape iconography engendered by popular art and letters.

The reverse of this relationship—the penetration of popular imagery by views generated in the studios of academic artists—can be seen by comparing a woodcut illustrating still another history of the Willey tragedy in Peter Parley's *Book of Curiosities, Natural and Artificial* (Boston, 1832) with Thomas Cole's early painting *A Storm Near Mount Washington* (ill. 75 and 76), done for Daniel Wadsworth in 1828. Presumably less for purposes of expediency than to exploit the greater authority of the high art image, the Cole-derived print is employed to illustrate the account. Bearing no direct relationship to Parley's narrative, this illustration departs significantly from earlier practices. Indeed, the cleavage between the text and image encountered here—Cole's view of the western slopes of the Presidential Range bears no connection, geographic or didactic, to the history of the Willey tragedy—points to a process of dis-

73. *View of the White Mountains After the Late Slide,* Vistus Balch, engraver, after a lost painting by Henry Cheever Pratt, illustration for *The Token,* 1828*

74. *Avalanches in the White Mountains,* lithograph after a sketch by Daniel Wadsworth, illustration for Theodore Dwight, *Sketches of Scenery and Manners in the United States,* 1829*

75. *The White Mountains,* anonymous woodcut illustration for Peter Parley's *Book of Curiosities, Natural and Artificial,* 1832*

76. Thomas Cole, *Storm Near Mount Washington,* 1828. Collection of Yale University Art Gallery*

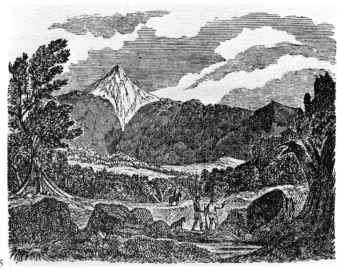

75

63

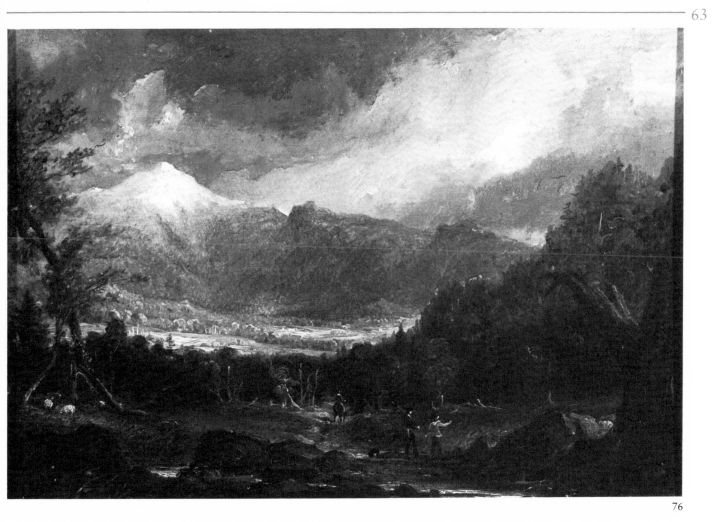

76

77

association among the sister arts that became exacerbated as the century proceeded.

The issue central to all of these concerns is the Romantic preference for dealing with nature in terms of a restricted set of predetermined images. Since they could be detached from any underlying reality, they were therefore susceptible to replication in numerous contexts. As a mechanism for recycling the landscape through the popular imagination, illustrated books and maps provided the dominant models. For the White Mountains, the early locus lay, for reasons of association, in the Crawford Notch and the Presidentials. In this nineteenth century process of transforming actuality into ideality and experience into artifice, the White Mountains became, as Albert Gelpi has recently observed, the first great American wilderness to "be exploited culturally for the benefit of city dwellers."[9]

The role of Dwight, Wadsworth, and Cole in defining this early vision of the wilderness for America raises yet another important question. That the idea of American nature was articulated by New Englanders predominantly in terms of the New England landscape is not surprising. More surprising is the extent to which this monolithically defined image of national landscape value was accepted by Americans and Europeans alike. To a considerable degree, such questions have as much to do with the nature of art as with the art of nature.

The earliest European images of American scenery, for example, in which the White Mountains figure prominently, depended upon Thomas Cole's paintings rather than any fresh apprehension of the region. John Howard Hinton's lavishly illustrated *History and Topography of the United States of America,* published in London in 1831, employs engravings after three of Cole's celebrated White Mountain views, including the *Storm near Mount Washington.* The book also established new standards of publication, as it was bound in quarto with the copper plate engraving independent of the text. In discussing the topography of New Hampshire, Hinton expresses the conventional notions that "the physiognomy" of the state is "bold, prominent and often sublime." The location of the domain of Sublimity, in the American Northeast, and not, for example, in the southern Appalachians, is consistent with the native perception of landscape virtue.

The most popular example of this transatlantic genre of deluxe travel literature is Nathaniel P. Willis's *American Scenery* (London, 1838–39), decorated with engravings after drawings made by the British illustrator William H. Bartlett on his visit to America in 1836. From a total of 119 prints, 11 views are of New Hampshire and the White Mountains, demonstrating the extent to which the region enjoyed popular acclaim and had become a part of the established itinerary. A characteristic example of Bartlett's heightened panoramic style is *Mount Jefferson (from Mount Washington)* (ill. 80) showing numerous small climbers in various modes of rapport with the rocky summits of the Presidentials. In what amounts to a kind of landscape liturgy, these figures strike various reverential poses before the spectacle of snow-clad peaks and fertile valleys. At the extreme right, a communicant stands upon a rocky pulpit, while other figures enact prescribed rituals of landscape devotion. Willis's verbal glosses amplify the sentiments expressed pictorially: "It strikes the European traveller . . . that the New World of Columbus is also a new world from the hand of the Creator." This view of the American as a New World Adam in the Edenic Paradise enjoyed considerable vogue on both sides of the Atlantic in the decades preceding the Civil War. Though Cole considered Bartlett a mere "manufacturer of views," both artists shared a common Romantic sensibility toward nature and a landscape iconography in which mountains, sky, and valleys function typologically to express divine attributes.

The publication of *American Scenery* in 1838–39 spawned a number of deluxe American publications seek-

Notch of the White Hills, from the North.—See p. 158.

—See p. 158.

77. *The Willey Slide,* anonymous woodcut illustration for John Farmer, *A Catechism of the History of New Hampshire,* 1829*

78. *Notch of the White Hills From the North,* woodcut after a drawing attributed to Daniel Wadsworth, illustration for Theodore Dwight, *Things as They Are; Notes of a Traveller,* 1834*

ing to rival these European works. For the most part, these early publications were less refined in their production and often assumed unusual, even bizarre, formats. The first indigenous attempt to deal with the representation of the White Mountains on an enlarged physical and aesthetic scale was a curious publication unpromisingly titled *Final Report on the Geology and Mineralogy of the State of New Hampshire.* Published in Concord in 1844 in quarto and written by Charles H. Jackson, it contains half a dozen lithographic views of prominent sites in the White Mountains by J. D. Whitney copied by the firm of C. Cook of Boston. For the most part, these sophisticated book illustrations rival the standards established by the London publishers. As might be expected, they depend upon traditional Sublime landscape formulas for the representation of Crawford Notch and the Presidentials. Whitney, however, enlarges the canon of White Mountain iconography to include Franconia Notch (ill. 79) and its *genus loci,* the Old Man of the Mountain. This extraordinary rock formation, which Daniel Webster referred to as a sign hung out by the Diety in New Hampshire, had only been discovered in 1805, though by the 1840s it was becoming a clear rival to Mount Washington and Crawford Notch as New Hampshire's foremost landscape symbol.

In the context of Jackson's publication, with its arid, scientific prose, Whitney's sensitive landscape interpretations stand tensely opposed and are, seemingly, gratuitous additions. Randomly distributed throughout the text and bearing no direct relationship to it, Whitney's illustrations do not form a coherent pictorial accompaniment. On the contrary, the image of the Old Man of the Mountain, with its writhing anthropomorphized foreground trees and axially aligned profile, deliberately invokes traditional religious imagery to create a numinous landscape. Whitney creates a kind of secularized Last Judgment, with the trees in the middle distance cleanly divided into groups of the damned and the elect.[10] The wrenching disjunction between text and image encountered here—for Jackson's geological description could scarcely have elicited Whitney's pictorial response—is more of a problem for modern observers than for the readers of the Romantic age, who more readily accommodated rough alliances between art and science.

The masterpiece of American nineteenth century scenic cum scientific literature is William Oakes's *Scenery of the White Mountains* (Boston, 1848) with illustrations by Isaac Sprague. Reproduced in folio with sixteen lithographic plates by the Boston firm of John H. Bufford—the most famous lithographer of the age—Oakes's *Scenery* is an extraordinary monument to the midcentury reverence for nature. Oakes, a renowned botanist who first described the alpine and arctic flora found on the higher slopes of Mount Washington and for whom one of its major gulfs is named, was among the most influential figures of the time in directing popular attention toward the White Mountains. Imbued with an impulse to glorify and quantify nature simultaneously, Oakes perceived the mountains both as objects for scientific investigation and as monuments for religious veneration.

Like his contemporaries Thoreau and Emerson, Oakes was deeply influenced by European nature philosophy, and his writing oscillates fluently between factual description and mystical exaltation. Oakes, who is best described as a scientist-pantheist, articulated the belief for his generation that mountains "are no less monuments of the goodness and wisdom, than of the power and glory of God, their great Creator."

Sprague's drawings, brilliantly realized in Bufford's lithography, afford a magnificent visual accompaniment to the text, happily resolving the respective claims of word and image. Stylistically related to the Romantic-Realism of midcentury painting, they are at once close topographic descriptions and reverential icons of nature. His view of the southern peaks from the Ammonoosuc (ill. 81) forms

79. *The Old Man of the Mountain,* illustration by J. D. Whitney, for Charles T. Jackson, *Final Report on the Geology and Mineralogy of the State of New Hampshire,* 1844. Lent by Special Collections, Dimond Library, University of New Hampshire

80. *View from Mount Washington,* illustration after William Bartlett, for Nathaniel P. Willis, *American Scenery,* 1838–1839. Collection of Dartmouth College Library

81. *White Mountains from the Giant's Gate near the Mount Washington House,* illustration by Isaac Sprague, for William Oakes, *Scenery of the White Mountains,* 1848. Lent by Douglas Philbrook

a useful comparison with earlier efforts to visualize the site (cf. ill. 70 and 72). As set against Kidder's cartographic image, Sprague's drawing is clearly based upon accurate observation of the place while, contrary to Cole's rhetorical scheme, it is strikingly spare and laconic. Eschewing such Picturesque elements as enframing trees, dramatic lighting, storm-tossed clouds, and human *staffage,* Sprague's image appears curiously devoid of literary or associational content. In what would appear to be a striking anticipation of the mood and formal mechanisms of later Luminist compositions in painting, Sprague adopts an emphatic horizontal format that presents nature objectified in a moment of tranquil stillness.[11] The classic, planar balance of the design, which virtually effaces the presence of the artist, further dispenses with the normative histrionics of Romantic landscape art. This remarkable prefiguration of many aspects of the formal and ideational canon of a major American art movement, Luminism, bears further testimony to a lively and unsuspected relationship between popular and academic levels of imagery in the nineteenth century.

Some time in the early 1850s, the New Hampshire–born artist Benjamin Champney, returning from study in Europe, established his summer residence in the valley of the Intervale at North Conway. This event signified a shift in the locus of cultural interest from the western side of Mount Washington to its eastern slopes. Attracting many of the major figures of the second generation of so-called Hudson River School painters to his studio (Kensett, Casilear, Durand, Cropsey, etc.), Champney founded the first artistic colony on American soil. Champney's memoirs, published at the end of the century, suggest something of his attitude upon settling at North Conway: "We [he and Kensett] had seen grander, higher mountains in Switzerland, but not often as much beauty and artistic picturesqueries brought together in one valley."[12] The rhetorical shift from Sublimity to beauty expressed in this passage

further denotes a major realignment in values that began to take place at midcentury.

On another occasion Champney compared North Conway to the Barbizon, recording that "dozens of umbrellas were dotted about under which sat artists from all sections of the country." The notion of Champney's colony as an American Barbizon, one that has since gained wide currency, is belied by their own aesthetics which had little, if anything, to do with the art of Millet and Rousseau.

Despite his aspirations to high art, Champney was not averse to working for popular commercial enterprises, as evidenced by a number of drawings made to serve as lithographic inserts for G. P. Bond's 1853 map of the White Mountains (ill. 157). Characteristic of his lyric and pastoral realism, these classically composed works lack the spiritual resonance of earlier, Romantic responses to the White Mountains. Rather, they afford an arcadian image of place, idyllic and sustaining of human life; a benevolent and defanged nature. Champney's writings, which complement his art, seldom rise above a temperate level of mysticism. His verbal descriptions, for example, compare favorably with his visualizations of the Intervale: "The meadows were enticingly beautiful as they led off by the lower bluffs and hills to the grandeur of the Washington group. The sun and changing clouds had so managed the artistic effect that day that the whole scene seemed something more than terrestial."

The midcentury détente of Champney's art and letters, however, remained only one of the possible modes of representing nature. Heightened forms of Romanticism continued to assert themselves well into the second half of the century in the works of such academic figures as Church and Bierstadt and, with equal intensity, in the popular arts. Typical of this late-flowering Romanticism is an anonymous view lithographed by Bufford, representing a somewhat fanciful picture of the White Mountains used to decorate a treatise on flax making, engagingly entitled

82. *View of the First Power Flax Spinning Mill in America,* John H. Bufford, lithographer, illustration for Stephen M. Allen, *Fibrilia; A Practical and Economical Substitute for Cotton,* 1861*

83. *White Mountain Echoes,* cover for sheet music, lithograph by Crow, Thomas and Co., New York, 1861*

84. *Mount Washington,* anonymous lithograph, ca. 1875*

Fibrilia (ill. 82). Published in Boston in 1861, the book advocated substituting flax for cotton and was illustrated by an imaginative view of the first power flax spinning mill in America, located near Conway.[13] Writing foreground trees, dramatic light and shadow, and impossibly extruded alpine peaks rising above a vaporous layer of clouds, form a *retardataire* image that conjures up visions of the earliest representation of the White Mountains (cf. ill. 70).

Another indication of the evolving complexity of popular and artistic perceptions of the White Mountains can be found in comparing Champney's bucolic vision of the Presidentials, in which nature is reduced to an object of refined aesthetic contemplation, with a written description from an early railroad guide to the White Mountains. Both landscapes, verbal and pictorial, are dated 1853. According to the prose account, Mount Washington affords a dismal spectacle, eternally shrouded in "an ocean of cloud," which "billows, misty and sombre, reels away to the far horizon, on every side, an ocean which has, as it were, by the 'stroke of an enchanter's wand,' become suddenly and forever congealed, and that at a moment when whirlwind and tempest were heaving it into gigantic surges. We can conceive of no better comparison than the waste, the melancholy, tempest ridden main, frozen in the midst of its strength. Sunshine and shadow chase each other over the silent waste, light and darkness fleck its surface; but the prevailing feature is one of shadow and gloom."[14] The style of this passage, and of the guidebook, possesses more the tone of Cole's paintings than Champney's arcadian realism.

Despite these diverse perceptions, or perhaps because of them, tourists soon followed in the wake of the artists. Railroads penetrated the region between 1853 (Littleton, N.H.) and 1872 (North Conway), and by 1876 a tourist could ride from Boston to the top of Mount Washington (the cog railroad was completed in 1869, the link from Fabyan's Hotel to the base in 1876) without having to set foot on the ground.

Tourism has been described as the application to life of lessons learned from art. As a mechanism for concentrating and distilling experience, landscape art was especially serviceable. An illustrated cover to some sheet music published in 1861 provides useful insight into this process (ill. 83). In this curious design, the expectations of the White Mountain tourist (the term employed in its more resonant nineteenth century meaning) have been codified into a sequence of nine worthwhile experiences ranging from the Mount Washington bridle path at the upper right to the Flume at the lower left. Each of these sites had been canonized initially by art, whence they entered the prescribed ritual of a summer visit to the mountains.

The clear precedence of academic landscape painting over images of popular landscape sites is also linked to the American tendency to manipulate the experience of nature in the interest of commercial expediency. In this connection, images of nature become susceptible not only to codification but also to a form of disembodiment. An example of this practice can be seen in an anonymous color lithograph (a forerunner of the souvenir postcard) from the mid 1870s that was doubtless intended for the tourist trade. Clearly labeled *Mount Washington,* it is derived, however, from an engraving of Mount Hood in Oregon that was used to illustrate the 1872 edition of William Cullen Bryant's well-known travel book *Picturesque America* (cf. ill. 84 and 86).

Bryant's extended eulogy of American nature is one of the most lavish publications of the nineteenth century. An attempt to reunite the war-torn nation through a common reverence for nature, *Picturesque America* imposed a carefully edited vision of the American landscape upon the post–Civil War generation. In the opulent illustrations of Harry Fenn and others, the mountain scenery of New England, New York, and the southern Appalachians (ill.

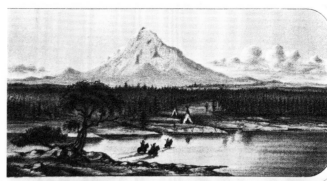

MOUNT WASHINGTON.

44 and 151) takes on a heightened appearance in response to a powerful postbellum recrudescence of the Romantic imagination of nature. The basis of this restored vision, however, is not the art of Thomas Cole and Hudson River School painting. Rather, it appears strikingly analogous to the works of such pioneer Western photographers as Timothy O'Sullivan and William Henry Jackson. It was especially the latter's dramatic photographs of the Rockies and Yosemite, which first appeared in the East in the early 1870s, that provided the model for steep precipices, narrow paths, and soaring mountains in Fenn's engravings.

The contrast between Fenn's pictorial theatrics and the work of major artists after the Civil War can be appreciated in a comparison of two nearly contemporary views of the Mount Washington bridle path (ill. 151 and 85). The flatulence of Fenn's image of a hazardous descent stands in opposition to an illustration of the summit of Mount Washington made for the July, 1869, issue of *Harper's Weekly* by Winslow Homer (ill. 85). This wood engraving, copied from one of Homer's drawings of fashionable White Mountain tourists during the summers of 1868 and 1869, accents the mundane realism of the event rather than the experiences of angst-ridden Sublimity. Stressing facts rather than acts, Homer invests the scene with the sober dignity and classic constraint of his early style. Some historians have suggested that the quiet gravity of Homer's art reflects the philosophical morbidity and the general internalization of American experience in the decades following the Civil War. Whatever the case, it is certain that the once-potent image of the White Mountains is no longer capable of bearing its older meaning in the art of Homer. Together with the landscapes of such painters as Inness and Martin, Homer's art reflects, at the highest level of culture, the inability of American nature to bear its former freight of meaning.

Further reactions to Fenn's embroidered vision of nature can also be found in the earliest White Mountain guidebooks that employ photographs rather than graphics for illustration. In this connection, Moses Sweetser observed: "The present volume has, at least, the merit of accuracy, since its views were taken by photography . . . so that no false idealization or vulgar hyperbole can intervene to belie the aspect of the scenery, and prepare the traveller for grave disappointments." That fruitful alliance of "taste" and "accuracy"—the Romantic synthesis spoken of by Theodore Dwight—is challenged by this sober realism.

For the most part, the photographs in the many editions of Sweetser's guide shift the *representata* from nature to tourists and their logistics. Images of hotels, trains, and trestles replace the older emblems of White Mountain scenery, as the works of man begin to supplant the works of God in the American imagination. The stunning photography of the Frankenstein Trestle (ill. 91), one of several representations of a new technological Sublime,[15] brings us, in a sense, full circle. Traversing the area of slides that first gave resonance to the White Mountains, the subject of the photograph forms an instructive comparison with Thomas Cole's early visualization of the notch (ill. 51 and 72). In both instances, the sweep of powerful diagonals involves the spectator in a spectacle of forceful process. A low vantage suborns man to imponderable sources of energy. Violent contrasts of light and shadow stimulate the imagination.

In the unyielding contest between nature and culture, which first focused attention upon the notch, the issue was resolved in favor of the latter. The dream of American nature, which was sustained for the better part of a century, was forfeited to prosperity and expediency. In creating new modes for apprehending the White Mountains, the idea once again fathered the reality.

85. *The Summit of Mount Washington,* wood engraving after a drawing by Winslow Homer, illustration for *Harper's Weekly,* July 10, 1869*

86. *Mount Hood from Columbia River,* illustration after R. Swain Gifford, for William Cullen Bryant, ed., *Picturesque America,* 1872*

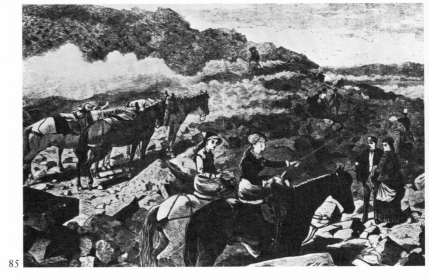

85

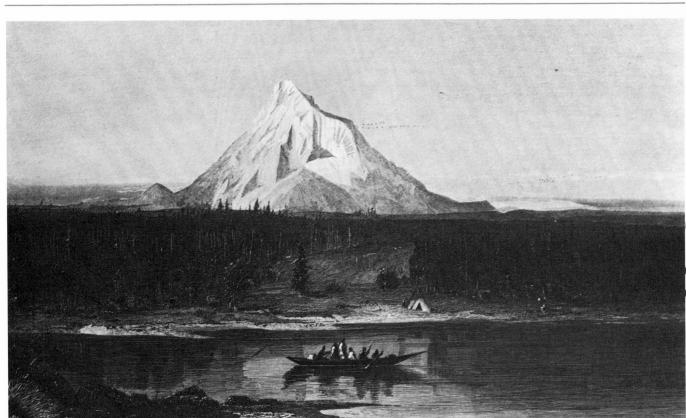

86

A SOCIAL HISTORY
OF THE
WHITE MOUNTAINS

1. Richard Hakluyt, *The Principal Navigations Voyages Traffiques & Voyages of the English Nation,* vol. 8 (New York: Macmillan Co., 1904), p. 438; Samuel Eliot Morison, *The European Discovery of America: The Northern Voyages, A.D. 500–1600* (New York: Oxford, 1971), pp. 308, 464–470; Frederick W. Kilbourne, *Chronicles of the White Mountains* (Boston: Houghton Mifflin, 1916), pp. 18–19.

2. James Kendall Hosmer, ed., *Winthrop's Journal, "History of New England," 1630–1649,* vol. 2 (New York: Charles Scribner's Sons, 1908), pp. 62–63, 85–86; Everett S. Stackpole, Lucien Thompson, and Winthrop S. Meserve, *History of the Town of Durham, New Hampshire* (1913; reprint ed., Somersworth: New Hampshire Publishing Company, 1973), p. 4; Charles H. Bell, *History of the Town of Exeter, New Hampshire* (Exeter, 1888), p. 25; Frederick Clifton Pierce, *Field Genealogy* (Chicago: Hammond Press, 1901), pp. 949–950; George Hill Evans, *Pigwacket* (Conway, N.H.: Conway Historical Society, 1939), pp. 5–17; John Josselyn, *New-Englands Rarities Discovered* (London, 1672), reprinted in *Transactions and Collections of the American Antiquarian Society,* IV (Worcester, Mass.: American Antiquarian Society, 1860), p. 140n; Frederick Tuckerman, "Early Visits to the White Mountains and Ascents of the Great Range," *Appalachia* 15, no. 2 (August 1921), pp. 111–127.

3. Tuckerman, "Early Visits," pp. 116–118; Charles E. Faye, "The March of Captain Samuel Willard," *Appalachia* 2, no. 4 (December 1881), pp. 336–344; Jeremy Belknap, *The History of New-Hampshire,* 2 vols. (New York and London: Johnson Reprint, 1970, originally 1784, 1791, and 1792 as 3 volumes), pp. 35–36.

4. Hugh D. McLellan, *History of Gorham, Me.* (Portland, Me.: Smith & Sale, 1903), pp. 50–57; James O. Lyford, *History of Concord, New Hampshire,* 2 vols. (Concord: Rumford Press, 1896), pp. 173–180; Belknap, *History of New-Hampshire,* 1, pp. 285, 306; Tuckerman, "Early Visits," pp. 120–121.

5. Belknap, *History of New-Hampshire,* 1, pp. 305–306.

6. Matthew Patten, *The Diary of Matthew Patten of Bedford, N.H.* (Bedford: by the town, 1903), p. 160.

7. Roy Hidemichi Akagi, *The Town Proprietors of the New England Colonies* (Gloucester, Mass.: Peter Smith, 1963, originally in 1924), pp. 46–47; John W. Reps, *Town Planning in Frontier America* (Princeton: Princeton University Press, 1965), pp. 145–183.

8. Charles E. Clark, *The Eastern Frontier: The Settlement of Northern New England, 1610–1763* (New York: Alfred A. Knopf, 1970), p. 173.

9. Clark, *Eastern Frontier,* pp. 171–172; Akagi, pp. 184–188.

10. Kilbourne, *Chronicles,* pp. 39–40, 48–49, 52–57; Georgia Drew Merrill, ed., *History of Carroll County, New Hampshire* (Boston: W. A. Fergusson, 1889), pp. 815–822; George C. Evans, *History of the Town of Jefferson, New Hampshire, 1773–1927* (Manchester, N.H.: Granite State Press, 1927), pp. 21–27.

11. Harold Fisher Wilson, *The Hill Country of Northern New England: Its Social and Economic History, 1790–1930* (New York: Columbia University Press, 1936), p. 23.

12. Benjamin G. Willey, *History of the White Mountains* (New York: Hurd & Houghton, 1870), pp. 73–146; Kilbourne, *Chronicles,* pp. 70–100; F. Allen Burt, *The Story of Mount Washington* (Hanover, N.H.: Dartmouth Publications, 1960), pp. 15–51.

13. The Rev. A. N. Somers, *History of Lancaster, New Hampshire* (Concord, N.H.: Rumford Press, 1899), p. 366; Willey, *History of the White Mountains,* pp. 58–59; Howard S. Russell, *A Long, Deep Furrow: Three Centuries of Farming in New England* (Hanover, N.H.: University Press of New England, 1976), p. 371; Wilson, *Hill Country,* p. 84, 210; Norman W. Smith, "A Mature Frontier—The New Hampshire Economy, 1790–1850," *Historical New Hampshire* 24, no. 3 (Fall 1969), pp. 3–19, especially, 5.

14. Smith, "Mature Frontier," pp. 6–10.

15. Thomas C. Hubka, "The Connected Farm Buildings of Northern New England," *Historical New Hampshire* 32, no. 3 (Fall 1977), pp. 87–115.

16. J. Willcox Brown, "Forest History of Mount Moosilauke," *Appalachia,* Part I (June 1958), p. 28.

17. Wilson, *Hill Country,* p. 104.

18. James Walter Goldthwait, "A Town That Has Gone Downhill," *The Geographical Review* 17, no. 4 (October 1927), pp. 527–552.

19. Kilbourne, *Chronicles,* pp. 27–32; Jeremy Belknap, *Journal of a Tour to the White Mountains in July, 1784* (Boston: Massachusetts Historical Soci-

87

ety, 1876), passim.

20. Kilbourne, *Chronicles,* pp. 33, 35; George Shattuck, "Some Accounts of an Excursion to the White Hills of New Hampshire in the Year 1807," *Philadelphia Medical and Physical Journal* 3, pt. 1 (1808), pp. 26–35.

21. Jacob Bigelow, "Some Account of the White Mountains of New Hampshire," *New England Journal of Medicine and Surgery* 5 (October 1816), pp. 321–338; Kilbourne, *Chronicles,* pp. 35–37; Burt, *Mount Washington,* pp. 185–186.

22. Stearns Morse, ed., *Lucy Crawford's History of the White Mountains* (Hanover, N.H.: Dartmouth Publications, 1966), pp. 73–74; William Oakes, *Scenery of the White Mountains* (Boston, 1848); Kilbourne, *Chronicles,* pp. 37–38; Burt, *Mount Washington,* p. 187.

23. George H. Daniels, *American Science in the Age of Jackson* (New York and London: Columbia University Press, 1968), pp. 6–33.

24. Kilbourne, *Chronicles,* pp. 108–110, 120–122; Burt, *Mount Washington,* pp. 187–188.

25. Charles T. Jackson, *Final Report on the Geology and Mineralogy of the State of New Hampshire* (Concord, 1841);

Kilbourne, *Chronicles,* pp. 204–208; Daniels, *American Science,* p. 214.

26. Kilbourne, *Chronicles,* pp. 146–148, 215–217; Allen H. Bent, *A Bibliography of the White Mountains* (Boston: Appalachian Mountain Club, 1911), p. 54.

27. Kilbourne, *Chronicles,* pp. 208–210.

28. Kilbourne, *Chronicles,* pp. 310–314; C. H. Hitchcock, *Second Annual Report Upon the Geology and Mineralogy of the State of New Hampshire* (Manchester, 1870).

29. Kilbourne, *Chronicles,* pp. 314–321; Burt, *Mount Washington,* pp. 197–202.

30. Kilbourne, *Chronicles,* pp. 321–322; Burt, *Mount Washington,* p. 202.

31. Kilbourne, *Chronicles,* pp. 212–213; C. H. Hitchcock, *Second Annual Report; Report (3rd) of the Geological Survey of the State of New Hampshire* (Nashua, 1871); *Report (4th) of the Geological Survey of the State of New Hampshire* (Nashua, 1872).

32. C. H. Hitchcock, with J. H. Huntington, *The Geology of New Hampshire,* 3 vols., (Concord, 1874–1878); H. F. Walling and Charles H. Hitchcock, *Atlas of the State of New*

Hampshire (New York: Comstock & Cline, 1877); Bent, *Bibliography,* p. 86.

33. Bent, *Bibliography,* pp. 16–25, 35–41; Jeffrey S. Wallner, "Butterflies and Trout: Annie Trumbull Slosson and W. C. Prime in Franconia," *Historical New Hampshire* 32, no. 3 (Fall 1977), pp. 129–143; Kilbourne, *Chronicles,* pp. 217–218.

34. Wallner, "Butterflies," passim; Peter J. Schmitt, *Back to Nature: The Arcadian Myth in Urban America* (New York: Oxford University Press, 1969), passim.

35. Timothy Dwight, *Travels in New England and New York,* 4 vols, ed. Barbara Miller Solomon (Cambridge: Harvard University Press, 1969), 2, pp. 81–112; Peter B. Bulkley, "A History of the White Mountain Tourist Industry, 1818–1899" (M.A. thesis, University of New Hampshire, 1958), pp. 2–17.

36. Morse, *Lucy Crawford,* passim.

37. Morse, *Lucy Crawford,* pp. 123–125; Mary Jane Thomas, "Reminiscences of the White Mountains," ed. Harriet S. Lacy, *Historical New Hampshire* 28, no. 1 (Spring 1973), pp. 37–52, especially 46.

38. Burt, *Mount Washington,* p. 188; Frederick Tuckerman, "Gleanings from the Visitors'

Albums of Ethan Allen Crawford," *Appalachia* 14, no. 4 (June 1919), pp. 367–383, especially 378.

39. Carroll Town Records, New Hampshire Historical Society.

40. Kilbourne, *Chronicles,* p. 27.

41. Peter B. Bulkley, "Horace Fabyan, Founder of the White Mountain Grand Hotel," *Historical New Hampshire* 30, no. 2 (Summer 1975), pp. 53–77, especially 56.

42. Bulkley, "History," p. 15; *The White Mountain and Winnepissiogee Lake Guide Book* (Boston: Jordan and Wiley, 1846), pp. 28–36; John Hayward, *The New England Gazetteer* (Boston and Concord, N.H., 1839).

43. Bulkley, "Horace Fabyan," pp. 54–60; *White Mountain and Winnepissiogee Guide,* pp. 68–69.

44. Bulkley, "Horace Fabyan," pp. 63–64.

45. Bulkley, "History," pp. 19–20.

46. Boston & Lowell Railroad, *Mountain, Lake and Valley by the B. and L.* (Boston: Boston & Lowell Railroad, 1887), pp. 199 and 204.

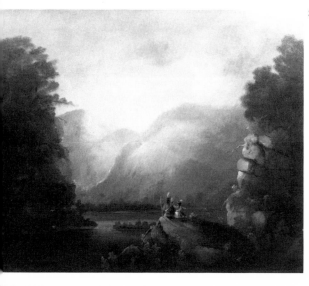

87. Alvan Fisher, *Indians Crossing a Frozen Lake*, 1845. Lent anonymously

88. John Rowson Smith, *White Mountain Sunrise with Indians*, 1841. Lent anonymously

7. Bulkley, "History," pp. 30–31.

8. Burt, *Mount Washington*, pp. 66, 73–82.

9. Bulkley, "History," pp. 31–32; Kilbourne, *Chronicles*, pp. 338–340.

0. Bulkley, "History," p. 70.

1. Glen M. Kidder, *Railway to the Moon* (Littleton, N.H., Courier Printing, 1969), passim.

2. Burt, *Mount Washington*, p. 83, 87–90; Bulkley, "History," p. 70.

3. Burt, *Mount Washington*, p. 151.

4. Schmitt, *Back to Nature*, p. xv–xxiii, 167–176, and passim.

5. See the *White Mountain Directory*, vol. 7, 1932–1934 (Beverly, Mass. and Portland, Me.: Crowley & Lunt, 1932), p. 725, 727, 755–757.

6. Kilbourne, *Chronicles*, p. 408.

7. Ralph D. Paine, "Discovering America by Motor," *Scribners Magazine* 53, no. 2 (February 1913), p. 146.

8. C. Francis Belcher, "The Logging Railroads of the White Mountains," *Appalachia* 1–9 (December 1959–December

1965), 1, pp. 516–517.

59. William Robinson Brown, *Our Forest Heritage: A History of Forestry and Recreation in New Hampshire* (Concord: New Hampshire Historical Society, 1958), p. 28; Wilson, *Hill Country*, pp. 46–48.

60. Brown, "Forest Heritage," p. 30.

61. Helenette Silver, *New Hampshire Game and Furbearers: A History* (Concord: New Hampshire Fish and Game Department), p. 64; Kilbourne, *Chronicles*, pp. 220–228; *Report of the New Hampshire Forestry Commission for the Years 1901–1902* (Concord: Ira C. Evans, 1901–1902), p. 68.

62. Edwin Sutermeister, *The Story of Papermaking* (Boston: S. D. Warren, 1954), pp. 59–70; Walling and Hitchcock, *Atlas*, p. 46; David C. Smith, *A History of Lumbering in Maine, 1861–1960* (Orono: University of Maine Press, 1972), pp. 233–246.

63. Belcher, "Logging Railroads," 3, 4, 5; Brown, "Forest Heritage," pp. 221–224; Anthony Nicholas Bahros, "History of the White Mountain National Forest" (M.A. thesis, University of New Hampshire, 1959), pp. 11–17.

64. Belcher, "Logging Railroads," 1, passim.

65. Belcher, "Logging Railroads," 1–9, passim.

66. Belcher, "Logging Railroads," 5, p. 517.

67. Robert E. Pike, *Tall Trees, Tough Men* (New York: W. W. Norton, 1967), passim.

68. Brown, "Forest Heritage," p. 196.

69. Brown, "Forest Heritage," pp. 189–198; Belcher, "Logging Railroads," 5, pp. 511–515, and 4, pp. 365–366; Pike, *Tall Trees*, pp. 90–94.

70. Belcher, "Logging Railroads," 5, p. 512; Brown, "Forest Heritage," pp. 191–193.

71. Belcher, "Logging Railroads," 4, p. 363.

72. His essay "The Significance of the Frontier in American History" was read before the annual meeting of the American Historical Association in 1893.

73. Schmitt, *Back to Nature*, pp. xvi–xxi.

74. Schmitt, *Back to Nature*, passim.

75. Schmitt, *Back to Nature*, pp. 96–105.

76. "New England College Outing Clubs," *Appalachia* 13, no. 4 (December 1915), pp. 353–359.

77. Charles A. Newhall, "1888—The A.M.C. Hut System—1963: Madison Spring Hut," *Appalachia*, no. 137 (December 1963), pp. 605–613.

78. Brown, *Forest Heritage*, pp. 18, 23, 28; *Report of the Forestry Commission of New Hampshire* (Concord: Parsons B. Cogswell, 1885); Charles D. Smith, "The Mountain Lover Mourns: Origins of the Movement for a White Mountain National Forest, 1880–1903," *The New England Quarterly* 33, no. 1 (March 1960), pp. 37–56.

79. Smith, "Mountain Lover Mourns," p. 41.

80. Bahros, "History," pp. 32–36, 41; Paul E. Bruns, *A New Hampshire Everlasting and Unfallen: An Illustrated History of the Society for the Protection of New Hampshire Forests* (Concord: SPNHF, 1969), p. 9; Smith, "Mountain Lover Mourns," pp. 43–44, 47.

81. *Reasons for a National Reservation in the White Mountains* (Concord: SPNHF, 1903), pp. 5–7.

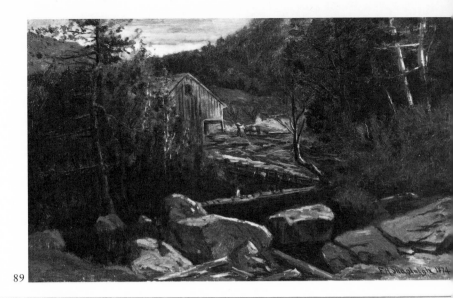

89

PERCEPTIONS OF THE WHITE MOUNTAINS: A GENERAL SURVEY

1. Barbara Novak O'Doherty, "Some American Words: Basic Aesthetic Guidelines, 1825–1870," *American Art Journal* 1, no. 1 (Spring 1969), pp. 78–91.

2. *Transactions of the American Philosophical Society* 2 (1786), pp. 42–49. See also "Review of Belknap's Description of the White Mountains," *The [London] Monthly Review* 76 (February 1787), pp. 138–139.

3. Walter J. Hipple, Jr., *The Beautiful, the Sublime, and the Picturesque in Eighteenth Century British Aesthetic Theory* (Carbondale: Southern Illinois University Press, 1957), pp. 83–98; and Samuel H. Monk, *The Sublime: A Study of Critical Theories in Eighteenth Century England* (New York: Modern Language Association of America, 1935), p. 87.

4. Catherine H. Campbell, "Two's Company: The Diaries of Thomas Cole and Henry Cheever Pratt on Their Walk through Crawford Notch, 1828," *Historical New Hampshire* 33, no. 4 (Winter 1978), pp. 109–133.

5. Wadsworth went so far as to ask the name of every mound and shadow. See D. Wadsworth to T. Cole, December 2, 1827,

Cole Papers, New York State Library, Albany, N.Y. In regard to the painting see Theodore E. Stebbins, Jr., *The Hudson River School: 19th Century American Landscapes in the Wadsworth Atheneum* (Hartford: Wadsworth Atheneum, 1976), p. 18.

6. Louis Legrand Noble, *The Life and Works of Thomas Cole,* ed. Elliot S. Vesell (Cambridge: Harvard University Press, 1964), p. 185. William Gilpin wrote to Cole: "Nature should be copied, as an author should be translated. If, like Horace's translator, you give word for word, your work will necessarily be insipid. But if you catch the meaning of your author, and give it freely, in the idiom of the language into which you translate, your translation may have both the *spirit* and *truth* of the original. *Translate nature* in the same way. Nature has its idiom, as well as language; and so has painting." Stebbins, ibid.

7. Thomas Cole, "Essay on American Scenery," (1835) in *American Art, 1700–1960, Sources and Documents,* ed. John McCoubrey (Englewood Cliffs, Prentice-Hall, Inc., 1966), p. 103.

8. Stebbins, *Hudson River School,* loc. cit.

9. *Catalogue of Paintings at the Artists' Exhibition in Harding's Gallery* (Boston, 1834), #138.

From the same exhibition, #153 is probably the painting now known as *Waiting for the Stage Coach* in the New Britain Museum of Art. In the same year Thomas Doughty, Fisher's friend in Boston, exhibited a *View on the Saco River* (#58) that is unknown today.

10. Fisher's style is principally derived from English landscapes, particularly the watercolors of John Cozens, Frances Towne, and Joseph Turner. See Robert C. Vose, Jr., "Alvan Fisher, 1792–1863, American Pioneer—Landscape and Genre," *Connecticut Historical Society Bulletin* 27, no. 4 (October 1962); and Charlotte B. Johnson, *The Life and Work of Alvan Fisher* (Master's thesis, New York University, 1951).

11. Theodore E. Stebbins, Jr., "Thomas Cole at Crawford Notch," *National Gallery of Art: Report and Studies in the History of Art* 2 (1968), pp. 133–145. Note the change from the Princeton University Art Museum drawing that represents the notch in the summer. For various versions of Crawford Notch see Catherine H. Campbell, "The Gate of the Notch," *Historical New Hampshire* 33, no. 2 (Summer 1978), pp. 91–122.

12. See Nicolas Cikovsky, Jr., "The Ravages of the Axe: The Meaning of the Tree Stump in Nineteenth Century American

Art," *Art Bulletin* 61, no. 4 (December 1979), pp. 613–614. Also see Barbara Novak O'Doherty, "The Double Edged Axe," *Art in America* (January–February 1976), pp. 44–50, especially p. 47.

13. Frederick W. Kilbourne, *Chronicles of the White Mountains* (Boston and New York: Houghton Mifflin Co., 1922), pp. 75–83, 116–117, and 173–174. Hawthorne's 1832 trip to the White Mountains is his only recorded visit, aside from the fact that he died at the Pemigewasset House in Plymouth.

14. Kilbourne, *Chronicles,* pp. 10–13.

15. Leo Marx, *The Machine in the Garden* (New York: Oxford University Press, 1964), pp. 3–33. Marx called this land the middle landscape.

16. Christopher Hussey, *The Picturesque: Studies in a Point of View* (London: Putnam, 1927); and Hipple, *The Beautiful,* pp. 185–190, 210–214, and 254–262.

17. Pp. 2–4 in the manuscript dictated in 1953 by his son S. D. Thompson. Collection of Mrs. Phyllis Greene.

18. Most of these hotels were soon consumed by fire; e.g., the Crawford House in 1859. See Peter B. Bulkley, "A History of the White Mountain Tourist In-

89. Frank Henry Shapleigh, *Sawmill, Jackson, N.H.,* 1874. Collection of Kennedy Galleries, New York

dustry, 1818–1899" (Master's thesis, Dartmouth College, June 1958), pp. 32–53; on the railroads, see pp. 23, 30, and 44–45.

19. Moses Sweetser, *Here and There in New England and Canada; Among the Mountains* (Boston: Boston and Maine Railroad, 1892), p. 20; and Benjamin J. Champney, *Sixty Years' Memories of Art and Artists* (Woburn, Mass.: privately printed, 1900), p. 102. Both comment on the good rooms and food at the very reasonable price of $3.50 per week.

20. T. W. Higginson, "A Day in the Carter Notch," *Putnam's Monthly* 2 (December 1853), p. 573; of the forty, twelve remained throughout the year. Champney says of the artists' colony: "North Conway and the neighborhood of Artists' Brook . . . became almost as famous as Barbizon and the Forest of Fontainbleau" *Sixty Years',* p. 160.

21. Champney, *Sixty Years',* p. 102. Compare Cole's fascination with the Sublime as expressed in his "Essay on American Scenery" cited in note 7.

22. Champney's work reflects some of the most recent trends in academic European art, which he experienced directly while studying in Paris, Italy, and Germany from 1841 to

1849. See *Sixty Years',* pp. 16–101.

23. Wilson Flagg, *The Woods and By-Ways of New England* (Boston: James R. Osgood, 1872), p. 132.

24. Such as *Landscape* of 1825 in the Rhode Island School of Design collection. See Peter Bermingham, *Jasper F. Cropsey 1832–1900* (College Park: University of Maryland, 1968), p. 24.

25. Barbara Novak, *Nature and Culture in American Landscape Painting, 1825–1875* (New York: Oxford University Press, 1980), passim.

26. Lois Marie Fink, *Academy: The Academic Tradition in American Art* (Washington: National Collection of Fine Arts, 1975), pp. 29–49. Also Maybelle Mann, *The American Art-Union* (New York, 1977), pp. 3–6; and Charles E. Baker, "The American Art-Union," *American Academy and American Art-Union,* ed. Mary Bartlett Cowdry (New York: The New-York Historical Society, 1953), pp. 164–171.

27. See also the 1866 Century Association painting and the Yale University Art Gallery and the Corcoran Gallery of Art oil sketches. John K. Howat, *John Frederick Kensett, 1816–1872* (New York: The American Federation of the Arts, 1968), cata-

logue number 38.

28. Charles E. Beckett did illustrations in this guidebook. See Campbell, "The Gate of the Notch," pp. 107, 109.

29. King intertwined his "own inadequate prose [with], passages from Bryant, Emerson, Longfellow, Whittier, Lowell, and Percival" p. viii. Throughout the book one also finds quotes from Ruskin's writings.

30. Kenneth Woodbridge, *Landscape and Antiquity: Aspects of English Culture at Stowhead 1718 to 1838* (Oxford: Clarendon Press, 1970), pp. 4–5: "According to Locke, men if given freedom would seek the good because they were endowed with reason"

31. Benjamin Willey, *Incidents in the White Mountains* (Boston: Nathaniel Noyes, 1856), pp. 301–304.

32. These also took on qualities not unlike eighteenth century English gardens with their orchestrated Picturesque modes and carefully placed sculpture and architecture, which carried such profound moralistic and political implications while appearing to be indigenous to the place. See Woodbridge, *Landscape and Antiquity,* passim.

33. Elizabeth Lindquist-Cock, "Stereoscopic Photography and

the Western Paintings of Albert Bierstadt," *The Art Quarterly* 33, no. 4 (1970), p. 364. See also Lindquist-Cock's dissertation, *The Influence of Photography on American Landscape Painting* (New York: Garland Publishing, Inc., 1977).

34. William C. Lipke and Philip N. Grime, "Albert Bierstadt in New Hampshire," *Currier Gallery of Art Bulletin* 2 (1973), p. 28.

35. Durand had done an engraving after Cole's design of *Winnepiseogee Lake* for William Cullen Bryant's *The American Landscape* (New York: Elam Bliss, 1830). On Durand's 1838 trip, see the letter to his wife of 30 June 1839, Asher B. Durand Papers, New York Public Library.

36. On Ruskin's influence in America see Roger B. Stein, *John Ruskin and Aesthetic Thought in America, 1840–1900* (Cambridge: Harvard University Press, 1967). Ruskin's views, which were best known through his book *Modern Painters,* volume one of which appeared in 1847, were especially supported in *The Crayon* (1855–61) and *The New Path* (1863–65). Durand wrote a series of articles in *The Crayon* in November 1855, October 1856, August 1858, and February 1860, in which he set forth his own version of these concepts.

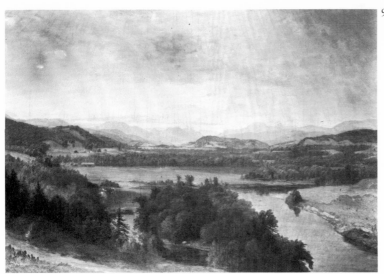

90

90. Asher Brown Durand, *Franconia, White Mountains,* ca. 1857. Lent by The New-York Historical Society, Robert L. Stuart Collection

91. *The Frankenstein Trestle,* photograph for Moses F. Sweetser, *Views in the White Mountains,* 1879. Lent by Special Collections, Dimond Library, University of New Hampshire

37. David B. Lawall, *Asher B. Durand: His Art and Art Theory in Relation to His Times* (New York: Garland Publishing, Inc., 1977), pp. 293–327. See also David B. Lawall, "Introduction," *A. B. Durand, 1796–1886* (Montclair: Montclair Art Museum, 1971), pp. 19–22: "Durand forged an optimistic religious faith that is a New York parallel to New England Transcendentalism."

38. Charles B. Ferguson, "Essay," *Aaron Draper Shattuck, N.A., 1832–1928, A Retrospective Exhibition* (New Britain, Conn.: New Britain Museum of American Art, 1970).

39. Bulkley, "White Mountain Tourist Industry," pp. 38–39, 44–45, and 56.

40. Alonzo J. Fogg, *The Statistics and Gazeteer of New Hampshire* (Concord, 1874), p. 399.

41. Bulkley, "White Mountain Tourist Industry," pp. 67–68. This was not the case in all towns, such as Littleton, Jackson, and Bartlett, where manufacturing dominated the economy.

42. F. Allen Burt, *The Story of Mount Washington* (Hanover, N.H.: Dartmouth Publications, 1960), pp. 112–123. Burt's grandfather and father edited and published the newspaper.

43. Champney bought a house in North Conway (which still stands) in 1854. See Champney, *Sixty Years',* pp. 106–107.

44. See Catherine H. Campbell, "Crawford Notch in Fact and Fancy" (Master's thesis, S.U.N.Y.-Albany, 1976), p. 105; and Burt, *Mount Washington,* pp. 63–72.

45. See, for example, Philip Hamenton, *Thoughts About Art* (Boston, 1871), pp. 123–126 and 131–134.

46. "The Stereoscope and Stereograph," *Atlantic Monthly,* June 1859.

47. William C. Darrah, *Stereo Views, A History of Stereographs in America and their Collection* (Gettysburg: Times and New Publishing Co., 1964), pp. 27–30, 35–39, 41–47. Thomas Southall, *The Kilburn Brothers Stereoscopic View Company* (Master's thesis, University of New Mexico-Albuquerque, 1977), pp. 10–26; and Thomas Southall, "White Mountain Stereographs and the Development of a Collective Vision," *Points of View: The Stereograph in America—A Cultural History,* ed. Edward W. Earle (Rochester: Visual Studies Workshop, 1979), pp. 98–99.

48. Katherine M. McClinton, *Louis Prang* (New York: Clarkson and Potter, 1973).

49. Champney, *Sixty Years',* pp. 170–172.

50. Stebbins, *Hudson River School,* p. 6. Worthington Whittredge derisively labeled the American landscape painters the Hudson River School in an interview in the *New York Tribune* in reference to their provinciality. See also Frederick A. Sweet, *Hudson River School* (Chicago: Art Institute of Chicago, 1945); Samuel Isham, *History of American Painting* (New York, 1905), p. 232 where he speaks of "the Hudson River School or the White Mountain School"; and Thomas Flexner, *That Wilder Image* (New York: Bonanza Books, 1962), pp. 266–267 and 293–294 where he speaks of the Rocky Mountain School.

51. Champney, *Sixty Years',* p. 103: "We had seen grander, higher mountains in Switzerland, but not so much beauty and artistic picturesqueness brought together in one valley [Conway]." Hence, the small scale was not only the physical size of the painting, but also its conception.

52. I am indebted to Ann Reynolds for the work on this problem that she did for me during the fall of 1979 while at Smith College. The Boston Art Club was founded in 1855 to establish a place for local artists to show their work and to get together; the club continued to exist into the twentieth century.

53. See his *Reminiscences of the Boston Art Club* (Boston, 1885).

54. Peter Bermingham, *American Art in the Barbizon Mood* (Washington: Smithsonian Institution Press, 1975), pp. 20–21 and 140–141.

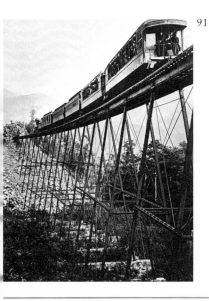

91

THE REAL AND THE IDEAL: POPULAR IMAGES OF THE WHITE MOUNTAINS

1. John Farmer and Jacob B. Moore, *A Gazetteer of the State of New-Hampshire* (Concord: J. B. Moore, 1823); John Farmer, *A Catechism of the History of New Hampshire* (Concord: C. Hoag and M. G. Atwood, 1829); Samuel Griswold Goodrich (Peter Parley pseud.), *The First Book of History for Children and Youth* (Boston: Richardson, Lord, and Holbrook, 1832).

2. See Walter J. Hipple, Jr., *The Beautiful, the Sublime, and the Picturesque in Eighteenth Century British Aesthetic Theory* (Carbondale: Southern Illinois University Press, 1957).

3. Cf. Reverend Carlos Wilcox, "The Account of the Late Slides" in *The Boston Newsletter and City Record* 2 (September 16, 1826), p. 122 and "The Late Storm of the White Mountains" in *The Christian Spectator* 12 (1826), p. 625. The best known fictionalized account is Nathaniel Hawthorne's short story "The Ambitious Guest," published in 1835.

4. In Benjamin G. Willey's *Incidents in White Mountain History* (Boston: Nathaniel Noyes, 1856), the author compares his brother's half-way house to the hostel of "the monks of St. Bernard [sheltering] wanderers upon the Alps."

5. Pratt's painting, entitled *View of the White Mountains after the Late Slide,* is known only through the engraving by Vistus Balch illustrating a fictionalized account published in the literary gift-book, *The Token, A Christmas and New Year's Present* (Boston: Carter and Hendee, 1828). Pratt's sketchbook of the 1828 trip to the White Mountains with Cole is still unpublished and is in the Karolik Collection of the Boston Museum of Fine Arts. See also Marcia Clark, "A Visionary Artist Who Celebrated Wilds of America," *Smithsonian* 6, no. 6 (September 1975), pp. 90–97, on Cole's and Pratt's visit to Crawford Notch.

6. Thomas Cole, "Essay on American Scenery," 1835, republished in *American Art, 1700–1960, Sources and Documents,* ed. John McCoubrey (Englewood Cliffs, N.J.: Prentice-Hall, Inc., 1966), pp. 98 ff.

7. Cf. Wolfgang Born, *American Landscape Painting* (New Haven: Yale University Press, 1948), p. 81. Born argues that the panoramic style was introduced by the British illustrator William H. Bartlett on his American visit of 1836.

8. Barbara Novak, "The Meteorological Vision: Clouds," *Art in America* 68, no. 2 (February 1980), pp. 103 ff.

9. See Albert Gelpi, "White Light in the Wilderness; Landscape and Self in Nature's Nation," *American Light, the Luminist Movement 1850–1875* (Washington: National Gallery of Art, 1980).

10. Cf. Edward Roth's novel *Christus Judex* (Boston: I. N. Andrew, 1864), p. 9, which compares the Old Man to an Italian Renaissance painting: "Right over the altar was a large painting, containing one single figure. It did not represent the Crucifixion, as is generally the case with such pictures: on the contrary, the figure—of which I could distinctly see only the head—seemed to be sitting. But this head affected me most powerfully. It was the profile of a pale, noble countenance gazing sorrowfully yet immovably on some heart-rending sight. Oh, the sterness of that brow, though the eye was mild and the mouth gentle and loving! And the chin: it was the embodiment of inexorability: it told of strict justice, but no mercy . . . that was the beatified countenance of the Lord Christ."

11. Fitz-Hugh Lane, one of the founders of the Luminist movement, served his apprenticeship at Pendleton's lithography shop in Boston from the early 1830s until 1848. He would certainly have been familiar with the products of Bufford's workshop.

12. See Benjamin Champney, *Sixty Years' Memories of Art and Artists* (Woburn, Mass.: Privately printed, 1900).

13. Stephen Merrill Allen, *Fibrilia: A Practical and Economical Substitute for Cotton* (Boston: L. Burnett and Company, 1861).

14. Sylvester B. Becket, *Guide Book of the Atlantic and St. Lawrence, and St. Lawrence and Atlantic Rail Roads* (Portland, Maine: Sanborn & Carter, 1853), p. 101.

15. For a discussion of the techno-sublime, see J. Gray Sweeney, *Themes in American Painting* (Grand Rapids: Grand Rapids Art Museum, 1977).

92. Frank H. Shapleigh, *Mount Washington and Walker's Pond from a Barn*, 1885. Collection of Dartmouth College Museum & Galleries, purchased from the Whittier Fund

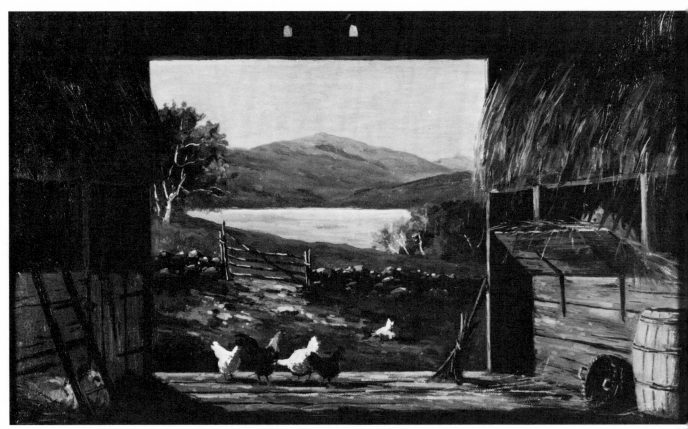

92

CATALOGUE
OF THE
EXHIBITION
Catherine H. Campbell

Height is recorded first, then width. Measurements are taken to the next larger eighth of an inch and to the next larger millimeter. Paintings, drawings, magazine illustrations, and photographs are listed by artist; prints, books, maps, and miscellaneous objects are listed by title.

PAINTINGS
AND
DRAWINGS

BIERSTADT, ALBERT

Born: Solingen, Germany; January 7, 1830
Died: New York, N.Y.; February 18, 1902

Bibliography:
A. Bierstadt. Fort Worth, Texas: Amon Carter Museum, 1972.
Albert Bierstadt. New York: M. Knoedler and Company, Inc., 1972.
Hendricks, Gordon. *Albert Bierstadt, Painter of the American West.* New York: Harry N. Abrams, Inc., 1974.
Lipke, William C. and Grime, Philip N. "Albert Bierstadt in New Hampshire." *Currier Gallery of Art Bulletin* 2 (1973), pp. 20–37.

Together with Frederic Church, Bierstadt was the most celebrated American artist of the 1860s and '70s. Little is known of his basic artistic training. The family moved to New Bedford, Massachusetts, from Germany when Bierstadt was about three years old. By 1850, he had mastered enough technique to advertise instruction in monochromatic painting. Apparently any formal training came between 1853 and 1857, when he returned to Düsseldorf, Germany, to study painting. Though he seems to have had no specific teacher, he became a friend of Emanuel Leutze, Sanford Gifford, Worthington Whit-tridge, and William Stanley Hazeltine. On his return to this country, he organized an exhibition of 150 paintings in New Bedford which included works by all the leading American artists of the day. That December, the Boston Athenaeum Gallery became the first museum to buy one of his works, *The Portico of Octavia, Rome.* From then on his career was assured.

Bierstadt always loved mountains and visited the White Mountains before he left for Düsseldorf, for his signature appears in the register on top of Mount Washington on August 11, 1852. He returned again at various times from 1858 to 1862. He stayed at the Conway House in Conway, listing himself as "A. Bierstadt, New York," on September 13, 1862. He also spent considerable time at the Glen House in 1869 while at work on *Emerald Pool,* which he considered his finest work.

Sometime in 1859 or 1860, Bierstadt visited Crawford Notch with his brother, Edward, working in the then new medium of photography. *The Crayon,* in January, 1861, noted: "We would call the attention of admirers of photographs to a series of views and studies taken in the White Mountains, published by Bierstadt Brothers of New Bedford, Mass. The plates are of large size and are remarkably effective. The artistic taste of Mr. Albert Bierstadt, who selected the points of view, is apparent in them. No better photographs have been published in this country." Bierstadt became internationally renowned for his beautiful and enormous paintings of the newly accessible Far West, and his works found their way into public and private collections at staggeringly high prices.

His popularity and wealth rose to tremendous heights, only to fade as the rise of interest in the Barbizon School and Impressionism turned public taste away from his highly detailed landscapes, suffused with golden light. By 1895 he declared himself bankrupt, and his paintings were relegated to attics and forgotten.

MAPLE LEAVES, NEW HAMPSHIRE
1862
Oil on paper
33.7 × 48.9 cm.; 13½ × 19¼ in.
Signed reverse, lower right: White Mountains/ study of Maple leaves/ North Conway, N.H./ 1862
Lent anonymously

The goldenrod, steeplebush, and browning skunk cabbage, together with the maple leaves, all point to late summer or early autumn as the time of year this work was painted. It is a prime example of the careful studies that Bierstadt made and incorporated into his large, finished canvases. Probably this study was made at the Conway House, where Bierstadt stayed in 1862, and perhaps it was a sketch for *Connecticut River at Claremont, N.H.* which was shown at the Boston Athenaeum Gallery in 1862 (now listed as *Ascutney Mountain from Claremont, N.H.,* dated 1862). *(ill. 45)*

SHADY POOL, WHITE MOUNTAINS
Ca. 1869
Oil on paper mounted on canvas
56.2 × 76.6 cm.; 22⅛ × 30⅛ in.
Signed lower right (in pen): ABierstadt
Collection of Hirshhorn Museum and Sculpture Garden, Smithsonian Institution

This painting may have been executed in 1869 when the artist was staying at the Glen House in Pinkham Notch while at work on more than 200 sketches for *Emerald Pool* (Huntington Hartford Collection), which he considered his *magnum opus.* The only other identifiable sketch for *Emerald Pool* is titled *Study of Ferns, White Mountains, Emerald Pool* (Florence Lewison Gallery, New York, N.Y.). It is of the same carefully worked style as *Shady Pool,* totally unlike his earlier quick sketches of the White Mountains of 1858 or 1860. *(ill. 21)*

LAKE AT FRANCONIA NOTCH, WHITE MOUNTAINS
n.d.
Oil on canvas
34.3 × 48.9 cm.; 13½ × 19¼ in.
Signed lower right: ABierstadt
Collection of The Newark Museum

This work, probably done in the 1850s and considered as early in the artist's career, already points to Bierstadt's love of wild, unspoiled nature. The shy, delicate deer, who flees with white scut signaling danger at the slightest provocation, is here poised, serene and alert in the foreground by the lake. All is still and precisely ordered, rendered in controlled brush strokes and colors. This device, indicating the untrammeled forest, was frequently used by the artist in his later western paintings. In 1859, on Bierstadt's first trip west he wrote: "I enjoy camp life exceedingly. This living out of doors, night and day, I find of great benefit. I never felt better in my life." Not for Bierstadt's brush were Homer's views of decorous

ladies enjoying croquet games at mountain hotels, or Champney's meadows dotted with white umbrellas. He concentrated on the grandeur and loneliness of mountain country wherever he found it. *(ill. 9)*

BRICHER, ALFRED THOMPSON
(sometimes "Albert")

Born: Portsmouth, N.H.; April 10, 1837
Died: New Dorp, N.Y.; September 30, 1908

Bibliography:
Alfred Thompson Bricher. Indianapolis, Ind.: Indianapolis Museum of Art, 1973.
Brown, Jeffrey R. "Alfred Thompson Bricher." *American Art Review* (Jan.–Feb. 1974), pp. 69–75.

In the 1860s Bricher followed his contemporaries to the popular vistas of the White Mountains. Here, particularly at North Conway, he studied and painted with Albert Bierstadt, William Morris Hunt, William Paskell, Gabriella Eddy, and Benjamin Champney. Bricher was a prolific artist; in 1860–1861 alone, his sketchbook records twenty finished paintings. Attesting to his popularity as an artist, as well as to the popularity of his subject matter, are numerous chromolithographs made after his work. Among them are *Late Autumn*; *White Mountains*; *Sawyer Pond, New Hampshire*; *White Mountains*; *Mount Chocorua and Lake*; and *On the Saco.*

In 1868 Bricher married and moved to New York from Boston and continued to exhibit widely. George Walter Vincent

93. Alfred Thompson Bricher, *New England Landscape ("Mount Kearsarge")*, 1864. Lent by Austin Arts Center, Trinity College; The George F. McMurray Collection

93

94

Smith, founder of the museum in Springfield, Massachusetts, became Bricher's patron. During the following decade, he turned to seascapes and spent much of his time exploring the coast of Maine, Narragansett Bay, and the Jersey shore. Though his popularity waned as tastes changed to the French schools, he continued to paint the seascapes for which he is best known today.

NEW ENGLAND LANDSCAPE
("Mount Kearsarge")
1864
Oil on canvas
31.2 × 61.0 cm.; 12¼ × 24 in.
Signed lower left center: A.T. Bricher, 1864
Lent by Austin Arts Center, Trinity College; The George F. McMurray Collection

Though this painting has been thought to be Mount Kearsarge, it is a view of Mount Washington from the Saco, very similar to one which Sanford Gifford painted in 1854. A chromolithograph by Louis Prang of the same subject by Bricher was published in 1866. Bricher was fond of painting water in all its aspects and produced many seascapes. His White Mountain subjects—Echo Lake, the Saco, Walker's Pond, the Ellis River, Israel's River—all reflect this interest. Here the hazy stillness of the water is an excellent example of his ability. *(ill. 93)*

BROWN, GEORGE LORING

Born: Boston, Mass.; February 2, 1814
Died: Walden, Mass.; June 25, 1889

Bibliography:
George Loring Brown: Landscapes of Europe and America, 1834–1880. Burlington, Vt.: The Robert Hull Fleming Museum, University of Vermont, 1973.

Nicknamed "Claude" Brown for the French landscape painter Claude Lorrain(e) whom he admired, George Loring Brown was among the most celebrated of American painters living abroad in the nineteenth century. He received his only formal artistic training from Eugene Isabey in Paris during his first trip to Europe in 1832 and 1833. On his return to Boston, Brown was inspired and encouraged by the aging Washington Allston and exhibited frequently at the Boston Athenaeum. He did not stay long, however; for in 1839 or 1840 he went back to Europe and settled in Italy, making a comfortable living for nearly twenty years by painting Italian landscapes for sale to the American and European tourists there.

In 1859, Brown returned to the United States and in the 1860s and 1870s he made many sketching trips to the White Mountains. Perhaps Brown's greatest New Hampshire scene was *The Crown of New England*, a huge, panoramic view of Mount Washington, which was purchased by the Prince of Wales in 1861 (now lost). A letter Brown wrote from Jackson, N.H. in 1878 reveals his attraction to the mountains:

This town where I am is the Switzerland of New England. It is the most splendid region I have been in for studies. Shapleigh of Boston is still here and Niles has just left. I am surprised that all our artists do not come up here, for waterfalls, rocks, trees, mountains, *it is unsurpassed.*

After another brief trip to Europe in 1879, Brown settled in Malden, Massachusetts. He painted mostly Italian scenes in later life, responding to a preference by the public for his European views.

AUTUMN MORNING IN NEW HAMPSHIRE
1867
Oil on canvas
62.2 × 90.8 cm.; 24½ × 35¾ in.
Signed lower right: Geo. L. Brown 1867
Lent by Austin Arts Center, Trinity College; The George F. McMurray Collection

Perhaps because he spent so much of his time abroad, George Loring Brown was not a part of the close-knit group of Boston artists that developed before the Civil War. He differed from them in his aesthetic sensibilities and in his approach to landscape art. He developed an unorthodox technique of applying paint in layers and using glazes to create surface tension. He strove for decorative effect in his art, not moral inspiration. Nevertheless, he was part of that group of artists who were attracted to the White Mountains to paint landscapes. *Autumn Morning in New Hampshire,* with its play of light and shade, vibrancy of color and loose han-

94. George Loring Brown, *Autumn Morning in New Hampshire,* 1867. Lent by Austin Arts Center, Trinity College; The George F. McMurray Collection

95. Harrison Bird Brown, *View of Welch Mountain,* 1863. Collection of the Portland Museum of Art, Me.; Gift of Morton C. Bradley

dling of detail, is typical of the work Brown did that set him apart from his contemporaries. Though the subject of this imaginary scene is not unlike other artists' depictions of rural life in New Hampshire, it seems evident that Brown was more interested in capturing the excitement and sparkle of the autumn morning than in the specifics of his subject. *(ill. 94)*

BROWN, HARRISON BIRD

Born: Portland, Me.; 1831
Died: London, England; March 10, 1915

Brown achieved great eminence as a landscape painter during his lifetime in Maine. He began as an apprentice sign and banner painter and at the age of twenty-one established his own shop.

In the 1850s, John Neal, benefactor and friend, encouraged Brown to broaden his artistic endeavors. Brown formed a partnership with his brother George, who assumed the role of sign painter, and, soon after, Brown was free to become fully involved with landscape painting.

Portland's thriving business community patronized their native son's work. Brown gained prominence through exhibitions in The National Academy of Design in New York, the Philadelphia Exposition of 1876, Boston, and London. Whittier and Longfellow owned his works. In 1892 Brown was elected president of The Portland Society of Art.

Later in 1892, for reasons unknown, Brown moved to London, where he spent his remaining years. Speculation suggests Brown wished to be near his one surviving child who had joined her husband in Europe.

VIEW OF WELCH MOUNTAIN
1863
Oil on canvas mounted on cradled masonite
30.2 × 50.8 cm.; 11⅞ × 20 in.
Signed left center: H.B. Brown '63
Collection of Portland Museum of Art, Me. Gift of Morton C. Bradley

This scene is fairly unusual, for, though it is very similar to many views of Mount Washington from the Saco evoking the peace of a golden summer day, it is a different area, much less favored by the majority of artists. Conway Valley was the most popular area for nineteenth century artists to paint, but a rival group, which included Asher Durand, Winckworth Gay, and Thomas Addison Richards, preferred the views from Campton Village, where they stayed at the "Stag and Hounds and Ferocious Eagle" hotel. They painted Welch Mountain, the Franconia Range, the Pemigewasset River, and the mountains that ringed Waterville Valley. They corresponded, extolling the beauties of their respective sites, in *The Crayon,* using signatures such as "Burnt Umber" and "Flake White"; these letters make amusing reading. *(ill. 95)*

VIEW OF MT. WASHINGTON
1866
Oil on canvas
63.5 × 107.7 cm.; 25 × 42 ⅜ in.
Signed lower right: H.B.B., dated 1866
Collection of Portland Museum of Art, Me. Gift of Mrs. Louis L. Hills, Jr., in memory of Mrs. Louis L. Hills, Sr., and Mr. Louis L. Hills, Sr., 1973

Brown, like many other mid-nineteenth century painters of White Mountain scenery, drew a variety of elements to produce an ideal concept of Mount Washington from the Valley of Conway. Though many other views of this mountain were taken from a hill overlooking the whole valley, this view is from below the level of the plain in order to enhance the rugged majesty of the surrounding hills. The falls and mill are possibly an adaptation of Goodrich Falls in nearby Bartlett. *(ill. 40)*

BARN INTERIOR
Ca. 1880
Oil on canvas
46.4 × 76.2 cm.; 18¼ × 30 in.
Signed lower left: H. B. Brown
Collection of Portland Museum of Art, Me. Gift of the Reverend George Monks, Commander John P. Monks, and Mrs. Constantine Pertzoff, 1944

This familiar New England view was a favorite of many artists of the White Mountain School. Brown's rendition is more detailed than Shapleigh's paintings of the same subject, which so often frame a distant scene. One's eye wanders from the worn boards and ladder at the left to

96. Benjamin Champney, *Mount Moat Range from Locust Lane*, 1858. Lent by Mrs. L. Hamlin Greene

97. Benjamin Champney, *Golden Afternoon*, ca. 1870. Lent by Mrs. L. Hamlin Greene

98. Benjamin Champney, *Still Life*, n.d. Lent anonymously

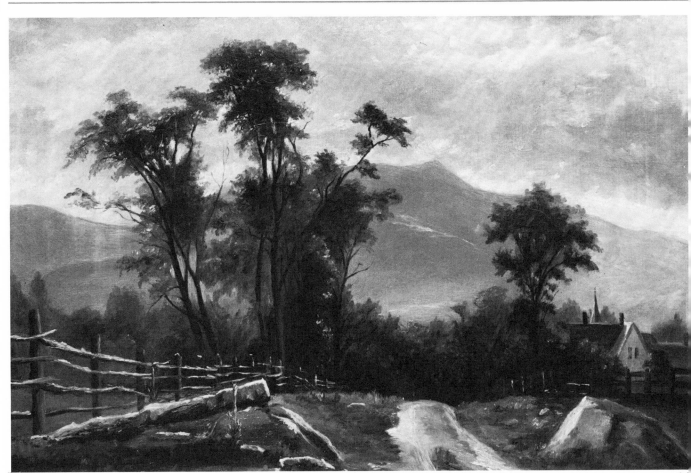

96

97

98

the strutting chickens and the man with the whetstone in the middle distance; then one looks beyond the solid gable of the house to the luminous sky and comes back to the dusky recesses of the barn, with keg and harnesses and hay mow. Such scenes evoked happy summer memories of country boarding houses: searches for eggs in the barn, hayrides, and warm, fresh milk. *(ill. 4)*

CHAMPNEY, BENJAMIN

Born: New Ipswich, N.H.; November 17, 1817
Died: Woburn, Mass.; December 11, 1907

Bibliography:
Champney, Benjamin. *Sixty Years' Memories of Art and Artists*. Woburn, Mass.: Privately printed, 1900.

"Probably no artist in America is more allied to one particular place than Benjamin Champney to North Conway." The *Boston Transcript* in 1889 voiced an association which is still appropriate today; indeed, Champney is now often considered the founder of the White Mountain School. The example of Cole and Pratt before him and the very popular engravings in Willis's *American Scenery* attracted Champney to the region. As early as the 1850s, he was one of the principal artists responsible for popularizing North Conway as a haven for artists. Later he could write that the Saco Valley was "dotted all about with the white umbrellas" of artists sketching.

Champney's early training came as an apprentice to the lithographer William Pendleton in Boston. He made several trips to Europe in the 1840s. In 1850 he visited the White Mountains with John F. Kensett, staying at Thompson's Kearsarge Tavern in North Conway. They were later joined by John Casilear. The next summer, Champney returned with other Boston artists, only to find Kensett already there with his New York artist friends. From these beginnings, the popularity of North Conway grew as a location to paint from nature.

In 1853, Champney married and a year later moved into a house in North Conway. For nearly half a century he spent his summers there, always welcoming visitors to his small studio next to his house. In winter, he would return to Boston, where he was active in the Boston Art Club (of which he was a founder). He exhibited regularly there and at the Boston Athenaeum and also at the National Academy of Design, the American Art-Union, and the Pennsylvania Academy of the Fine Arts.

MOUNT MOAT RANGE FROM LOCUST LANE
1858
Oil on canvas
38.8 × 59.1 cm.; 15¼ × 23¼ in.
Signed lower left: B. C. 1858
Lent by Mrs. L. Hamlin Greene

Champney brought many major American painters of the day to North Conway. Kensett was a close friend, Casilear, Rossiter, Durand, Huntington, Church, Bierstadt, Sonntag, and many others formed a convivial group which met at Champney's studio and Thompson's Tavern to discuss their craft and dissect each others' sketches. They were all realists who worked in the *plein air,* returning to New York's Tenth Street Studio or Boston's Tremont Temple in winter to complete their summer's gleanings. In this finished sketch, Champney has introduced a giant mullen by the felled tree, and the trees are identifiable as locusts. *(ill. 96)*

GOLDEN AFTERNOON
Ca. 1870
Oil on canvas
28.6 × 23.5 cm.; 11¼ × 9¼ in.
Unsigned
Lent by Mrs. L. Hamlin Greene

This type of nonspecific scene was extremely popular with the small art collector. Champney's sun-dappled sketch is a variation on a theme which Asher Durand used so often, though the latter emphasized almost Pre-Raphaelite detail. There is a simple, direct statement of a brook (probably Artists' Brook in North Conway) on a summer afternoon. It would evoke memories of a pleasant summer holiday in the country for the viewer. *(ill. 97)*

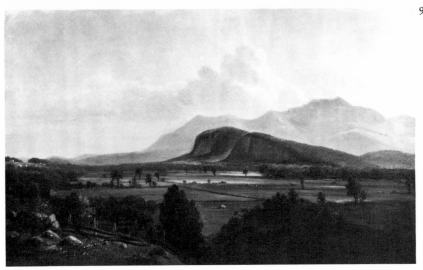

99. Benjamin Champney, *Moat Mountain from Intervale,* ca. 1870. Lent by White Mountain National Bank, North Conway, N.H.

100. Edmund C. Coates, *View of Meredith,* 1863. Collection of Kennedy Galleries, New York

MOAT MOUNTAIN FROM INTERVALE
Ca. 1870
39.4 × 64.2 cm.; 15½ × 25¼ in.
Signed lower left: Benjamin Champney—1872
Lent by White Mountain National Bank, North Conway, N.H.

Champney, in his long years of summer residence in North Conway, painted literally hundreds of views of the area. This summer picture looks southwest to the two spectacular cliffs known as White Horse and Cathedral Ledges with Moat Mountain rising in the right background. There are at least three almost identical paintings of this same scene by Champney which should be compared to an early work by Albert Bierstadt from the same viewpoint. Only the Düsseldorf clarity of the latter separates the paintings and identifies the artist. In comparison to Bierstadt, Champney's mature style is blurred and generalized by the atmospheric quality he introduces into his work. The slanting spot of sunlight is emphasized by the darkling cliff, centering the eye on the middle of the canvas. The diagonal fencing leads one to the tiny, light dot of the haywain. This is a carefully thought-out composition, its horizontality giving a sense of space, while focusing the viewer's first attention on a small area. *(ill. 99)*

STILL LIFE
n.d.
Oil on canvas
53.4 × 43.2 cm.; 21 × 17 in.
Signed lower right: B. Champney
Lent anonymously

Champney's later style changed from a rather tight, precise handling of paint, which can be seen in his *Mount Chocorua,* to the more impressionistic brushstroke of this grouping of uncultivated flowers pressing in on an old house wall. In this picture the species of flower is only suggested, subordinated to the overall evocation of a profligate nature kindly invading the crumbling work of man. *(ill. 98)*

CHURCH, FREDERIC EDWIN

Born: Hartford, Conn.; May 4, 1826
Died: New York, N.Y.; April 7, 1900

Bibliography:
Avery, Myron H. "The Artist of Katahdin." *Appalachia* 25 (1944–45), pp. 147–154.
Frederic Edwin Church. Washington, D.C.: National Collection of Fine Arts, Smithsonian Institution, 1966.
Huntington, David C. *The Landscapes of Frederic Edwin Church.* New York: George Braziller, 1966.

The most important event in Church's formative years occurred when he moved to Catskill, New York, in 1844 and became, for the next two years, the only pupil ever accepted by Thomas Cole. By the age of nineteen, he was proficient enough to exhibit a painting at the National Academy of Design. Strongly imbued with the elegiac teachings of Cole, Church took down a tremendous number of sketches from nature, which he rearranged into painstakingly executed ideal paintings in his studio. In the 1850s and 1860s, exhibitions of his works were outstanding public events. Crowds were so large that police had to keep order. His techniques were so realistic that people passed a hand before his *Niagara* to find the source of the rainbow, which they felt could not be a painted effect. He traveled from the Arctic wastes to the jungle of the Andes gathering material for his representations of the Omnipotent Hand of God in Nature. By 1880, due to severe rheumatism which curtailed his manual dexterity, as well as changes in public taste, Church's painting activity declined markedly, and he turned his interest to the embellishment of his home, Olana, in Hudson, New York, which remains a museum to this day.

INTERVALE AT NORTH CONWAY
Ca. 1856
Oil on canvas
34.3 × 50.2 cm.; 13½ × 19¾ in.
Unsigned
Lent anonymously

Though this painting is neither signed nor dated, it was undoubtedly taken on the spot by Church on the at least three trips to the White Mountains between 1850 and 1856 on his way to Maine. The work has the tight, detailed traits of Church's early style, and can be compared to *New England Scenery* of 1851, or *Mount*

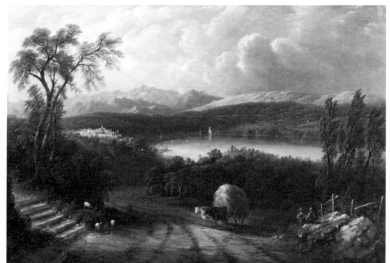

Kaatdn of 1853. The painting was given to Lucretia Titus, a family friend, by the artist as a wedding gift and remained in the family until purchased by the Kennedy Galleries in 1972. Church was familiar enough a figure in the White Mountain region to have Church's Falls on Sabbaday Brook named for him, yet so few paintings of the White Mountains by this artist are known that for a time this picture was thought to be a Catskill scene. The pastoral composition is very similar to one by Asher B. Durand, painted about 1855. Both works include the small barn seen in the center of the painting. *(ill. 46)*

COATES, EDMUND C. (sometimes listed as Edmund F., Edward, or E. D. Coates.)

Little is known of this artist who is purported to have been born in England. His name is listed with the variations noted above in New York City directories of 1837, and 1841 to 1843. Coates exhibited at the Apollo Gallery in 1839 and 1840, and spent ten years, from 1837 to 1847, working on a view of Weehawken, N.J. He seems to have traveled about the Northeast, for he painted a view of Niagara Falls in 1845 and produced several Canadian views.

VIEW OF MEREDITH
After Bartlett
1863
Oil on canvas
59.7 × 90.2 cm.; 23½ × 35½ in.
Signed and dated lower left: E.D. Coates 1863.
Collection of Kennedy Galleries, N.Y.

Whether Coates was actually ever in New Hampshire is open to conjecture, as this view is an accurate adaptation of the engraving of the same subject by William Bartlett which appeared in *American Scenery* in 1838. The village seen nestled in the background and the church across the bay are so factually placed that, despite the exaggerated height of the distant mountains, the spot from which this view was taken can be identified to this day. (The location is on Route 3, locally called Corliss Hill Road.) Coates is known to have done at least one other painting taken from the work of another artist, for he used a drawing by Charles Lanman as his model for one of his oils. *(ill. 100)*

COLE, THOMAS

Born: Lancashire, England; February 1, 1801
Died: Catskill, N.Y.; February 11, 1848
Bibliography:
Campbell, Catherine H. "Two's Company, The Diaries of Thomas Cole and Henry Cheever Pratt on Their Walk through Crawford Notch, 1828." *Historical New Hampshire* 33, no. 4 (winter 1978), pp. 109–133.

Noble, Louis L. *The Life and Works of Thomas Cole.* New York, 1853.
Thomas Cole. Rochester, N.Y.: Memorial Art Gallery of the University of Rochester, 1969.
Thomas Cole One Hundred Years Later. Hartford, Conn.: Wadsworth Atheneum, 1948.
The Works of Thomas Cole, 1801–1848. Albany, N.Y.: Albany Institute of History and Art, 1941.

Thomas Cole was eighteen when he came to America with his father. Cole had served in England as apprentice to both a calico designer and a wood engraver. It was not until he settled in Steubenville, Ohio, that he began to study painting. At the age of twenty-five, he was elected a member of the National Academy.

Later, Cole studied abroad, but most of his life was spent exploring the American wilderness of the Catskills, the White Mountains, the Adirondacks, and Mount Desert Island on the coast of Maine, returning during the winter months to his New York City studio to paint finished compositions from the accumulated sketches of his summer excursions.

Cole made a trip to the White Mountains with fellow artist Henry Cheever Pratt in 1828, two years after the Willey landslide disaster and only eight years after the first footpath was opened on Mount Washington. He returned to the White Mountains for the last time in 1839.

In the years between 1836 and 1848, Cole created the allegorical series *The Course of Empire* and *The Voyage of*

101. Jasper F. Cropsey, *Mount Chocorua and Railroad Train,* 1869. Collection of Diplomatic Reception Rooms, Department of State, Washington, D.C.

102. Jasper F. Cropsey, *Winter Landscape, North Conway,* 1859. Lent by Henry Melville Fuller

Life. His aim was to uplift mankind through art, and he became despondent when friends and patrons preferred his landscapes. Alone in his moral pursuit and weakened by his personal struggle for survival, Cole died of pneumonia during the winter of 1848 in his Catskill home while working on a third epic series, *The Cross and The World.* Only after Cole's death did a memorial exhibit of his work, and the publicized sale of *The Voyage of Life* to the American Art-Union, reveal the measure of his genius.

LAKE WINNIPESAUKEE
1827 or 1828
Oil on canvas
62.3 × 87.7 cm.; 24½ × 34½ in.
Unsigned
Collection of Albany Institute of History and Art, Gift of Mrs. Ledyard Cogswell, Jr.

This painting was worked up from a sketch taken on a trip through the White Mountains of New Hampshire in 1827 or in October, 1828, with his friend Henry Cheever Pratt. The earlier date is more probable, as the finished painting was shown at the National Academy of Design as number three in 1828, and listed as being owned by his patron, Daniel Wadsworth of Hartford, Conn. It was engraved by his friend Asher B. Durand the same year and published in William Cullen Byant's *The American Landscape* in New York in 1830. Cole wrote of this painting: "Its mountains do not stoop to the water's edge, but through varied screens of forest may be seen ascending the sky softened by the blue haze of distance. . . ." The

whole composition, the drawing of the trees, and the use and placement of the two figures, demonstrate that Cole had studied the work of the landscape painters of the past, from Claude Lorrain(e) and Salvator Rosa to Joseph Turner and Washington Allston. *(ill. 12)*

AUTUMN TWILIGHT, VIEW OF CORWAY [MOUNT CHOCORUA] PEAK
1834
Oil on wood panel
35.6 × 49.6 cm.; 13¾ × 19½ in.
Signed, lower right: T. Cole. Signed reverse: T. Cole/Catskill/1834
Collection of The New-York Historical Society

Thomas Cole was sent to New Hampshire by his patron, Daniel Wadsworth, with requests for paintings of specific views. The artist was particularly fascinated by Mount Chocorua and its legend, and climbed the mountain in 1828 with Henry Cheever Pratt. There are at least four other paintings of this scene by Cole, all slightly different. He incorporated the spectacular peak in *The Last of the Mohicans, The Picnic,* and *The Hunter's Return.* It can be seen in the background of *Lake Winnipesaukee* in this exhibition. Cole preferred to paint allegorical sequences such as *The Course of Empire* and *The Voyage of Life,* feeling that they presented a higher order of art than mere landscape. However, he managed to infuse his ideology into landscapes so as to indicate that nature was the Visible Hand of God. Here the tangle of dead trees indicates the inevitability of death. The

mountain is serene in the last rays of the sun whose reflection just touches the tiny insignificant figure of the Indian in the lower right. Man is infinitesimal and unimportant, but God is good. *(ill. 10)*

CROPSEY, JASPER F.

Born: New York, N.Y.; 1823
Died: Hastings-on-Hudson, N.Y.; June 22, 1900

Bibliography:
Bermingham, Peter. *Jasper F. Cropsey, 1823–1900; A Retrospective View of America's Painter of Autumn.* College Park, Md.: University of Maryland, 1968.
Cropsey, Jasper. *Paper Dealing with the White Mountains.* Washington, D.C.: Archives of American Art microfilm.
Talbot, William S. *Jasper Cropsey, 1823–1900.* Washington, D.C.: National Collection of Fine Arts, Smithsonian Institution, 1970.

Jasper Cropsey received his early training as an architect and set up his own office in New York in 1843. He began painting shortly thereafter, for he first exhibited in New York at the National Academy in 1844. Just a year later, he was elected an associate member and was made a full member in 1851. Cropsey's interest in architecture continued throughout his life and was a strong influence in his painting, most evident in his precise arrangement and outline of forms.

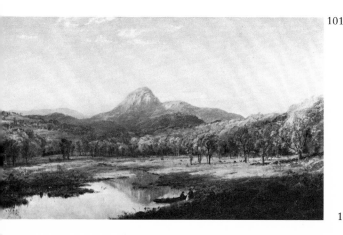

101

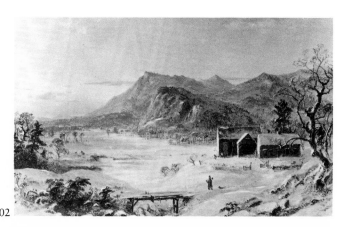

102

89

But Cropsey was best known for his lavish use of color and, as a first generation member of the Hudson River School, painted autumn landscapes that startled viewers with their boldness and brilliance. He traveled in Europe from 1847 to 1849, and lived in England from 1856 to 1863. Surviving sketchbooks indicate that Cropsey was in the White Mountains in the summer of 1852 and in 1855–56. He may have made another visit to the area in 1878. His sketches from nature done on these trips are often marked with color notes as well as the subject or location.

Cropsey became interested in Luminism after the Civil War and also in watercolor painting, and founded the American Watercolor Society in 1867. He exhibited at the National Academy, the Pennsylvania Academy of Fine Arts, the Boston Athnaeum, and in London at the Royal Academy. Failing health may have caused his later paintings to be overworked and consequently less popular.

INDIAN SUMMER MORNING IN THE WHITE MOUNTAINS
1857
Oil on canvas
99.7 × 155.6 cm.; 39¼ × 61¼ in.
Signed lower left: J.F. Cropsey 1857.
Collection of The Currier Gallery of Art

Painted in England from sketches done earlier in the White Mountains, *Indian Summer Morning* was exhibited at the Royal Academy in 1857. It was one of the first American landscapes to be seen by the English and it sold for $1,000, the highest amount Cropsey had received to that date. The rugged American wilder-

ness was depicted in all its Sublime glory, unmarked by the presence of man. Brilliant autumn colors and careful, sharp drawing characterize the painting. The broken, dead tree in the foreground became almost a trademark of the painters who followed Thomas Cole. Like Cole, Cropsey strove to idealize the American landscape and identified himself with the movement to raise landscape painting to the status of historical or allegorical painting. The White Mountains provided a setting, like the Catskills or the Adirondacks, in which to paint the American experience of discovery and civilization in a new continent. *(ill. 52)*

EAGLE CLIFF, FRANCONIA
1858
Oil on canvas, backed by panel
61.0 × 99.0 cm.; 24 × 39 in.
Signed lower left: J. F. Cropsey 1858
Collection of North Carolina Museum of Art

Also painted in England, this view, done a year after *Indian Summer Morning in the White Mountains*, shows the progress of civilization in the wilderness. The subject of a family inhabiting a log cabin, with cleared land and farm animals around them, illustrated man's existence in harmony with the wilderness in America. Cropsey's treatment of the scene follows the example of Cole, who painted a similar subject in *A View Near Conway, New Hampshire*, which was reproduced in an engraving of 1830 by Fenner & Sears. Cole, during his trip to the White Mountains in 1828, wrote of being greeted by "a number of dirty, rosy-faced

children," who "looked as though they had been well fed but never washed." Though the prospects were dim for those who had chosen to live in the untamed wilderness, both Cole and Cropsey seemed to romanticize that existence in their paintings.

Cropsey painted other versions of this scene in Franconia Notch with Eagle Cliff in the background. In them, as in this painting, he sometimes inverted the image of the cliff to create a more symmetrical composition. The earliest surviving sketch Cropsey did of this location is dated September, 1852. He painted a similar view, titled *Pioneer's Home, Eagle Cliff, White Mountains,* in 1859 (private collection). *(ill. 14)*

WINTER LANDSCAPE, NORTH CONWAY
1859
Oil on canvas
26.1 × 41.3 cm.; 10¼ × 16¼ in.
Signed lower right: J.F. Cropsey, 1859.
Lent by Henry Melville Fuller

Artists usually arrived in the White Mountains in early summer, sketched and painted until September or October, and then returned to their studios in Boston or New York to make finished paintings from their sketches. Winter scenes, because of this pattern, are rare. Perhaps Cropsey lingered into the winter months one year to witness a snowfall, for in his sketchbook (private collection) is a drawing entitled *Winter in Conway Valley,* from which this painting was most surely done. The setting is the intervale above North Conway, looking south to the Ca-

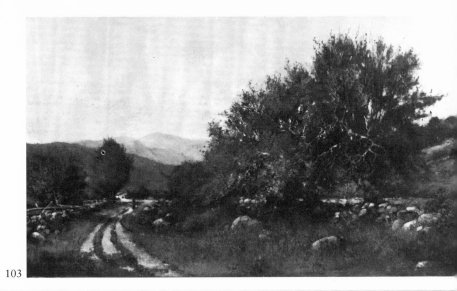

103

thedral and White Horse ledges, with Moat Mountain in the background. In the foreground is a small bridge over a stream, a house and barn, and a man going out to cut wood with a dog at his heels. Cropsey's concern with color is no less apparent here than in his autumn scenes; rich pinks and blues are used to highlight reflections and shadows in the snow. But his vision of the landscape has progressed to include man living in harmony with nature. Even in a cold, seemingly inhospitable climate, he might be saying, nature can be beautiful and inspiring. This painting, done while Cropsey was in England, could be seen as a tribute to the varied climate and the hardy inhabitants of his native country. *(ill. 102)*

MOUNT CHOCORUA AND
RAILROAD TRAIN
1869
Oil on canvas
50.8 × 83.8 cm.; 20 × 33 in.
Signed lower right: J.F. Cropsey 1869
Collection of Diplomatic Reception Rooms, Department of State, Washington, D.C.

Following the Civil War, railroads opened up the White Mountains to a huge influx of tourists and produced an accompanying economic boom. While the railroad brought rapid improvements in transportation and communication all across the United States, its presence was not easily assimilated in the scheme of the landscape painters in America. They tried to see it as a symbol of progress and improvement, and yet lamented its intrusion into the wilderness and its destruction of all that

the wilderness had signified. This ambivalence was expressed by Cropsey in several paintings, the first of which was *Starucca Viaduct* (Toledo Museum of Art), painted in 1865. Like that painting, *Mount Chocorua and Railroad Train* shows a broad, panoramic view of a pastoral landscape. The railroad train is placed in the distance, small and unthreatening. Its significance and impact, both to the viewer and on the landscape, is minimized by the composition. Cropsey was concerned with the progress of civilization, and he made several attempts to incorporate the railroad into that vision, but in the end it seems to have been too much for him. Later views of Mount Chocorua, painted in the 1870s, leave out the train entirely. *(ill. 101)*

DEFREES, T.

Almost nothing is known of this White Mountain artist except that perhaps he was Belgian or French. His style of painting shows strong influence of the French Barbizon School. Instances of European artists coming to America to paint the landscape are significantly more rare than American painters in Europe, but the presence of Defrees in the White Mountains from around 1880 to at least 1887 may indicate that this exchange did occur.

MIDSUMMER MORNING, OLD TREES ON THE FIVE MILE ROAD, JACKSON, N.H.
1887
Oil on canvas
35.6 × 61.0 cm.; 14 × 24 in.
Signed lower right: TDefrees. 1887
Lent anonymously

Inscribed on the reverse with the title, location, date, and the artist's name, this painting appears to be one of a pair painted by T. Defrees in Jackson in 1887. The other view is titled *Midsummer Morning, Moat Mountain from Hillside Pasture, Jackson, N.H.* The subjects are similar—this view on Five Mile Road contains a central figure walking along a dirt road. Stone and rail fences follow the curve of the road, which leads to a house in the distance. Old trees with thick foliage line the way. Although the location is stated explicitly, the scene is not specific or precise in its imagery and the brush style and hazy atmosphere place it less in an American tradition than in the European landscape mode. *(ill. 103)*

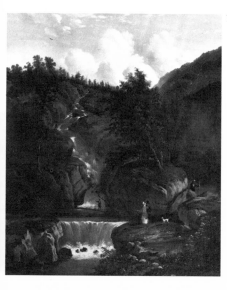

DE GRAILLY, VICTOR

Born: Paris, France; November 6, 1804
Died: 1889

Bibliography:
Banks, William Nathaniel. "The French Painter Victor De Grailly and the Production of Nineteenth-Century American Views." *Antiques* (July, 1972), pp. 84–103.

De Grailly learned his craft under the French artist, Jean Victor Bertin. At the Salon from 1830 to 1880, he regularly exhibited landscapes in the manner of, or as direct copies from, seventeenth century Dutch masters. Copies by him of Van Ruisdael and Hobbema are known. However, De Grailly's most successful work seems to have been the execution of parlor-size canvases after engravings of William Henry Bartlett's views of the eastern United States in *American Scenery,* published in England in 1838. Though there is no reason to think that De Grailly ever left his native country, such a number of the American views after Bartlett are in this country, often several representations of the same scene, that one wonders whether there was an outlet for his work in the United States.

SILVER CASCADE
Ca. 1850
Oil on canvas
62.2 × 52.7 cm.; 24½ × 20¾ in.
Signed lower right: DeGrailly
Lent anonymously

This scene, copied from an engraving based on sketches by Thomas Doughty in *American Scenery,* is one of several versions of this subject by De Grailly. The works of Doughty and De Grailly are sometimes confused. Silver Cascade was a favorite subject. Timothy Dwight, when he first saw the site in 1797, extolled it as one of the most beautiful cascades in the world. Consequently, it was a focal point for all travelers through Crawford Notch. *(ill. 104)*

DOUGHTY, THOMAS

Born: Philadelphia, Penn.; July 19, 1793
Died: New York, N.Y.; July 24, 1856

Bibliography:
[Doughty, Howard.] *Life and Works of Thomas Doughty.* The New-York Historical Society.
Goodyear, Frank H. Jr. *Thomas Doughty, 1793–1856: An American Pioneer in Landscape Painting.* Philadelphia: Pennsylvania Academy of the Fine Arts, 1973.

Thomas Doughty's first vocation was as a leather currier. It was not until 1820 that Doughty decided "contrary to the wishes of my friends and family, to pursue painting as a profession." He was then almost thirty years old. Encouraged by the local artist Thomas Sully, Doughty painted the scenery around Philadelphia and learned to master the effects of light and shade and the use of color. He probably visited New England first between 1820 and 1828. In these years he was elected to membership at the National Academy and exhibited there and at the Pennsylvania Academy of Fine Arts.

In 1827, the Boston Athenaeum exhibited works by Thomas Doughty and from 1828 to 1838 he lived and worked in that city, traveling in the summers to the White Mountains. Doughty, Alvan Fisher, and Chester Harding stayed at Thompson's Tavern in North Conway in those early years for two dollars a week.

He journeyed to England in 1838 and 1839 and made a later trip from 1845 to 1847. Doughty died in 1856 in poor health, with his popularity as an artist waning. Though he was one of the first artists to visit the White Mountains, his painting was generally of a modest and unspectacular nature. James Thomas Flexner wrote of Doughty that his was "the first incomplete statement of the style of the Hudson River School."

TUCKERMAN'S RAVINE
n.d.
Oil on canvas
48.3 × 68.6 cm.; 19 × 27 in.
Label attached to stretcher is inscribed:
Thomas Doughty, Tuckerman's Ravine,
White Mountains, N.H.
Collection of Allen Memorial Art Museum, Oberlin College. Gift of
C. F. Olney

Tuckerman Ravine is a glacial cirque on the east side of Mount Washington just below the summit. It was named after Edward Tuckerman, a professor of botany at Amherst College who explored and collected botanical specimens in the White Mountains from 1837 through 1853.

However, there is some question that this painting by Doughty is actually a view of Tuckerman Ravine. The slight dip of the near horizon suggests the lip of the bowl-like ravine, but the slopes on either side are far too gradual for the steep walls of the ravine. The presence of trees indicates that the location is not a high-altitude one. Furthermore, the summit in the background differs distinctly from the peak of Mount Washington, nor is the peak visible when standing in the ravine. Possibly the artist intended to show Tuckerman Ravine only as a shadowy depression in the side of Mount Washington. If so, this view could be from Pinkham Notch looking to the Presidential Range.

Whatever the location, the composition is made up of striking contrasts of light and shade. Nature's presence overpowers any intrusion by man, powerfully asserting herself and inspiring awe with the huge pile of boulders in the foreground and the massive summit in the distance. *(ill. 2)*

DURAND, ASHER BROWN

Born: Jefferson Village (now Maplewood), N.J.; August 21, 1796
Died: Maplewood, N.J.; September 17, 1886

Bibliography:
Durand, John. *The Life and Times of Asher B. Durand.* 1894; reprint ed., New York: Da Capo Press, 1970.

Son of a watchmaker and silversmith, Asher Durand served a five-year apprenticeship to engraver Peter Maverick in Newark, N.J., after which he became a partner. His reputation as an engraver was firmly established with the publication of his engraving after John Trumbull's *Declaration of Independence,* in 1823.

During the ten-year period between 1821 and 1831, Durand married; helped found the New York Drawing Association (1825), The National Academy of Design (1826), and The Sketch Club (1827); and formed a partnership, with his brother Cyrus and Charles C. Wright, which specialized in the production of banknotes. In 1830 he published *The American Landscape,* which included engravings of well known localities by native artists and a text by William Cullen Bryant. He suffered the death of his wife the following year.

In 1832, Durand dissolved his profitable business affiliation with the engraving firm and turned to painting when Luman Reed commissioned him to paint portraits of the seven American presidents. Soon, Durand was inundated with portrait commissions from an American public grown affluent on Jacksonian credit; yet when the financial crisis struck in 1837, he was left, like so many others, without work. With Cole's encouragement, Durand took up landscape painting.

Jonathan Sturges advanced money to Durand for a European tour and, for two years (1840–41), he traveled through England, France, the Lowlands, Germany, Switzerland, and Italy. Upon his return, he exhibited ten European studies at The National Academy of Design. In 1845, he was elected Second President of the Academy, a position he held until his resignation in 1861.

Durand worked in North Conway during the summer of 1855 with Benjamin Champney, Albert Hoit, Alvan Fisher, John F. Kensett, and Daniel Huntington and returned to the White Mountains the following two summers. After the death of his second wife in 1857, Durand spent his remaining years painting in New York. He produced his last painting, *Sunset Souvenir of the Adirondacks,* in 1877, nine years before his death.

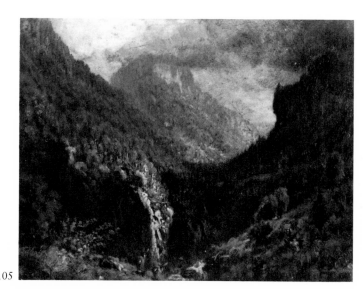

105. John Joseph Enneking, *Old Man of the Mountains*, n.d. Lent anonymously

105

FRANCONIA, WHITE MOUNTAINS
Ca. 1857
Oil on canvas
50.8 × 76.2 cm.; 20 × 30 in.
Unsigned
Lent by The New-York Historical Society, Robert L. Stuart Collection

Durand spent several summer months in New Hampshire during 1855, 1856, and 1857. First attracted to the area by fellow artists, gathered with Champney in North Conway, he seems to have been particularly drawn to Campton, which opened on the scene of Mount Lafayette and the Franconia Mountains, rather than the more usual rendezvous of artists in the Conway Valley, bounded by Mount Washington and the White Mountains. This stunning panoramic view, bathed in the characteristic mellow light favored by Durand, expresses the serenity and pastoral arcadia seen so often in his work. The Pemigewasset River is calm, the air balmy, foreground detail is carefully delineated, as one would expect from his training as an engraver. One is lulled by the easy beauty of the view; rain, snow, cold winds, black flies, or any other annoyance could not mar the peace of the idyllic land. Mr. R. L. Stuart, for whom the picture was painted, noted, when he sent the artist a check in payment: "Being much pleased with the painting, I have made the amount still more than I mentioned to you." *(ill. 90)*

ENNEKING, JOHN JOSEPH

Born: Minster, Ohio; October 4, 1841
Died: Hyde Park, Mass.; November 16, 1916

Bibliography:
Pierce, Patricia; and Kristiansen, Rolf. *John Joseph Enneking.* Abington, Mass.: Lougere Printing, 1972.

John Enneking was orphaned at the age of sixteen and left his father's farm to live with an aunt. His first art lessons, taken at Mount St. Mary's College in Cincinnati, were interrupted when he enlisted in the Union Army during the War Between the States. Severely wounded in action and discharged from service, Enneking eventually made his way to Boston to continue art lessons. For a time he studied industrial drawing and lithography, but dropped it when his eyes weakened. Tinsmithing proved more profitable, and while he flourished at this occupation he married and built a large home in Hyde Park, Mass. He became a partner in a wholesale establishment that soon after failed, and again Enneking returned to art.

His efforts finally met success, and by the time he sailed for Europe in 1872, his career as an artist had been assured. He traveled through England, Holland, Austria, Germany, Italy, and France, studying with Adolph-Henrich Lier, Léon Bonnet, and Charles Daubigny, and became acquainted with Millet and Corot. His later style became more and more Impressionistic, losing much of the grandeur of his earlier European teachers. He won medals in Boston, St. Louis, and at The Pan-American Expositions of 1901 and 1915, in Buffalo and San Francisco respectively.

OLD MAN OF THE MOUNTAIN
n.d.
Oil on academy board
23.2 × 30.8 cm.; 9⅛ × 12⅛ in.
Signed lower left: Enneking. On back of panel is stamped a large "W" indicating that it came from Norman Ward, a grandson of Enneking
Lent anonymously

This mountainous scene bears little resemblance to the emblem of the state of New Hampshire. The stormy scene presents Enneking as capable of far more dramatic work than his more usual pastoral scenes and evening-lit forests. He must have been generally a phlegmatic personality, for while painting on the slopes of Mount Chocorua with friends, a bear strolled out of the forest, at which everyone fled except Enneking, who remained, unperturbed, to finish his work. *(ill. 105)*

FISHER, ALVAN

Born: Needham, Mass.; 1792
Died: Dedham, Mass.; February 14, 1863

Bibliography:
Vose, Robert C., Jr. "Alvan Fisher, 1792–1863, American Pioneer in Landscape and Genre." *Connecticut Historical Society Bulletin* 27, no. 4 (Oct. 1962).

Alvan Fisher was a Boston painter who studied decorative painting on furniture with John Ritto Penniman early in his career. He aspired to paint pictures, however, and later worked hard to shake off "that mechanical, ornamental touch." By 1816, Fisher was producing scenes of stables and barnyards that were novel at that time and showed his skill in painting animals and the effects of light. He had enough portrait commissions as well to enable him to make an adequate living and to become well established in the Boston artistic community. The Pennsylvania Academy of the Fine Arts first exhibited Fisher's work in 1817, and later his work was shown in New York and at the Boston Athenaeum. The National Academy of Design elected him an honorary member in 1827. Throughout his career, Fisher traveled extensively along the east coast of the United States, and in 1825 he visited Europe, taking numerous sketches and notes.

Fisher was in the White Mountains with Thomas Doughty and other Boston artists prior to 1856. Working in the romantic tradition of the early Hudson River School, Fisher's landscape compositions were sometimes imaginary scenes and often featured animal as well as human forms.

INDIANS CROSSING A FROZEN LAKE
1845
Oil on canvas
61.0 × 76.2 cm.; 24 × 30 in.
Signed lower left: A. Fisher
Lent anonymously

Unusual not only because it is a winter landscape, but also for its depiction of native Americans, *Indians Crossing a Frozen Lake* is undoubtedly one of Fisher's most imaginative compositions. By the mid-nineteenth century, travelers in the White Mountains would not have encountered many Indians except perhaps those who had married with the local population or who came down from Canada in the summers to sell souvenirs to the tourists. But Indian lore and legends were very popular and figured prominently in the various histories and travel guides published in the nineteenth and early twentieth centuries. Moreover, Fisher had painted American Indians in his illustrations of Cooper's novel, *The Prairie,* in 1828, and he made reference to B. B. Thatcher's *Tales of the Indians* in his notebooks. Drawn from these ideas, he might have been inspired by the White Mountains' historical connection with Indians and composed this scene. *(ill. 87)*

CROSSING THE SACO RIVER, CONWAY
n.d.
Oil on canvas
69.9 × 101.0 cm.; 27½ × 39¾ in.
Unsigned
Lent anonymously

Fisher's special talent for painting animals and a proclivity for genre scenes are revealed in this view of a party of tourists on horseback crossing the Saco River. The peak of Mount Washington towers over the small figures in the foreground, creating a contrast in scale that is further developed by the contrasts of light and shade and the sense of intimacy versus distance. The spirited horses and the gay costumes of the riders are painted in careful detail. While the presence of women may seem incongruous, early histories of the region and travel guides tell us that women were consistently present in the parties of adventurers and tourists in the White Mountains. *(ill. 106)*

106. Alvan Fisher, *Crossing the Saco River, Conway,* n.d. Lent anonymously

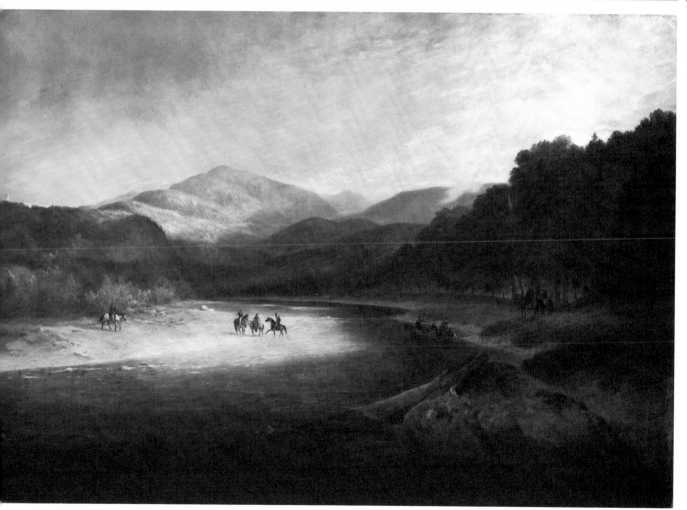

107

GAY, WINCKWORTH ALLAN

Born: Hingham, Mass.; August 18, 1821
Died: Hingham, Mass.; February 23, 1910

Winckworth Gay first studied painting with Robert Weir at West Point and later, in 1847, with Constant Troyon in Paris. He returned from Europe in 1850 and established a studio in Boston, where he stayed for most of the remainder of his life.

Benjamin Champney had been Gay's traveling companion in Europe and the two friends visited North Conway together in 1853. While Champney later made that village his New Hampshire home and painted many views of the surrounding scenery, Gay became more closely associated with the Franconia Notch area. Most of his White Mountain paintings are depictions of that region. He often stayed at the Stag and Hounds Inn in Campton Village with other artists like Asher Durand, Samuel Gerry, Samuel Griggs, and George Loring Brown. Gay exhibited at the Boston Athenaeum and in New York City and Philadelphia, showing both European and New England landscapes and coastal scenes.

Typical of his style, which showed the strong influence of his early training in the French and English landscape traditions, were broad, panoramic compositions painted with careful attention to detail and topographical accuracy. Henry Tuckerman wrote in his *Book of the Artists* in 1861 that the expressions of "truth, beauty and grandeur" in Gay's paintings were comparable to the writings of Hawthorne, Thoreau, Emerson, and Dana.

WELCH MOUNTAIN FROM WEST CAMPTON
1856
Oil on cardboard
21.0 × 30.5 cm.; 8½ × 12 in.
Inscribed on back of board, top center in black ink: Welch Mt. from West Campton, N.H./ W.A.G. 1856.
Collection of The Brooklyn Museum, Dick S. Ramsay Fund

Welch Mountain, now generally unknown to casual tourists, rises majestically above the town of West Campton and is particularly spectacular because of its vast open granite ledges. The town, in the nineteenth century, was a prosperous, thriving agricultural community with several mills on the Mad River, seen here meandering placidly in the center of the painting. As in many of the paintings of the mid-nineteenth century, particularly Harrison Bird Brown's view of the same scene (ill. 95), the pastures stretching far up the hillsides are indicative of the importance of agriculture to the community. Gay was one of the coterie of artists who carried on a friendly rivalry in letters to *The Crayon* with the Conway area artists. *(ill. 109)*

GERRY, SAMUEL LANCASTER

Born: Boston, Mass.; May 10, 1813
Died: Roxbury, Mass.; April, 1891

Like many of his contemporaries, Gerry had no formal training as an artist but made the ritualistic trip abroad to observe paintings of the masters in England, France, Italy and Switzerland. Gerry maintained a studio in Boston and, for a while, conducted classes at the Tremont Street Studio Building there. He supported the Boston Art Club from its inception in 1854, and was one of its first presidents. Throughout his career, Gerry painted portraits, genre, and animals, as well as landscape, exhibiting them at the Boston Athenaeum, the Pennsylvania Academy of the Fine Arts, and the American Art Union in New York.

HARVEST TIME, RED HILL, SQUAM LAKE, N.H.
Ca. 1857
Oil on canvas
35.6 × 50.8 cm.; 14 × 20 in.
Signed lower right: S. L. Gerry
Lent by Henry Melville Fuller

The vast expanse of Red Hill presented gently rising slopes to the south and west which made excellent pasture land. The Cook family settled on the saddle of the mountain about 1788 and farmed, made maple sugar from the extensive maple groves, and gave refreshment to summer visitors who climbed the hill from Center Harbor, having read Timothy Dwight's glowing description of the magnificent

108

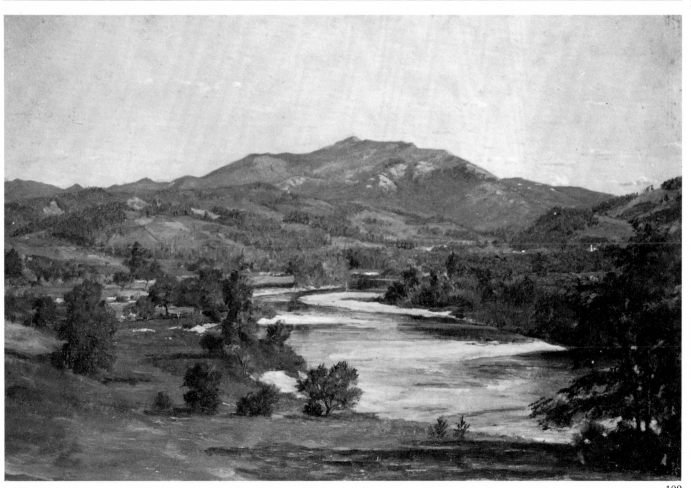

109

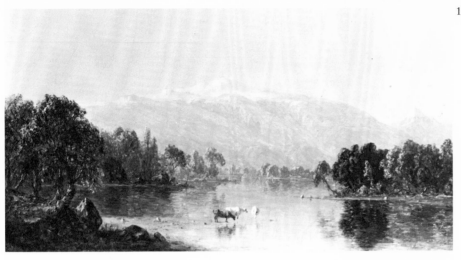

110. Sanford Robinson Gifford, *Mount Washington from the Saco*, ca. 1854. Lent anonymously

111. A. M. Gregory, *Winter Sunset, Walker's Pond, Conway, N.H.*, 1886. Lent anonymously

112. Samuel W. Griggs, *Haying Time in New England*, 1876. Lent anonymously

view to be obtained from the summit. This is an autumn view of the Cook fields with Squam Lake glittering in the distance and the farm workers bringing to an end the summer's harvest. *(ill. 107)*

THE FLUME
n.d.
Oil on canvas
80.4 × 50.8 cm.; 31⅝ × 20 in.
Signed lower left: S. L. Gerry
Collection of New Hampshire Historical Society

The Flume, with its suspended boulder, was one of the major attractions of the Franconia Notch until the famous spring freshet of 1883 drove the boulder to oblivion. The cool, narrow canyon was a welcome asylum from the summer heat and gave one a sense of awe. Gerry, who started painting in the White Mountains before 1840, roamed New Hampshire for more than thirty years. He was perhaps the first to paint a finished work of this famous subject. *(ill. 108)*

GIFFORD, SANFORD ROBINSON

Born: Greenfield, N.Y.; 1823
Died: New York, N.Y.; 1880

Bibliography:
Cikovsky, Nikolai Jr. "Introduction," *Sanford Robinson Gifford.* Austin, Texas: University of Texas Art Museum, 1970.

One of the few artists of the nineteenth century to attend college, Sanford Robinson Gifford was born in Greenfield, Saratoga County, New York, and studied from 1842 to 1844 at Brown University. He left Providence for New York City to pursue a career in art in 1845. A sketching trip to the Catskills and Berkshires in the following year focused Gifford's interest on landscape painting. He became an associate member of the National Academy in 1850 and a full member in 1854, contributing regularly to exhibitions there after 1847. Gifford made several trips to Europe, one in 1855–1857 and another in 1859. He then served in the Civil War. From 1868 to 1870 he was again in Europe. A growing interest in Western scenery led to his exploration of the Rocky Mountains in 1870 with fellow artists Worthington Whittredge and John F. Kensett and prompted Gifford to make a second trip west in 1874. Gifford was in the White Mountains as early as 1853–54 and again following his service in the war, in 1865 or 1866. Like most of the Hudson River School artists, Gifford traveled widely and painted American scenery in many regions of the United States.

MOUNT WASHINGTON FROM THE SACO
Ca. 1854
Oil on canvas
26.6 × 50.8 cm.; 10½ × 20 in.
Lent anonymously

Sanford Gifford, a leading exponent of the Luminist movement, was a frequent visitor to the Conway area and painted many major works there. He was a friend of Bierstadt, Casilear, Kensett, and Champney, and, in the summer of 1854, rented a house with Samuel Coleman, R. W. Hubbard, and Aaron D. Shattuck near Moat Mountain House in Conway. This oil sketch was worked up from a pencil drawing titled *Mount Washington from the Saco*, dated September 16, 1854. A slightly larger, more finished version is also known, and a similar view, engraved by Wellstood, appeared in the *Ladies Repository*. John F. Weir, at a memorial meeting for Gifford at the Century Club in 1880, noted: "Gifford's art was poetic and reminiscent. It was not realistic, in the formal sense. It was nature passed through the alembic of a finely organized sensibility." *(ill. 110)*

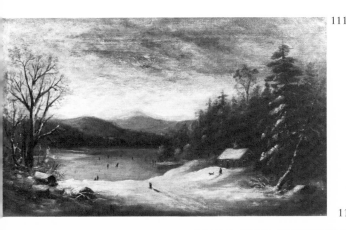

111

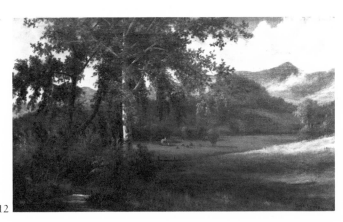

112

GREGORY, A. M.

Active in the 1880s

Only one small piece of information has come to light about this artist. Probably coming from Boston or its environs, he was listed as assistant in the painting department of the Academy of Art, which was situated at 460 Washington Street in Boston. The principal was W. H. Titcombe, who can be identified as William H. Titcombe (or Titcomb) (ill. 123).

WINTER SUNSET, WALKER'S POND, CONWAY, N.H.
1886
Oil on canvas
28.6 × 50.2 cm.; 11¼ × 19¾ in.
Signed lower right: A. M. Gregory 1886
Lent anonymously

This charming winter scene, though apparently designated as an actual place, is too vague in brushwork to be identified. It is improbable, also, that such a clear, glassy surface would be present on the lake with thick snow on the land. The artist, who hovers between the amateur and the professional, has presented the pleasurable aspects of winter; skating, sledding, walking in the snow with a pet dog, with the security of a warm cottage in the background. *(ill. 111)*

GRIGGS, SAMUEL W.

Born: unknown
Died: Boston, Mass.; May 16, 1898

Almost nothing is presently known about this artist. He was listed as an architect in Boston from 1848 to 1852 and as an artist from 1854 until his death. The competency of his brushstroke strongly suggests that he had professional training. His earliest currently datable painting of a White Mountain scene is 1858. That year, he exhibited three paintings, one of which was a White Mountain view, in an exhibition gathered together by Albert Bierstadt and held at New Bedford, Mass. He also exhibited at various times at the Athenaeum Gallery in Boston from 1855 to 1863 and at the Boston Art Club. The year of his death he lived at 63 Studio Building in Boston.

HAYING TIME IN NEW ENGLAND
1876
Oil on canvas
38.8 × 64.5 cm.; 15½ × 25⅜ in.
Signed and dated lower right: S. W. Griggs 1876
Lent anonymously

The subject of this work evokes effectively a warm summer afternoon. The wisps rising on the mountain are from fires lighted to clear the land for pastures, a common practice at the time. The haywain is a tiny object in the gentle landscape which Griggs has bathed in the long, slanting light of late afternoon. The scene is thought to be of Mount Whiteface from the intervale. *(ill. 112)*

HALSALL, WILLIAM FORMBY (or Formsby)

Born: Kirkdale, England; November, 1841
Died: Provincetown, Mass.; March 21, 1919

William Halsall was primarily known for his marine paintings. He came by his love of the ocean early in life, for he went to sea at the age of twelve and was a sailor for the next seven years. In 1860, he came to Boston and turned to fresco painting with William E. Norton, who was also his teacher. After serving for two years in the Navy during the Civil War, he returned to Boston and took up fresco painting again in 1863. He studied at the Lowell Institute for eight years, and, during this time, he turned to marine paintings, sharing a studio with Norton, his old teacher.

SUMMIT OF MOUNT WASHINGTON IN WINTER
1889
Oil on canvas
48.3 × 68.6 cm.; 19 × 27 in.
Signed lower right: W.F. Halsall '89
Lent by Littleton Public Library

There is no evidence that Halsall actually painted or sketched this frigid scene from nature, but many early stereoscopic views attest to the accuracy of this scene of the bleak, ice-covered buildings, with rime, blown like pennants from the poles in the center left. The frame, with its strong pattern of ferns, leaves, flowers, and wheat beards, offers an important foil to the

114

100

simple cloud masses and snow banks of the painting. *(ill. 113)*

HART, WILLIAM

Born: Paisley, Scotland; 1823
Died: Mount Vernon, N.Y.; 1894

Brought to this country by his parents as a youngster, William Hart began his career as a coach and ornamental painter in Troy, N.Y. For several years he traveled through the state as an itinerant painter before going abroad to study. From 1852 on, he kept a studio in New York City. From the dates of his White Mountain views, he must have traveled in the area many times between 1859 and 1870. *Chocorua Peak* was engraved by Wellstood in 1861, giving his work a wide audience. He exhibited at the Boston Athenaeum Gallery and at the National Academy of Design throughout his active life as an artist. Albany, N.Y. was an important art center in the mid-nineteenth century and Hart's work was exhibited at the studio of Erastus Dow Palmer in that city in 1864, for the benefit of the United States Sanitary Commission.

MOONLIGHT ON MOUNT CARTER, GORHAM
1859
Pencil and white wash on brown paper
31.2 × 48.0 cm.; 12¼ × 18⅞ in.
Signed lower center: Wm. Hart 1859
Collection of Vassar College Art Gallery

This is an unusual view of the White Mountains, which Hart probably chose

because Gorham was one of the first areas adjacent to the White Mountains which could be reached by train. Franconia and Crawford notches could only be gained by a long and arduous coach ride. William Hart's early years of training as a commercial painter sharpened his eye to the essence of a scene such as this one. The composition is effectively balanced by the white of the rising moon and the dark mass of the trees at the right. The deep folds of the mountain lead the eye to the peak placed in the center of the picture. *(ill. 7)*

HILL, EDWARD

Born: Wolverham, England; December 9, 1843
Died: Hood River, Oregon; 1923

Less known than his brother Thomas, Edward Hill was also a landscape painter, primarily of New Hampshire scenery. He grew up in Taunton and Salem, Mass., and began work as a decorative painter at the Heywood-Wakefield Company in Gardner, where his brother also worked.

In 1864, he married and moved to Nashua, New Hampshire; ten years later, he bought land further north in Lancaster and probably built a home there. He traveled to North Carolina in 1879 and between 1880 and 1895 made several trips to England and Italy. His surviving paintings of the White Mountains date from the late 1870s through the 1890s. In 1895, he probably moved back to Nashua, where he is listed in the city directory of that year.

Hill painted at the Glen House in Pinkham Notch with John Paul Selinger and at the Flume House, where he is said to have had his own studio. His friendship with the photographer Benjamin West Kilburn of Littleton may hold further clues to his history. About 1879, Hill had a studio in Littleton and many of his paintings bear a close relationship to the stereopticon views which Kilburn produced at his factory there between 1867 and 1909. Late in his life, Hill visited Colorado, and he died in Oregon in 1923. *(Author's note:* Charles and Gloria Vogel extended valuable assistance concerning Hill.)

LUMBERING CAMP IN WINTER
1882
Oil on canvas
50.8 × 76.2 cm.; 20 × 30 in.
Signed lower left: Edward Hill 1882
Collection of New Hampshire Historical Society

Painted ten years before *Maple Sugaring in New Hampshire,* this scene is a similar portrayal of men working to make a living in the harsh winter environment of the mountains. The setting in both is a forest interior, here on a grey winter day with only a small patch of sky visible through the trees. No sunlight enters the scene. The snow on the ground is dingy and tracked with mud and the task of cutting trees and hauling logs seems endless and insurmountable. The bright red and blue splashes of laundry drying on a line outside the cabin afford the only relief from the pervasive gloom. A bearded figure leading a team of oxen goes about his

113. William Formby Halsall, *Summit of Mount Washington in Winter,* 1889. Littleton Public Library, N.H.

114. Edward Hill, *View from Mount Willard,* ca. 1877. Collection of New Hampshire Historical Society

work with resignation and the unquestioning posture of one whose only concern is survival. Hill's image of the scene is filled with bleakness and yet provides viewers of this century with an insight into the details of the logger's life nearly a century ago. *(ill. 32)*

VIEW FROM MOUNT WILLARD
n.d.
Oil on canvas
30.5 × 50.8 cm.; 12 × 20 in.
Signed lower left: E. Hill
Collection of New Hampshire Historical Society

Crawford Notch was a popular location for landscape painters in the White Mountains. The sweeping symmetrical curves of the mountains were ideal to focus attention on the single dwelling in the notch and the towering slopes on either side—a composition employed by other artists such as Thomas Cole, Alvan Fisher, and Frank Shapleigh. This view is taken from Mount Willard, looking south, with the Willey farm in the center. The slides and shadows on the mountains are the prominent features of the landscape, and the house seems dwarfed and abandoned. In the distance, a thin curve along the mountain ridge suggests the presence of the railroad, but the artist only hints at that intrusion of man in this painting. Uncharacteristically, Hill has made a moderately successful attempt to paint a realistic sky and the effect of light on the air and landscape. He uses bright, clear color to create a simple, straightforward depiction of the mountain vista. *(ill. 114)*

HODGDON, SYLVESTER PHELPS

Born: Salem, Mass.; December 25, 1830
Died: Dorchester, Mass.; August 20, 1906

Sylvester Hodgdon first studied with Benjamin Champney in Boston and, later, under Samuel Rouse in New York City. In the early 1850s, he worked as a lithographer for the firm of L. H. Bradford in Boston, during which time he executed views of the *Flume* and the *Old Man of the Mountain.* For thirty years he kept a studio in the Tremont Street Studio Building in Boston. Though primarily known for his landscapes, Hodgdon also taught life classes in both the Boston Museum School and the Boston Art Club, of which he was a charter member. During the 1870s, he worked in the then-popular medium of etching. His later work loses the tight linearity of his early paintings.

WHITE MOUNTAINS IN SEPTEMBER, NORTH CONWAY, N.H.
1853
Oil on canvas
50.8 × 76.2 cm.; 20 × 30 in.
Signed and dated lower right: S. P. Hodgdon 1853/White Mountains in September, North Conway, N.H.
Collection of The University of Michigan Museum of Art, Bequest of Henry C. Lewis, 1895

This familiar scene can be compared to many others of the same subject in the exhibition. Of continual fascination was the juxtaposition of winter and fading summer, here emphasized in the chill white cone of Mount Washington frowning on the sun-drenched intervale, dotted with sheep and cattle and a well-filled haywain. The following lines which John Greenleaf Whittier wrote in the prelude to *Among the Hills,* while staying at West Ossipee, N.H. in 1868, could have been written about this very painting.
. . . The locust by the wall
Stabs the noon-silence with his sharp alarm.
A single hay-cart down the dusty road
Creaks slowly, with its driver fast asleep
On the load's top. Against a hill,
Huddled along the stone wall's shady side,
The sheep show white, as if a snowdrift still
Defied the dog-star. . . .
(ill. 63)

HOMER, WINSLOW

Born: Boston, Mass.; February 24, 1836
Died: Scarboro, Me.; September 29, 1910

Bibliography:
Gardner, Albert Ten Eyck. *Winslow Homer*. New York: Bramhall, 1961.
Goodrich, Lloyd. *Winslow Homer*. New York: The Macmillan Company for the Whitney Museum of American Art, 1944.

At the age of nineteen, Winslow Homer was apprenticed to J. H. Bufford's lithographic firm in Boston. Although the superior quality of his work earned him more and more responsibility, he found the work stifling and tedious and, upon attaining his majority, he left the shop to become a freelance illustrator. In 1859, Homer moved to New York, where he studied briefly at the National Academy of Design and took a few painting lessons with Frederic Rondel. For the next seventeen years, his major source of income came from drawings for illustrated weeklies such as *Harper's*, *Leslie's*, and *Appleton's*. He devoted increasing attention to painting, however, and, in 1865, he was elected a member of the National Academy of Design and was further distinguished by the exhibition of his *Prisoners at the Front* at the Paris Exposition of 1866.

Homer went to Paris that year, but little is known of his activities during the 10 months he spent there. Domestic travel for the next 15 years included trips to the White Mountains the summers of 1868 and 1869, the Adirondacks, and Gloucester, Mass. in 1873. It is significant that, when Homer returned to Europe in 1881, he did not go back to Paris, which was bursting with American art students at the *ateliers*, but chose, instead, the small fishing community of Tynemouth, on the cold, grey, northeast coast of England.

Following his return home in 1882, Homer moved from his New York studio to the rugged coast of Prout's Neck, Maine. For the remainder of his life this was his home, though he continued seasonal travels to Quebec and the Adirondacks in the summer months, and Florida, Bermuda, and Nassau in the Bahamas in the winter.

SUMMIT OF MOUNT WASHINGTON
1869
Oil on canvas
41.3 × 61.0 cm.; 16¼ × 24 in.
Signed lower right: Winslow Homer-1869-
Collection of The Art Institute of Chicago. Gift of Mrs. Richard E. Danielson and Mrs. Chauncey McCormick

In this painting, the main figures have been pushed into the center of the composition, with the weary horses between them and the inhospitable foreground of jumbled rocks and dead twigs. Though sunlight plays on the figures, clouds and mist swirl over the mountain top, veiling the tiny climbers. There is a general sense of human frailty striving to ascend to the distant Summit House, seen vaguely in the very top of the picture.

Were not Homer such a pragmatist, one might read into this work the sort of Sublime lesson of man's insignificance before nature as the Visible Hand of God which had so imbued Thomas Cole's paintings. A very similar version of this painting was engraved for *Harper's* for July 10, 1869. There, however, perhaps for the sake of the wider audience, Homer enlarged the female figures and placed them as important in the foreground. Though the engraving is essentially the same, the rearrangement of the composition has changed the whole feeling of the work to that of a pleasant summer outing. *(ill. 24)*

HUNTINGTON, DANIEL

Born: New York, N.Y.; October 14, 1816
Died: New York, N.Y.; April 18, 1906

Bibliography:
Daniel Huntington. Ithaca, N.Y.: Ithaca College Museum of Art, 1971.

Daniel Huntington studied under Samuel F. B. Morse and is probably best known for his portraits, though his landscapes elicited the following comment in *The Crayon* of May, 1858: "M. Huntington was born a landscape painter, and it is to be regretted that the pictures he paints in this high department of Art are not more frequent. . . . His landscapes seem to be more the pastime of leisure hours than of steady laborious purpose. . . . [He possesses] a recognition of the spirit and principles of light . . . as may be seen in the *Mill Pond at Chocorua*."

This painting was exhibited at the National Academy of Design in the same year. Huntington was a member of this organization from 1841 to his death in 1906, president from 1862 to 1870, and president again from 1877 to 1890. He seems to have particularly enjoyed painting Chocorua, making sketches there as early as 1854. A view he executed in 1860 was engraved by John Filmore. A friend of Champney and the convivial group who congregated every summer in North Conway to paint and "talk shop," Huntington was often in the White Mountains and produced many sketches of the area.

CHICORUA POND AND MOUNTAIN
September 28, 1854
Pencil on cream paper
25.9 × 35.5 cm.; 10⅛ × 14 in.
Place and date on lower right: chicorua pond—Sep 28./54
Collection of Cooper-Hewitt Museum, Smithsonian Institution

The contemporary comment on Huntington's ability as a landscapist can be seen in this delicate, well-composed drawing. Huntington seems to have been particularly interested in depicting this mountain and produced several paintings of the scene. Earlier in his career, he represented the scene as a wild rocky looming form, surrounded by impenetrable forests. Here, some twenty years later, the land has been cleared by the industrious farmer and a tiny boat floats on the serene lake. In Huntington's long life, he saw many changes in the landscape made by man's encroachment on the New Hampshire wilderness. *(ill. 56)*

INNESS, GEORGE

Born: Newburgh, N.Y.; May 1, 1825
Died: Bridge-of-Allan, Scotland; August 3, 1894

Bibliography:
Ireland, Leroy. *George Inness.* Austin: University of Texas, 1965.

George Inness began his career in 1841 as an apprentice in a map engraver's firm in New York City, where he worked for one year. The only formal training he received came from Regis Gignoux in 1845, the same year he exhibited at the American Art-Union. He first exhibited at the National Academy of Design in 1844, and continued to do so for the rest of his life. He also exhibited frequently at the Brooklyn Art Association. Inness seems to have had an inner restlessness, for he moved frequently and made numerous trips to England, Italy, and France, where he was exposed to the Barbizon School. The last sixteen years of his life included trips to Mexico City, Cuba, Florida, the Yosemite Valley, and Europe. Inness was fond of New Hampshire and kept a studio on the second floor of the North Conway Academy for several years, until 1876.

Following Inness's exposure to the Barbizon School, his compositions lost the tight linearity of his early work. The broad, fluid brush work of this painting is representative of an emerging style he developed fully in later years. Of his painting and of an artist's obligations, Inness said: "A work of art does not appeal to the intellect. It does not appeal to the moral sense. Its aim is not to instruct, not to edify, but to awaken an emotion." Such a philosophy is a direct contradiction of the earlier aims of Thomas Cole, or Alvan Fisher, or the topographical clarity of David Johnson or Asher Durand.

MOUNT WASHINGTON
Ca. 1875
Oil on canvas
49.9 × 75.0 cm.; 19⅝ × 29½ in.
Signed lower right: G. Inness
Collection of Davis & Long Company, New York

This soft, gentle view is a startling contrast to many other paintings of this mountain. Mount Washington floats like a white cloud in the hazy air. Presumably, from the verdant greens, it is late spring. Cows browse peacefully, and a church spire glimmers through the trees. The eye of the artist, his training, and the period in which the work was executed, all give mute testimony in this canvas. *(ill. 68)*

JOHNSON, DAVID

Born: New York, N.Y.; May 10, 1827
Died: Walden, N.Y.; January 30, 1908

David Johnson's only specific training as an artist was a year's study, in 1850, under Jasper Cropsey. By the following year, he was in New Hampshire taking sketches

115. John Frederick Kensett, *Mount Washington,* 1851. Collection of the Corcoran Gallery of Art, Gift of William Wilson Corcoran

116. John Frederick Kensett, *The White Mountains, Mount Washington,* 1869. The Wellesley College Museum, Gift of Mr. and Mrs. James B. Munn (Ruth C. Hanford, '09) in the name of the class of 1909

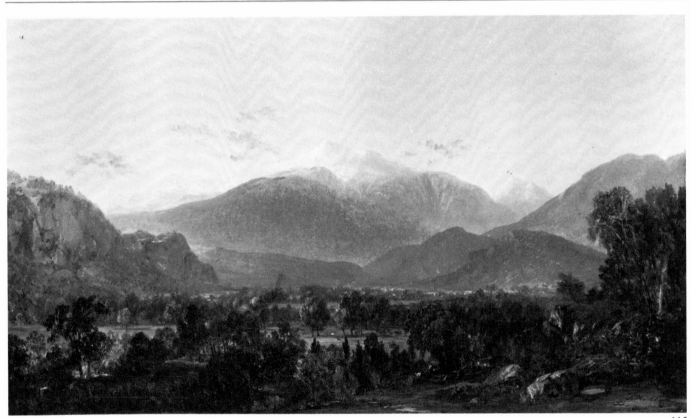

115

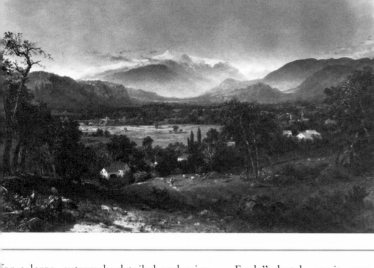

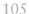

for a large, extremely detailed and crisp view of Mount Washington from the village of North Conway (Museum of Fine Arts, Boston; M. and M. Karolik Collection). He often returned to New Hampshire in ensuing years to paint works which he exhibited at the Brooklyn Art Association and at the National Academy of Design, to which he was elected as a member in 1861. Benjamin Champney, in his autobiography, noted Johnson as a friend and prophetically stated in 1900: "The solid and unpretending in art must patiently wait its time." It has taken almost a century for such solid and unpretending landscapes as Johnson's and others of his era again to be appreciated.

STUDY, FRANCONIA MOUNTAINS FROM WEST CAMPTON, N.H.
Ca. 1860
Oil on canvas
36.9 × 66.1 cm.; 14½ × 26 in.
Signed lower right with monogram: DJ; inscribed on reverse: Study, Franconia Mountains from West Campton N.H. D. Johnson
Collection of Wadsworth Atheneum, Hartford, Conn. Bequest of Mrs. Clara Hinton Gould

Comparison of this painting with the larger work by Asher B. Durand, dated 1858 (ill. 90), both of which are taken from an almost identical view, reveal such similarities—the road, the trees at the left, the houses in the middle, the tree bending over the Pemigewasset River—that this painting can almost certainly be dated about 1860. Perhaps Johnson also stayed at the "Stag and Hounds and Ferocious

Eagle" hotel, as it was affectionately called by the artists who stayed there, and where Durand spent August of 1856 and 1857.

The different approach to the subject by each artist is also of interest. Durand's sketch for his finished work is almost as sharply delineated as Johnson's finished work, but his final version heightens the Franconia Mountains and softens the atmosphere into a pastoral ideal. Johnson, on the other hand, leaves no detail out. The hills are cleared for pasture land, the sheaves are stacked, the notch is seen in factual clarity, unromanticized as to height. Such paintings as this give a valuable insight into the topography of New Hampshire and its agriculture and also recognize the great interest in precise records as supplied by photographs and as championed by Sir John Ruskin and the English painters of the Pre-Raphaelite Brotherhood. *(ill. 8)*

KENSETT, JOHN FREDERICK

Born: Cheshire, Conn.; March 22, 1816
Died: New York, N.Y.; December 14, 1872

Bibliography:
John Frederick Kensett. Saratoga Springs, N.Y.: Skidmore College, 1967.
John Frederick Kensett. New York: American Federation of the Arts, 1968.

Kensett first received instruction in the art of engraving from his father and later from his uncle, Alfred Daggett, who was a banknote engraver. At the age of

twenty-four, Kensett sailed for England with Asher B. Durand, John W. Casilear (both landscape painters who began as engravers), and Thomas P. Rossiter (a portrait painter).

While abroad for seven years, Kensett traveled widely, occasionally on foot, through France, Germany, Italy, and Switzerland, painting from nature. In 1845, he gained recognition from the Royal Academy and The British Institution in London, where a few of his paintings were exhibited.

During the forty-five years after his return to America, and before his sudden death of a heart attack, Kensett enjoyed a productive and successful artistic career. His philanthropic contributions to young, struggling artists and active membership in many art organizations earned him great esteem. He served on the council of the National Academy of Design and was a founder of the Artist's Fund Society of New York and the Metropolitan Museum of Art. In 1859, President Buchanan appointed Kensett a member of the first Federal Art Commission.

Among his artist friends was Benjamin Champney, whom Kensett first met in Paris; later in 1850 he traveled with his friend to the White Mountains. During his lifetime, Kensett's paintings commanded handsome prices. Sketches of Mount Washington and Franconia Notch sold for fifty and sixty dollars in 1851, and *Mount Chocorua* brought him $5,000 in 1866, when commissioned by the Century Club in New York, where it still hangs.

WHITE MOUNTAIN NOTCH
August 5, 1851
Pencil on colored paper heightened with white
27 × 37.6 cm.; 10⅝ × 14⅞ in.
Signed lower right: White Mountain Notch, August 5th, 1851
Lent by The Art Museum, Princeton University (Mather Collection)

This factual drawing can be compared to Thomas Cole's sketch of the same place, executed some twelve years earlier (The Art Museum, Princeton University), and one by William Trost Richards (ill. 118), the year the Notch House was destroyed by fire. There is little or no change in the sharply enclosed interval, with the tiny Notch House hidden among the trees at the left. The narrow cleft in the mountains, which was first discovered by settlers in 1771, was opened to trade in 1803 by the building of the Tenth Turnpike Road. The scene has remained essentially the same to this day. *(ill. 41)*

MOUNT WASHINGTON
1851
Oil on canvas
28.9 × 50.8 cm.; 11⅜ × 20 in.
Signed lower right: JF.K. 51
Collection of Corcoran Gallery of Art.
Gift of William Wilson Corcoran

Kensett first visited the White Mountains in 1849, and returned to North Conway in October of 1850 with his friend, Benjamin Champney. He came again in 1851, drawn to the majestic view of Mount Washington from the Conway Valley. This is a sketch for his large painting of the scene, which was bought by the American Art-Union in 1851 and engraved for them by George Smillie. He painted many views of Mount Washington throughout his lifetime, of which this is perhaps the first. *(ill. 115)*

THE WHITE MOUNTAINS, MOUNT WASHINGTON
1869
Oil on canvas
101.6 × 152.4 cm.; 40 × 60 in.
Signed lower right: J.K. 1869
Collection of The Wellesley College Museum. Gift of Mr. and Mrs. James B. Munn (Ruth C. Hanford, '09) in the name of the Class of 1909

Kensett painted this exact replica of his famous view, now lost, which was engraved for the American Art-Union in 1851. Many copies by other artists have come to light (e.g., ill. 122). Whether they were taken from the original, which may have hung in Benjamin Champney's North Conway studio, or from the engraving, can only be conjectured. It was certainly very popular and, as an evocation of pastoral America, it is a masterpiece, with its cluster of white houses, half hidden by trees, the golden valley stretching to the majestic mountains, the meandering Saco glinting in the sunlight in a time before factories and chugging trains filled the sky with smoke and polluted the rivers. *(ill. 116)*

MOORE, CHARLES HERBERT

Born: New York, N.Y.; April 10, 1840
Died: Hartfield, Hampshire, England; February 15, 1930

Bibliography:
Mather, Frank Jewett, Jr. *Charles Herbert Moore, Landscape Painter.* Princeton, N.J.: Princeton University Press, 1957.

Charles Moore's long life encompassed landscape painting, teaching fine arts and art principles at Harvard, and writing on the subject of art and art history. He was fascinated by the looming bulk of Mount Washington and studied it from every angle during the summers of 1869 and 1870. His style was the meticulous rendering of the English Pre-Raphaelite School, extolled by John Ruskin, and also embraced by William Trost Richards at about the same time. Both Richards and Moore produced exquisite watercolors of New Hampshire scenes. Though Moore painted professionally from 1858 to 1871, at which time he turned to teaching, his method was perforce slow and laborious, and his *oeuvre* is consequently small.

MOUNT WASHINGTON

Ca. 1870
Watercolor on paper
40.6 × 55.9 cm.; 16 × 22 in.
Lent by The Art Museum, Princeton University (Gift of Miss E. H. Moore)

Though this work is titled as a view of Mount Washington, it is, in reality, Moat Mountain, with Cathedral Ledge in the foreground. This delicate vignetted watercolor was probably taken from Humphrey's Ledge, near North Conway. Two meticulous graphite views of Mount Washington at the Fogg Art Museum are entirely different configurations; Moore's hyperrealism would brook no rearrangement of landscape features for effect. A notation on the reverse indicates that this work was exhibited at Everett and Williams rooms in Boston in the early 1870s, during the period that Moore was working on his many views of Mount Washington and a view of Kearsarge, dated 1872. (*ill. 117*)

PERRY, ENOCH WOOD, JR.

Born: Boston, Mass.; July 31, 1831
Died: New York, N.Y.; December 14, 1915

Enoch Perry went to Europe at the age of twenty-one and studied under Emanuel Leutze and Thomas Couture. First known as a portraitist, he settled in New York in 1866. He traveled widely in the far West and Hawaii. Returning to the East, he exhibited for many years at the National Academy of Design and turned more and more to genre painting. These paintings became extremely popular and were widely reproduced as chromolithographs.

THE PEMIGEWASSET COACH

Ca. 1899
Oil on canvas
108.0 × 169.0 cm.; 42½ × 66½ in.
Collection of Shelburne Museum, Inc.

This painting is almost a mirror image of another work by this artist—reproduced as a chromolithograph by the Artistic Publishing Company of New York in 1899—to which it should be compared. Though the chromo shows every detail and groups some of the children on the other side of the road, this painting is not entirely finished; wheel spokes, harness, and the hand of the waving lady are missing. The title presumably indicates the route through the valley of that name which leads to Franconia Notch, rather than the Pemigewasset House in Plymouth, N.H., for hotels of the period emblazoned their names boldly on the Concord coaches which they operated for their own hostelries. By the end of the century, these coaches were something of a rarity, having been replaced by railroads. (*ill. 27*)

PRATT, HENRY CHEEVER (sometimes Cheeves)

Born: Orford, N.H.; June 13, 1803
Died: Wakefield, Mass.; November 27, 1880

Bibliography:
Hodgson, Alice Doan. "Henry Cheever Pratt (1803–1880)." *Antiques* (November 1972), pp. 842–847.

Pratt's talent was discovered by Samuel F. B. Morse as the boy of fifteen was painting scenes on barn doors. The portrait artist took him to Boston as an errand boy and gave him lessons. Pratt assisted Morse in his work in Charleston, S.C. and also sketched in portrait heads in Morse's large painting of the House of Representatives. Probably through the early days of the National Academy of Design, Pratt and Thomas Cole, two years his senior, met and became friends. Together, they journeyed through the White Mountains in October, 1828, gathering sketches for studio paintings. Temperamentally, the two men were very different. Cole was poetic in feeling and wished through his paintings to convey the grandeur of nature as the Visible Hand of God. Pratt was factual and pragmatic. These traits are seen in both their paintings and their writings. Pratt was appointed official draughtsman to the United States-Mexican Boundary Commission, and his works reflect his topographical approach to landscape.

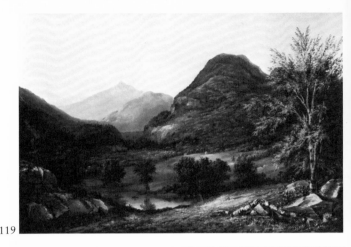

119

ON THE AMMONOOSUC
Ca. 1866
Oil on canvas
64.2 × 76.8 cm.; 25¼ × 30¼ in.
Lent by Museum of Fine Arts, Boston;
M. and M. Karolik Collection

An almost identical painting, of a slightly different size, is in the collection of the Orford (New Hampshire) Museum. It is dated circa 1866 and titled on the back, in the artist's hand, "Rapids in the Ammonoosuck at Littleton, N.H." The painting exhibited here had been thought to be from a sketch which Pratt made in 1828 a couple of miles from Crawford's Tavern, but Alice Doan Hodgson points out that Littleton is some 18 miles from Crawford's Tavern. *(ill. 36)*

RICHARDS, WILLIAM TROST

Born: Philadelphia, Penn.; November 14, 1833
Died: Newport, R.I.; November 8, 1905

Bibliography:
Morris, Harrison S. *Life of William T. Richards.* Philadelphia, Pa.: 1912.
William Trost Richards. Brooklyn, N.Y.: Brooklyn Museum, 1973.

William Trost Richards was one of the foremost proponents of the American Pre-Raphaelite movement, fostered in the 1850s—his formative years—by *The Crayon, The New Path,* and *The Craftsman,* all influential publications of the period. Meticulously faithful factual rendering was deemed essential, and

throughout his life, Richards practiced these tenets. His views of the White Mountains are almost photographically identifiable, yet he imbues them with a delicacy and atmospheric quality which makes them extraordinarily beautiful. Though he was proficient in oils, many of his most appealing works are executed in watercolor.

Richards was only twenty-one when he received a commission to have *Mount Vernon* engraved for the American Art-Union of 1854. Unfortunately, this was never carried out, as the Union was dissolved in 1853. His first publicly shown work was at the Bierstadt exhibition, in New Bedford in 1858, and, in 1859, he painted *The Great Stone Face.* In 1872, 1874, and 1876, he produced a number of watercolor views of the White Mountains of consummate beauty, several of which were presented to the Metropolitan Museum of Art by the Reverend Elias Magoon. In later years, Richards almost exclusively painted translucent watercolors of the sea.

CRAWFORD NOTCH
Ca. 1872
Pencil on paper (sketchbook sheet)
27.6 × 37.8 cm.; 10⅞ × 14⅞ in.
Lent by Oswaldo Rodriguez Roque,
New York

The personal touch of each artist in the renderings of this view by Thomas Cole, John F. Kensett, and William Richards make an interesting comparison. The scene is almost identical in all three sketches, though executed more than thirty years apart. This sketch may have

been taken in the early 1870s when Richards produced a series of exquisite watercolors of White Mountain views. The old Notch House is gone and the railroad has not yet thrust through the notch. The meadow that stretches to the mountain wall indicates human intrusion only in the faint track by the small pond, though, nearby, the Crawford House was a bustling hotel. *(ill. 118)*

SCOTT, JOHN WHITE ALLEN

Born: Roxbury, Mass.; 1815
Died: Cambridge, Mass.; March 4, 1907

John White Allen Scott began his artistic career as an apprentice to the lithographer William Pendleton, in his native Boston. Nathaniel Currier worked in the same shop. In the mid-1840s, Scott and Fitz Hugh Lane formed a business partnership to make and publish lithographs in Boston. Beginning about 1842, Scott exhibited his paintings at the Boston Athenaeum and other local galleries. He was a member of the Boston Art Club and, by 1905, had outlived all its other members. Scott painted and sketched until the end of his life.

118. William Trost Richards, *Crawford Notch,* ca. 1872. Lent by Oswaldo Rodriguez Roque, New York

119. John White Allen Scott, *In the Notch,* 1857. Collection of New Hampshire Historical Society

IN THE NOTCH
1857
Oil on canvas
61.0 × 91.5 cm.; 24 × 36 in.
Signed lower right: J.W.A. Scott/1857
Collection of New Hampshire Historical Society

This painting seems to be an imaginative amalgam of various elements in the New Hampshire mountains. Chocorua appears shadowy in the background, and the large, steep hill on the right might be a free interpretation of the cone of that mountain. The artist seems to have wished to present an idyllic scene, with tiny houses nestled against the mountain, bathed in warm sunlight; the meadow sloping to a pond on which floats a boat; a bowl of summer pasture land snug in the embracing arms of the hills. *(ill. 119)*

SHAPLEIGH, FRANK H.

Born: Boston, Mass.; March 7, 1842
Died: Jackson, N.H.; May 30, 1906

A relative latecomer to the artistic scene in the White Mountains, Frank Shapleigh was one of the most prolific painters of New Hampshire mountain scenery. Born in Boston, he studied there at the Lowell Institute of Drawing around 1860. When the Civil War broke out, he enlisted as a volunteer and served from 1862 to 1863. It was not until 1866 that he first visited the White Mountains. Between then and 1870, he visited California and went to Europe, where he studied in Paris with

Emile Lambinet, meanwhile continuing to maintain a studio in Boston.

He was a member of the Boston Art Club and frequently exhibited there. From 1877 to 1894, Shapleigh spent his summers at the Crawford House, living in a cozy studio near the big hotel, taking in pupils and painting hundreds of mountain scenes to sell to tourists. He was very successful and, according to Champney, who knew him well, "happy with his success."

A two-year trip to Europe from 1894 to 1896 ended his tenure at the Crawford House, and when he returned he built a home in Jackson called "Maple Knoll" behind the Jackson Falls House. He turned to watercolor painting almost exclusively in the 1890s and died in Jackson in 1906.

SAWMILL, JACKSON, N.H.
1874
Oil on panel
19.1 × 31.8 cm.; 7½ × 12½ in.
Signed and dated on lower right
Collection of Kennedy Galleries, New York

This work by Shapleigh was painted the year the artist was elected to the Boston Art Club. A prolific artist, he turned out hundreds of pleasant views of the White Mountains, both from his summer studio at the Crawford House and around Jackson, where he eventually built "Maple Knoll" as a permanent home. Because of his facility and tremendous volume of work, many of his paintings have a sketchy quality. They are accurate scenes

of his favorite haunts and can be verified by the many stereoscopic cards of the period. *(ill. 89)*

CRAWFORD NOTCH FROM MOUNT WILLARD
1877
Oil on canvas
55.9 × 91.5 cm.; 22 × 36 in.
Signed on reverse: The Crawford Valley from Mt. Willard by F.H. Shapleigh; on front, lower right: F.H. Shapleigh
Lent by Mr. and Mrs. Walter H. Rubin

Shapleigh produced many views of this spectacular cleft in the mountains. Charles Codman painted the scene as early as 1830, and Edward Hill was fond of the subject from the promontory over the precipitous cliff face of Mount Willard. After Thomas Crawford built a carriage road to this eminence in 1846, it was easily accessible, and guests from the Crawford House were consequently familiar with the scene. This view relieves the monotony of the great basin with the plume of smoke from the railway train, balanced by the white skirt of the onlooker and the patch of meadow land from the Willey House area. The scars of slides add tonal changes to the sweep of the hills, one warmly bathed in the setting sun, the other already greyed with the shadows of early evening. *(ill. 22)*

OLD MILL, JACKSON, N.H.
(GOODRICH FALLS)
1877
Oil on canvas
35.6 × 61.0 cm.; 14 × 24 in.
Signed lower left: F.H. Shapleigh 1877;
on reverse: Old Mill, Jackson, N.H. by
F.H. Shapleigh
Lent by Mr. and Mrs. Robert A. Gold-
berg, North Conway, N.H.

Goodrich Falls had attracted the eye of
such artists as Frederic Church, Albert
Bierstadt, and Edward Hill. In space, it is
a wonderful sight, falling some eighty feet.
However, Shapleigh chose to paint the
calm waters of the mill pond above, leav-
ing only the edges of the old plank dam
as a reminder of the turbulence beyond,
in a particularly pleasing composition.
Mills were an integral part of life in rural
New Hampshire and one of the first com-
mon buildings to be set up in a new com-
munity. Goodrich Falls now produces
electrical power. *(ill. 33)*

MOUNT WASHINGTON AND
WALKER'S POND FROM A BARN
1885
Oil on canvas
25.4 × 40.7 cm.; 10 × 16 in.
Signed lower right: F.H. Shapleigh 1885;
on reverse: Mt. Washington & Walker's
Pond from Old Barn in Conway, N.H.
by F.H. Shapleigh
Collection of Dartmouth College Mu-
seum & Galleries; purchased from the
Whittier Fund

Shapleigh painted this view many times—
Mount Washington seen from the interior
of a barn. A contrived view, it was never-
theless an effective device, for it juxta-
posed the elements of nature and
civilization. The landscape is literally seen
through a man-made structure and is lim-
ited and defined by it. Bright sunlight
from outside illuminates part of the barn
interior and focuses on the chickens and
a horse munching hay. One of Shapleigh's
better versions, this painting shows care-
ful attention to light and shadow which
are sometimes sacrificed in Shapleigh's
work to a sketchy, brushy style, the result
of his working very quickly. *(ill. 92)*

MOUNT WASHINGTON FROM
JACKSON
1885
Oil on canvas
55.9 × 91.5 cm.; 22 × 36 in.
Signed lower right: F.H. Shapleigh 1885
Lent anonymously

This view of the mountain was perhaps
taken from Wilson's Farm, two miles
from the town of Jackson. George Loring
Brown stayed here and produced his fa-
mous view, bought by the Prince of Wales
(since lost). According to an 1888 guide-
book, the same scene was popular with
Shapleigh, as well as George E. Niles and
George H. Merrill, both of whom had
studios in Jackson, and Benjamin Champ-
ney, among many others.
 Carter Notch is seen at the right, once
considered as a possible gap in the moun-
tains for a railroad between the Conways
and Gorham. The extensive cultivation up
the mountain slopes is evidence of the
importance of agriculture at the time.
Shapleigh's loose brushwork should be
compared to Shattuck's Pre-Raphaelite
detail in a similar view in this exhibition.
No atmospheric haze comes between the
viewer and the distance, but the factual
presentation is unimpeachable, a hall-
mark of Shapleigh's work. *(ill. 67)*

SHATTUCK, AARON DRAPER

Born: Francestown, N.H.; March 9,
1832
Died: Granby, Conn.; July 30, 1928

Bibliography:
Aaron Draper Shattuck 1832–1928 A
Retrospective Exhibition. New Britain,
Conn.: The New Britain Museum of
American Art, 1970.

Until recently, Aaron Shattuck's success
and popularity in the nineteenth century,
as a painter of portraits, landscapes, and
animals, had been forgotten. Born of old
New England stock, Shattuck was one of
nine children. After his early schooling in
Francestown, New Hampshire, and Low-
ell, Massachusetts, he sought portrait and
landscape painting instruction from Alex-
ander Ransom in Boston. A year later, in
1852, Shattuck moved to New York and
enrolled in antique and life classes at the
National Academy of Design. Ransom
followed his student to New York, where
they boarded together and recommenced
painting lessons.
 In 1854, Shattuck painted Mount Cho-
corua, Tuckerman Ravine, and Mount
Washington, and sold his first paintings.
His first exhibit at the National Academy

120. Aaron Draper Shattuck, *The Mountain Stream, July, 1858*, 1858. Lent by Katherine S. Emigh, granddaughter of the artist

120

of Design followed in 1855 when he was twenty-three years of age.

Shattuck enjoyed increasing recognition and popularity, exhibiting his work at the Boston Athenaeum, Pennsylvania Academy of the Fine Arts, Brooklyn Art Association, and the National Academy of Design. His paintings sold well, and many were reproduced by wood engraving illustrations.

Shattuck married Marian Colman, sister of the painter and illustrator Samuel Colman. They had five children.

In 1870, Shattuck moved to a farm in Granby, Conn., where he lived until his death in 1928. He discontinued painting in 1886 after a serious illness, reported to have been measles complicated by pneumonia. Thereafter, he received the profits made from sales of his patented design for stretcher keys, produced a new method for ventilating tobacco barns, and made violins.

THE MOUNTAIN STREAM, JULY 1858
July, 1858
Pencil on tinted paper, heightened with white
30.5 × 22.9 cm.; 12 × 9 in.
Signed lower left: The Mountain Stream/ July 1858/ White Mountains
Lent by Katherine S. Emigh, granddaughter of the artist.

This very beautiful sketch is strikingly similar to the finished painting by this artist titled *The Cascades, Pinkham Notch*, dated 1859. This is an excellent example of the careful, precise, on-the-spot drawings which nineteenth century

artists made, and from which they worked up finished paintings. It is in marked contrast to Cole's sketchy style. Here the artist has concentrated his attention on the flow of water through jumbled rocks, an extremely difficult subject. *(ill. 120)*

HAYING SCENE NEAR MOAT MOUNTAIN, CONWAY, N.H.
1859
Oil on cardboard
23.5 × 35.6 cm.; 9¼ × 14 in.
No signature, inscription by his granddaughter: 1859
Lent anonymously

Shattuck concentrated on small, delicate works, whose charm often outweigh the grandiose works that were just beginning to come into fashion at the time. This view of Cathedral Ledge and Moat Mountain, seen across the North Conway meadows, was painted by many artists who gathered to set up their white umbrellas on the banks of the Saco. A subtle picture, one must search to find the tiny haywain under the elm at the left, and a careful scrutiny of the sky reveals a crescent moon in the vaporous clouds. The tiny oil sketch for this finished painting is almost as carefully executed as the larger work. *(ill. 121)*

MOUNT WASHINGTON—AUTUMN GLORY
1864
Oil on academy board
22.9 × 38.1 cm.; 9 × 15 in.
Signed lower right: ADS
Lent by John H. Sanders; Concord, N.H.

The Pre-Raphaelite perfection of this small painting leads the eye from the fragile birches in the foreground in a curving sweep across the meadow to the vast barrier of Mount Washington and Wildcat Mountain. The cleared land creeping up the hillsides and the sun-drenched meadow in the foreground attest to man's harmonious existence with omnipotent nature. Though topographically accurate to the least detail, it is the mood of the painting which strikes the viewer so intensely: the golden peace of an autumn afternoon. *(ill. 42)*

SMITH, JOHN ROWSON

Born: Boston, Mass.; May 11, 1810
Died: Philadelphia, Penn.; March 21, 1864

John Rowson Smith studied under his father, John Rubens Smith, whose pupils later included Sanford Robinson Gifford. The elder Smith was primarily an engraver and lithographer, but John Rowson became a scene painter, working after 1832 in Philadelphia, New Orleans, St. Louis, and other cities. About the end of that decade, he took up panoramic painting and his most successful example,

121. Aaron Draper Shattuck, *Haying Scene
Near Moat Mountain*, 1859.
Lent anonymously

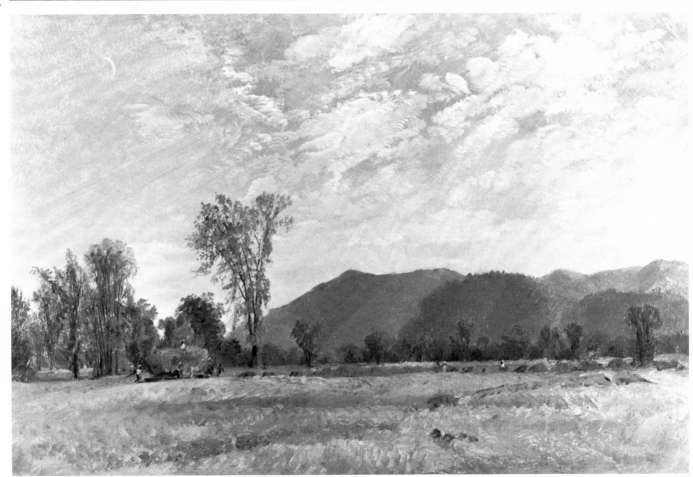

121

a panorama of the Mississippi, was exhibited in both the United States and Europe. He went to Europe in 1848 and afterwards settled in New Jersey, where he continued to paint scenery for theaters in New York and the south.

WHITE MOUNTAIN SUNRISE WITH INDIANS
1841
Oil on panel
50.8 × 61.0 cm.; 20 × 24 in.
Signed lower center: J.R. Smith 1841
Lent anonymously

John Smith's vocation as a scene painter for theaters is evident in this early view of the White Mountains. We do not know if he ever visited New Hampshire, though he traveled widely in the United States. The location of this view is probably imaginary. All the elements contribute to a totally stylized portrayal of a wilderness landscape. Broad, flat planes of bright, contrasting colors form the features of mountains, sky, and water, and in the center is placed a group of natives in almost classical costume. The overall effect is not unlike a backdrop for a theatrical production. The composition and nearly square shape of the canvas merit comparison with a painting done by Alvan Fisher a few years later, *Indians Crossing a Frozen Lake*. *(ill. 88)*

SMITH, RUSSELL

Born: Glasgow, Scotland; 1812
Died: November 8, 1898

Bibliography:
Lewis, Virginia E. *Russell Smith Romantic Realist*. Pittsburgh: University of Pittsburgh Press, 1956.
New Hampshire Landscapes 1848–1850. Boston: Vose Galleries, 1979.
Pennsylvania Landscapes 1834–1892. Boston: Vose Galleries, 1979.

Russell Smith settled in western Pennsylvania with his family when he was seven. He learned the trade of tool and cutlery manufacturing from his father. Painting instruction came from James Reid Lambdin of Pittsburgh, in 1828. After three years of study, he began the serious pursuit of painting theater scenery and portraits.

Throughout his life, Smith continued to paint scenery for theaters in Philadelphia, Boston, Washington, and Baltimore. His summers were spent traveling and painting the mountain landscapes along the Juniata and Susquehanna Rivers in New Hampshire and New York.

Smith married Mary Priscilla Wilson, accomplished painter of flowers, in 1838. Their two children also became proficient painters. In 1851–52, he traveled with his family to Europe and painted a panoramic view of the Holy Land.

Smith was elected a member of the Artist's Fund Society, and the Pennsylvania Academy of Fine Arts, which he also served as a member of the Board of Academicians. He devoted his last years to landscape painting.

MOUNT FRANKLIN
1848
Oil on canvas
61.0 × 91.5 cm.; 24 × 36 in.
Signed lower left: RS./Mount Franklin/Sept. 17, 1848/1,856 Feet
Collection of Kennedy Galleries, New York

The utterly bleak landscape dominated by Mount Franklin, the dark thrust of cloud shadow that silhouettes the fingers of rime ice on the rocks, and the tiny horse and man, could be an imaginary view of the Mountains of the Moon. Yet this is an accurate representation of an actual spot on the Crawford Path, cut in 1819 and, in 1840, converted to a bridle path, which can be seen winding into the distance. The sudden terrible storms in this area are even today noted in the Appalachian Guide Book as being extremely dangerous. *(ill. 15)*

122. Otto Sommer, *View of Conway Valley.* Lent anonymously

123. W. H. Titcomb, *Near Lake Winnipesaukee*, 1851. Lent anonymously

SOMMER, OTTO

There is almost no current information on this obviously competent artist, but the name would suggest a European background. Otto Sommer exhibited at the National Academy of Design from 1862 to 1866, and at the Boston Athenaeum Gallery in 1864. The titles all seem to be American views, but none is of the White Mountains. One of his works, *Westward Ho, or Crossing the Plains,* is in the Capitol at Washington, D.C. His first known landscape is of the Passaic River and is dated 1860. One of his landscapes, sold at auction in 1867, brought $150, a respectable sum for the period.

VIEW OF CONWAY VALLEY
n.d.
Oil on canvas
78.8 × 116.9 cm.; 31 × 46 in.
Signed lower right: Otto Sommer
Lent anonymously

It is impossible to say whether Sommer actually visited the Conway area, as this picture is an exact copy of Kensett's large painting of Mount Washington, now lost, which was engraved by Smillie for the American Art-Union in 1851. Many copies of this scene have appeared over the years by artists of varying talent. Without doubt the most popular view in the White Mountains, the scene blends the omnipotence of nature, in the guise of snow-capped Mount Washington, and man's industry in clearing fields, raising cattle, building snug dwellings, while God's land is blessed in the spire of the church. The man walking down the path personalizes the sense of security and peace of the pastoral landscape. *(ill. 122)*

SONNTAG, WILLIAM LOUIS

Born: East Liberty (now part of Pittsburg), Penn.; 1822
Died: New York, N.Y.; 1900

A Pennsylvanian by birth, William Sonntag began his artistic career in 1842 in Cincinnati, and worked there until 1853, when he first went to Europe. He returned to study in Florence two years later and, in the meantime, established himself as an artist in New York City. In 1861, the National Academy of Design elected him a member, and Sonntag exhibited there throughout his career. His summers were spent sketching in the mountains of New England and West Virginia, or abroad in Florence. Sonntag is best known today for his romantic Italian and American landscapes in the Hudson River School tradition, but in fact, he never painted the Hudson River at all. His only son, William Sonntag, Jr., became an artist and illustrator as well, but died before he reached the age of thirty. Sonntag outlived his son by a year.

CARTER DOME FROM CARTER LAKE
Ca. 1880
Watercolor on heavy white paper
34.6 × 35.9 cm.; 13⅝ × 14⅛ in.
Signed lower left (in black paint): [W].L. Sonntag
Collection of Cooper-Hewitt Museum, Smithsonian Institution

William Sonntag's interest in watercolor probably was sparked by the founding of the American Watercolor Society in New York in 1867. His dramatic sense of light and color was well suited to this new medium, evidenced here by this striking view of Carter Dome and Carter Lake. Sonntag summered in the White Mountains in 1878 and is known to have exhibited a view of the Carter Dome region in 1889 in Paris. Sharply defined trees and rocks contrast with the huge mass of Carter Dome in the background. The artist uses patches of color as well as broad planes to define the features of the landscape, which appears desolate and uninhabited. The oddly shaped mountain, on the east side of Pinkham Notch and overshadowed by the Presidential Range on the west, was rarely painted in the nineteenth century. It is to Sonntag's credit that he sought out the more remote and less popular subjects in the mountains and painted such detailed and accurate views. *(ill. 65)*

STONE, BENJAMIN BELLOWS GRANT

Born: Watertown, Mass.; January 21, 1829
Died: Catskill, N.Y.; August 11, 1906

Bibliography:
Campbell, Catherine. "Benjamin Bellows Grant Stone: A Forgotten American Artist." *The New-York Historical Society Quarterly* 62 (January 1978), pp. 22–42.

Benjamin Stone entered Benjamin Champney's art classes in Boston in 1851, after several years of work in a Boston ship chandler's establishment. In 1853, he moved to New York and enrolled as a student with Jasper Cropsey. In 1856, he rented Thomas Cole's studio from his widow and settled in Catskill, N.Y. All his life he kept in touch with contemporary artists, corresponding with Frederic Church, whom he frequently visited, his old teachers Champney and Cropsey, as well as Sanford Gifford, Sylvester Hodgdon, and many others. His early promise was curtailed by military service in the Civil War, and, after his return to Catskill, he turned out any work that came to hand—lithographs for Goupil, stage sets, book and magazine illustrations—and was often ill-paid. His painting, *Harvest*, a view taken in North Conway which he sold to Louis Prang for $50, was the most popular chromolithograph ever put out by that firm and netted Prang about $100,000 over the years it was in their catalogue.

GATE OF THE NOTCH
1858–1859
Oil on paper
17.5 × 25.1 cm.; 6⅞ × 9⅞ in.
Unsigned
Lent by Catharine Decker Memorial Collection, Greene County Historical Society, Coxsackie, N.Y.

Benjamin Stone spent his honeymoon in North Conway the summer of 1857, and among his many dated sketches is the study for this painting. This narrow defile, only twenty-two feet wide, was economically of great importance to commerce from northern New Hampshire to the seacoast. Thomas Cole painted his famous view of this notch some twenty years earlier. Both paintings emphasize the lonely grandeur and awe surrounding this natural cut through the otherwise impenetrable barrier of the mountains. Both dwarf the humans and add brooding storm clouds. The notch is still an impressive area to this day. Stone never mastered the medium of oils as well as the more linear style of pencil and lithography. His talent lay in the meticulous drawings he produced, many of which were reproduced by Goupil. *(ill. 43)*

TITCOMB, WILLIAM H. (or Titcombe)

Born: Raymond, N.H.; September 24, 1824
Died: Boston, Mass.; February 11, 1888

William Titcomb's rather naive, extremely individual, style would seem to indicate little formal training. After a career in merchandising, he apparently started painting professionally about 1860. He was successful as an artist and teacher in the Boston area until his death in 1888. At one time he was Principal and Director of the Art Department of the Academy of Art in that city. Many of Titcomb's works are New Hampshire views.

NEAR LAKE WINNIPESAUKEE
1851
Oil on canvas
55.7 × 76.6 cm.; 22¼ × 30⅜ in.
Signed lower left center: W. H. Titcomb 1851
Lent anonymously

This painting reflects the Romantic ideals of Thomas Cole, Thomas Doughty, and Alvan Fisher. The rain squall over the distant mountains seems to be blowing away, leaving house and pastures sunbathed and the cows peacefully browsing. The scene, however, indicates the more sophisticated resident of the second half of the century. The fields are cultivated, prosperous, and far-reaching. No stumps mar their sweep. Gone is the rude farm or simple cottage, replaced by an architecturally fashionable country seat. The view could have been painted anywhere in the Northeast. *(ill. 123)*

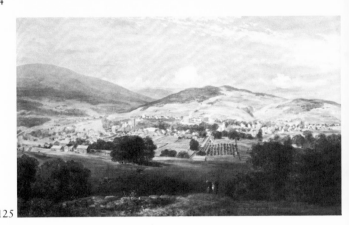

125

Unknown artist (attributed to T. Doughty)

MAIN STREET, NORTH CONWAY
1853
Oil on canvas
22.9 × 34.3 cm.; 9 × 13½ in.
Lent by Mrs. L. Hamlin Greene

The tree-lined country lane indicates by its title the rural character of North Conway in the middle of the nineteenth century. One or two houses, a fence and some meadow land are all that give evidence to human settlement. No railroad came near this town for another twenty years, and the influx of summer visitors was just beginning to come to the area. One should contrast the painting and engraving (ill. 126) of North Conway by David Johnson (Museum of Fine Arts, Boston; M. & M. Karolik Collection) to see a less rustic, simple depiction of the town. It was already becoming a favorite haunt of artists whose white umbrellas dotted the intervale by the meandering Saco. This semi-professional painting may have been executed by a pupil of Benjamin Champney. *(ill. 124)*

Unknown artist

MILL ON LAKE WINNIPESAUKEE
n.d.
Watercolor on paper
25.6 × 42.9 cm; 10⅛ × 16⅞ in.
Lent by Museum of Fine Arts, Boston;
M. & M. Karolik Collection

The exact subject of this topographical work is hard to identify. The shallow water and many protruding posts suggest the Weirs at the outlet of Lake Winnipesaukee, so named for the fish weirs used by the Indians and early settlers to catch the yearly run of shad. Both Laconia, early known as Meredith Bridge, and the length of the river were heavily built with all sorts of mills which took advantage of the continuous water power. The first sawmill in the area was built at the Weirs as early as 1766 and remained in use for many years. Woolen and knitting mills thrived throughout the nineteenth century at this site and the Busiel Mill, which still stands, is now designated a National Historic Site. *(ill. 37)*

Unknown artist

LITTLETON, N.H.
Ca. 1858–69
Oil on canvas
61.0 × 102.9 cm.; 24 × 40½ in.
Lent by Museum of Fine Arts, Boston;
M. & M. Karolik Collection

Bibliography:
History of Littleton, New Hampshire. 2 vol. Cambridge: University Press, 1905.

This townscape is obviously painted by a professional hand. Littleton is situated between the Ammonoosuc and Connecticut rivers, one of the many New England towns whose primary resource from its settlement to the early part of the twentieth century was agriculture. One can see the large areas of pasture land reaching far up the hillsides, and the neat garden rows in the valley. The work can be dated after 1853, at which time the first railroad reached the town, and probably after the Civil War, judging from the costumes of the people in the foreground and the group of factories in the left center, most of which grew to importance in the late 1860s. A woolen mill, a glove factory, and a shoe factory were prominent industries. The Kilburn Stereoscopic View Company, begun in 1855, was of worldwide importance. The artist has bathed the summer scene in a warm, serene light, extolling with his brush the virtues of industry and its attendant prosperity, punctuated by several church spires. *(ill. 125)*

124. Unknown (attributed to T. Doughty), *Main Street, North Conway*, ca. 1853. Lent by Mrs. L. Hamlin Greene

125. Unknown artist, *Littleton, N.H.*, ca. 1858–69. Lent by the Museum of Fine Arts, Boston; M. and M. Karolik Collection

126. *Mount Washington, North Conway*, unknown engraver, after David Johnson, 1855. Lent anonymously

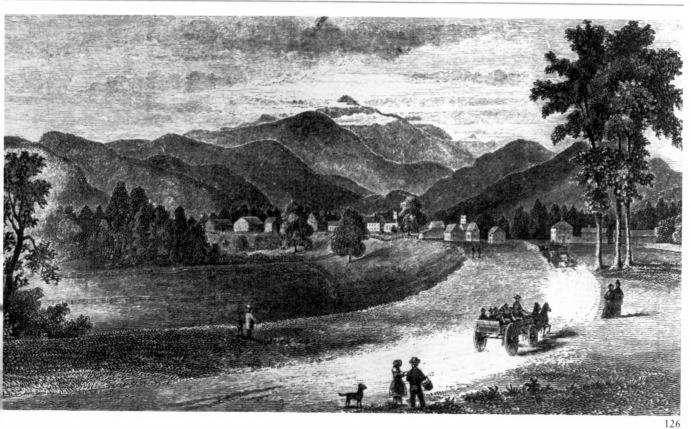

126

PRINTS

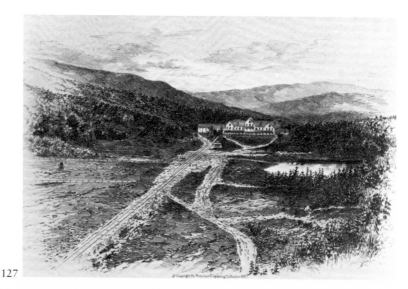

127. *The Crawford House,* published by Robinson Engraving Company, Boston, 1887. Collection of Dartmouth College Library

127

AT THE WHITE MOUNTAINS

F. Gleason
1875 (?)
Chromolithograph
37.6 × 53.4 cm.; 14⅞ × 21 in.
Collection of New Hampshire Historical Society

At the White Mountains was just the sort of view to appeal to the chromo audience. The color is bright. The pastoral scene is enlivened by cows, chickens, a barking dog, high-stepping horses, and coach passengers returning the wave of the woman in the doorway, all giving a sense of the security of the known. The imagination of the viewer is gently titillated as the road loses itself in the forest at the bend in the road, which is presided over by the enormous, looming mountain.

F. Gleason must have been a prolific worker. At his bankruptcy in 1877, when his firm was taken over by Strobridge of Boston, over 2,000 copies of *Winter Sunday in Olden Times* were in his stock. On the back of this chromo, the firm's name was printed in a florid cartouche as "The American and European Chromo Publishing Co." of 738 Washington Street in Boston. Gleason boasted of having over a million "elegant and costly" oil chromos in his picture gallery. Apparently, this firm sometimes backed its works with fine cloth to reinforce the printed paper. *(ill. 3)*

CHOCORUA'S CURSE

George W. Hatch, engraver, after the painting by Thomas Cole; printed by McKinzie; published by Carter and Hendee in *The Token*; edited by S. G. Goodrich
1830
Engraving
8 × 10.3 cm.; 3⅛ × 4⅛ in.
Collection of Dartmouth College Library

Thomas Cole climbed the mountain named for Chief Chocorua in October 1828, with his friend, Henry Cheever Pratt. Several versions of the rock on which the hapless Indian lies are to be found in sketches and finished paintings by Cole, though rearranged to suit the composition. The curse uttered by the dying man is purported to have made the countryside uninhabitable to the cattle, killing them with some unknown disease. Cole's romantic nature was intrigued by the legends he heard on that trip, and he carefully noted them in his diary. *(ill. 11)*

THE CRAWFORD HOUSE

Published by Robinson Engraving Company, Boston
1887
Etching
10.8 × 16.8 cm.; 4¼ × 6⅝ in.
Collection of Dartmouth College Library

The delicate, velvety tones of this engraving can only be produced from an incised metal plate. Vignetted in the fashion of the time, it is an accurate presentation of the view from Elephant's Head at the Gate of the Notch. It may actually have been taken from a photograph, as this was a favorite subject for stereographers as early as 1870. *(ill. 127)*

THE FERRY (ON THE ANDROSCOGGIN RIVER)

William Wellstood, engraver, after the painting by Albert Fitch Bellows; engraved for the *Ladies Repository*
n.d.
Engraving
11.5 × 16.9 cm.; 4½ × 6⅝ in.
Lent by Douglas Philbrook

The simple life of country folk was an intriguing subject to city dwellers. Here, a rope-ferry illustrates an early practical method of crossing a deep-running river such as the Androscoggin, which flows from northern New Hampshire through Maine. Though it is an excellent waterway for logging, its lack of shallow fords made such ingenious ferries imperative for travel and commerce. The ferryman's house is seen on the far side of the river, and the horn with which to call him hangs from a tree branch at the right.

The engraving is done from a painting by Albert Fitch Bellows. Bellows's paintings were very popular, and at least ten of them were engraved. *(ill. 6)*

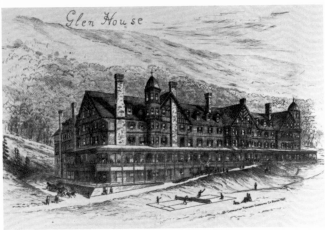

Glen House

Bellows first studied architecture at the age of sixteen, but soon left the profession to devote his career to art. For six years, he was principal of the New England School of Design, after which he went abroad for the first time for study in Paris and Antwerp.

He was the author of a book on art and pioneered in the medium of watercolor as well as etching. He was an early member of the American Society of Painters in Water Colors, and the Royal Belgian Society of Water-Colorists made him an honorary member, which demanded a unanimous vote of its members, very rarely accorded to foreigners. Bellows painted at least nine scenes in the White Mountains, which were exhibited at the Brooklyn Art Association and the National Academy of Design, of which he was a member from 1861 until his death.

GLEN HOUSE

Probably by F. H. Fassett; published by Robinson Engraving Company, Boston
1887
Etching
10.4 × 16.4 cm.; 4⅛ × 6½ in.
Collection of Dartmouth College Library

An 1889 publication described the Glen House as "English Cottage Style." It continued: "At the Glen House hay-fever is unknown.... People get strong, sleep well, have good appetites...." It was hardly a cottage in size, as it was nearly 300 feet long and had 450 feet of verandas on which to stroll. This is a view of the "new" Glen House, finished in 1887,

the old one having burned to the ground in 1884. Open wood fireplaces were in every suite and many rooms, and an hydraulic elevator had been installed. Its most unique attraction was its location at the foot of the Mount Washington Carriage Road, the starting point for two daily trips to the summit. This view is probably the architect F. H. Fassett's rendering, as the later engraving of 1889 is slightly less grandiose. *(ill. 128)*

HARVEST: NORTH CONWAY, WHITE MOUNTAINS

Louis Prang, engraver, after B. B. G. Stone
1869
Chromolithograph
21.6 × 36.9 cm.; 8½ × 14 in.
Lent by Douglas Philbrook

The invention of colored reproductions of famous works opened a large and lucrative market, and Louis Prang of Boston was its most important proponent, often using dozens of plates in the intricate process, including a final impress to simulate the texture of canvas. The firm produced all sorts of colored reproductions, from paintings by such well-known and popular artists as Frederic Church, Winslow Homer, Eastman Johnson, and Albert Bierstadt, to sentimental Sunday-school mottoes and sets of flowers, butterflies, and trade cards.

Benjamin Bellows Grant Stone noted in his diary in 1867 that he was working on

Autumn in North Conway, which is almost surely the basis for the chromolithograph titled *Harvest*. Stone further, rather bitterly, noted: "*Harvest* painted November 1867—sold for $50—published 1869—Sold at auction 1879 for $125.... Most popular chromo ever published. Sales the first year amounted to $21,000. Average sales from 1869 to 1878 $12,000 per year." *(ill. 129)*

HARVEST SCENE: MEREDITH, N.H.

after William H. Bartlett; published by Selmar Hess, N.Y.
Ca. 1850
Engraving
11.2 × 18.1 cm.; 4⅜ × 7⅛ in.
Lent anonymously

Bibliography:
William H. Bartlett and His Imitators. Elmira, N.Y.: Arnot Art Gallery, 1966.

William Bartlett often inveighed against the flagrant copying of his illustrations for *American Scenery*, published in London in 1838. This engraving is not a copy, but has been printed from the original plate. The name "Bartlett" and that of the engraver, "C. Cousen," have been imperfectly scratched out and the title has been changed from the original *View of Meredith, New Hampshire.* It is more heavily inked, perhaps due to the wearing of the plate through many earlier impressions. It should be compared with the freer adaptation by Edmund Coates in the large painting (ill. 100), also in this exhibition. *(ill. 16)*

128. *Glen House*, probably by F. H. Fassett; published by Robinson Engraving Company, Boston, 1887. Collection of Dartmouth College Library

129. *Harvest: North Conway, White Mountains*, Louis Prang, engraver, after B. B. G. Stone, 1869. Lent by Douglas Philbrook

130. *The Maplewood, Bethlehem, N.H.*, W. H. Brett, lithographer, after D. Drummond, after 1878. Collection of New Hampshire Historical Society

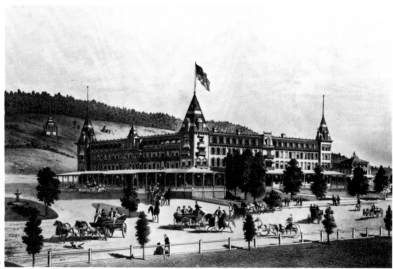

130

THE HEART OF THE NOTCH

from the painting by Harrison Bird Brown; published by Lakeside Press for the Maine Central Railroad
1890
Photogravure
33.5 × 51.5 cm.; 12 × 20 in.
Collection of Dartmouth College Library

Framed posters advertising points of interest on the Maine Central Railroad were common all over New England. The conquest of Crawford Notch by the Iron Horse was a great feat at the time. The up-grade from Bemis Station to the Crawford House was a thousand feet over deep ravines and through solid rock. This masterpiece of engineering was finally completed in 1875, and the workmen triumphantly chiseled in the rock beyond the first trestle: "First Crossing, June 1875, Engine No. 6."

The section foreman's dwelling, built in 1877, here seen beyond the trestle, was so isolated it was called "John o' Groats" after the forlorn and lonely tip of northern Scotland. Timothy Dwight's "most beautiful cascade perhaps in the world" can be seen coursing down the side of the mountain at the right to lose itself in the Dismal Pool, while the tiny train pursues its way around the vast bulk of Mount Willard. *(ill. 131)*

JACOB'S LADDER

published by Robinson Engraving Company, Boston
1887
Etching
10.2 × 16.3 cm.; 4 × 6½ in.
Collection of Dartmouth College Library

This is one of a series of engravings of White Mountain views produced as more artistic renditions than the photographs of the scenes which were currently available. A comparison with stereographs, though, would indicate a reliance on the part of the artist on the camera view. These engravings were also printed in sepia ink on satin, which added to the already soft, velvety tones of the prints. *(ill. 29)*

LAKE WINNIPESAUKEE SHOWING EXCURSION STEAMER

after J. Warren Thyng
n.d.
Lithograph
20.2 × 52.1 cm.; 8 × 20½ in.
Collection of New Hampshire Historical Society

This lithograph is after an original work by J. Warren Thyng. The print presents a factual, if somewhat naive, representation of Lake Winnipesaukee, with the Ossipee Mountains and Chocorua in the left background. Thyng's friend, John Greenleaf Whittier, wrote to him: "I sympathize with thee in the love of the New Hampshire hills and Chocorua is the most beautiful and striking of all."

Thyng studied under George Loring Brown and also at the National Academy of Design. He was acquainted with Church, Inness, and William Hart. He taught for many years in New Hampshire schools and founded the Akron School of Design in Ohio.

THE MAPLEWOOD, BETHLEHEM, N.H.

W. H. Brett, lithographer, after D. Drummond
After 1878
Lithograph
40.7 × 63.5 cm.; 16 × 25 in.
Collection of New Hampshire Historical Society

One of the foremost White Mountain hotels, the Maplewood was built by Isaac S. Cruft in 1876. Its salubrious location and pure air, its magnificent view of the Presidential Range, and its modern comforts and amenities brought the Maplewood such popularity that it had to be enlarged in 1878. The *Boston Medical and Surgical Journal* noted in 1878 that out of the sixty-two days in July and August, there were only three days in which invalids could not have remained out of doors with safety during the whole or part of the day. The Maplewood contained a post office, "a news-stand, hair dressing rooms, bath rooms, billiard room and bowling alleys, a large hall for dancing and entertainments, a first-class table, ex-

131. *The Heart of the Notch,* from the painting by Harrison Bird Brown, 1890. Collection of Dartmouth College Library

132. *Mount Washington and the White Mountains from the Valley of Conway,* Frances Flora Bond (Fanny) Palmer; published by Currier and Ives, ca. 1860. Lent by Mr. and Mrs. Charles O. Vogel

133. *Mount Washington from Frankenstein,* after the painting by Harrison Bird Brown; published by The Gray Lithography Company, 1890. Lent by Douglas Philbrook

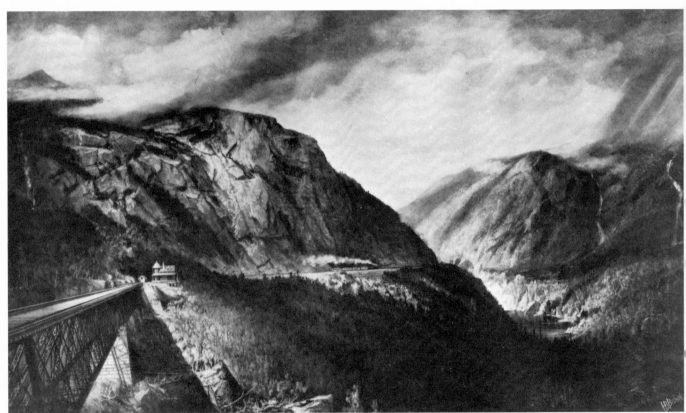

131

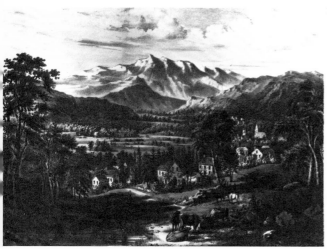

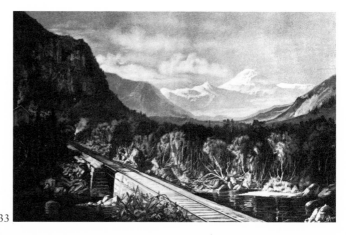

133

tensive play-grounds and a large livery stable." This last seems to have been well patronized from the extent and variety of the equipages in this lively lithograph. The gazebo at the upper left and the fountain are Victorian touches. *(ill. 130)*

MOUNT WASHINGTON AND THE WHITE MOUNTAINS FROM THE VALLEY OF CONWAY

Frances Flora Bond (Fanny) Palmer, lithographer, after the sketch by Fanny Palmer; published by Currier and Ives, New York, N.Y.
Ca. 1860
Hand-colored lithograph
41.3 × 52.1 cm.; 16¼ × 20½ in.
Lent by Mr. and Mrs. Charles O. Vogel

Each of the major views lithographed by Currier and Ives came in three sizes. This view of Mount Washington is the large size, showing the classic scene from North Conway, featuring the meadows and the country village. All such works were colored by hand on a production line system, one colorist generally painting in a specific area and passing it on to the next artist. For this reason, prints of the same scene will often have different coloring.

Fanny Palmer was one of the few artists employed by the firm of Currier and Ives to sign her works. A fine artist in her own right, she almost certainly exhibited at the Brooklyn Art Association in 1844 and at the National Academy of Design in 1868 and 1869. A careful, factual worker, she executed an on-the-spot sketch of Mount

Washington in 1860, which is probably the basis for this lithograph. In order to support a ne'er-do-well husband and her children, she began to work for Nathaniel Currier before 1852. *(ill. 132)*

MOUNT WASHINGTON FROM FRANKENSTEIN (as seen on the line of the Maine Central Railroad)

after the painting by Harrison Bird Brown; published by The Gray Lithography Company, New York, N.Y.
1890
Lithograph
31.8 × 49.6 cm.; 12½ × 19½ in.
Lent by Douglas Philbrook

This advertisement for the Maine Central Railroad features Frankenstein Cliff in Crawford Notch, which looms darkly to the left of the picture. It was named after Godfrey Nicholas Frankenstein, an artist friend of Dr. Bemis, before whose home the train stopped.

This view was painted to extoll the marvel of train travel, which could pierce the wildest mountain passes. Mount Washington has been enlarged beyond reality and dominates the scene, while the tiny engine chugs around the bend on a track depicted as straight and securely constructed, indicating man's conquest of forbidding nature. *(ill. 133)*

MOUNT WASHINGTON FROM THE VALLEY OF CONWAY

James Smillie, engraver, after the painting by John Frederick Kensett; published by the American Art-Union
1851
Engraving
17.9 × 26.5 cm.; 7 × 10¼ in.
Collection of Dartmouth College Library

Bibliography:
Mann, Maybelle. *The American Art-Union.* Washington, D.C.: Collage Inc.

From 1827 to 1853, the American Art-Union performed a unique and useful function in the promotion of American art. For the then not-inconsiderable sum of five dollars, anyone could buy a chance on an American work of art. Once a year, on Christmas day, the drawing was held. Depending on the number of tickets sold, works were purchased from artists such as Durand, Cropsey, Kensett, and a host of others.

One or two of these paintings were chosen each year to be reproduced as engravings. Those who did not win a painting in the lottery were rewarded by a handsome framed engraving of one of the works. The system was outlawed by act of Congress in 1853, as it was considered a form of gambling.

The engraving by James Smillie is after the presently unlocated painting by Kensett of the same title. Many copies, both professional and amateur, of this work have come to light by both signed and anonymous artists. The large painting by Otto Sommer of about 1865 in the pres-

134. *Mount Washington from the Valley of Conway,* James Smillie, engraver, after the painting by John Frederick Kensett; published by the American Art-Union, 1851. Collection of Dartmouth College Library

135. *Top of Mount Washington,* John Andrew, engraver, between 1854 and 1856. Lent by Douglas Philbrook

ent exhibition (ill. 122), is one such example. Kensett himself produced at least one other version in 1869. *(ill. 134)*

MOUNT WASHINGTON, NORTH CONWAY

unknown engraver, after David Johnson; published by *Appleton's Magazine,* 1871
1855
Wood engraving
9.0 × 15.6 cm.; 3½ × 6⅛ in.
Lent anonymously

David Johnson's lucid oil painting of the same subject, executed in 1852, now in the Karolik Collection of the Museum of Fine Arts, is almost certainly the basis for this view of Mount Washington from the village of North Conway. The looming mountain mass has been brought closer to the viewer, and the foreground has been changed somewhat, but the scene is essentially the same. Such engravings popularized our grandiose scenery through guidebooks and magazines such as *Harper's, Appleton's,* and *Leslie's.* To city dwellers, the small group of scattered houses, with their sense of space, the dearth of factories belching smoke, the fields, the trees, and the protective wall of mountains, all evoked a yearning for the simple pleasures of a country town. *(ill. 126)*

THE NOTCH HOUSE, WHITE MOUNTAIN

after William H. Bartlett; published by Currier and Ives, New York, N.Y.
After 1857
Hand-colored lithograph
19.0 × 31.1 cm.; 7⅞ × 12¼ in.
Lent anonymously

This lithograph, copied from the 1838 engraving after William H. Bartlett in *American Scenery,* is a less-talented adaptation, somewhat governed by the change of medium. The print was executed some time after 1857, at which time Currier and Ives formed a partnership. The inn had been destroyed by fire in 1854; however, the view was apparently still salable. Also the artist left the final "s" from the word "mountains." Like other Currier and Ives lithographs, this was colored by hand, as color printing did not come into general use until the advent of chromolithography after the Civil War. *(ill. 25)*

NORTH CONWAY MEADOWS

H. Harring, chromolithographer, after Benjamin Champney; published by L. Prang and Co., Boston
After 1870
Chromolithograph
38.1 × 61.0 cm.; 15 × 24 in.
Collection of Boston Public Library, Print Department

Champney painted a great many views of the flat, verdant, fertile Conway mead-

ows. The plain is periodically flooded by the here-somnolent Saco and provides rich soil for easy tillage. Long before the white man came, the area was sought by Indians as a place to settle and grow corn. This idyllic summer scene was reproduced by Prang from a painting still in a private collection. A "perfect" pastoral picture, this painting incorporates the pleasures of late afternoon summer sun, cows, children by the waterside, well-stacked sheaves, a haywain, golden fields of grain shaded by the arching New England elms, all protected by the great curving surfaces of the mountains. *(ill. 19)*

PEMIGEWASSET HOUSE, PLYMOUTH, N.H.

J. H. Bufford, lithographer
Ca. 1855
Lithograph
41.0 × 57.2 cm.; 16⅛ × 22½ in.
Collection of New Hampshire Historical Society

This view of the Pemigewasset House is printed in two tones, which indicates that it was an important print, demanding expensive and careful workmanship in the printing process. The large white building is emphasized by the printing technique, which also accents the groups of vacationing guests. Stereoscopic views of the hotel attest to the accuracy of the scene, which was drawn some time between 1851 and 1863.

The view is a document of summer pleasures and travel in the White Mountains in the mid-nineteenth century. The

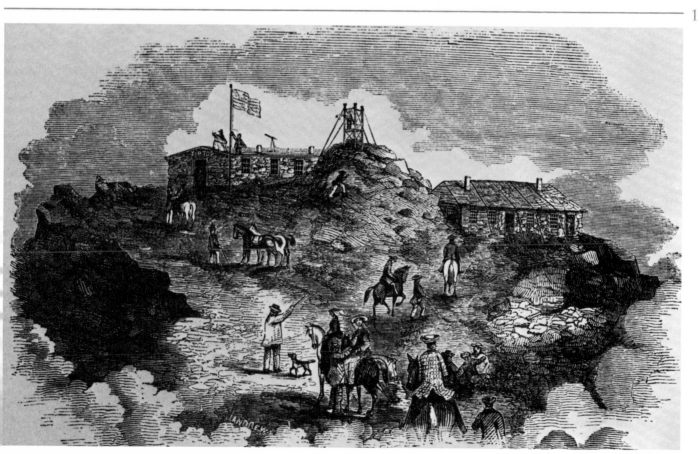

station was actually a part of the hotel, and the train, with box car and passenger cars, is prominent in the center of the picture. In the background, at the right and left of the hotel, are a private landau and a passenger coach, indicating other methods of travel available to the tourist. The whole picture presents a delightful scene of *détente* for adults, lounging in the shade, the children swinging and rolling hoops, the almost motionless boat, all flooded with warm sunshine. Surely, no hotel advertisement could be more felicitous. *(ill. 26)*

PUMPKIN TIME

H. Harring, chromolithographer, after Benjamin Champney; published by L. Prang and Co., Boston
After 1871
Chromolithograph
38.1 × 61.5 cm.; 15 × 24⅛ in.
Collection of Boston Public Library, Print Department

This view of autumn's bounty compares with *Autumn*, another Prang chromolithograph, after a painting by B. B. G. Stone, which is a very similar harvest depiction. The scene cannot be positively identified, an unusual occurrence in Champney's *oeuvre*. It bears all sorts of connotations, both worldly and theological. Elements from Champney's repertoire are put together to form an ideal view of a New Hampshire autumn; house with smoking chimneys, open barn door, swift-flowing creek, all bathed in glowing sunlight and guarded by the looming mountain. This would have been a subject dear to the hearts of city folk, far removed from the harsh realities of New England farm life. *(ill. 18)*

SUMMIT OF MOUNT WASHINGTON; 6380 FEET ABOVE THE LEVEL OF THE SEA

Sabatier, lithographer; Benjamin Bellows Grant Stone, delineator; Lemercier, Paris printer; published by M. Knoedler and Goupil & Co.
1857–1858
Lithograph
32.4 × 42.0 cm.; 12¾ × 16½ in.
Lent by Douglas Philbrook

This elaborate lithograph is an excellent example of the type of work turned out by nineteenth century artists specifically for reproduction. The barren top of Mount Washington offered a bleak challenge with its jumble of rocks, but Stone has managed to convey the scene's desolation with carefully delineated rocks, tiny, wind-blown figures, the two uninviting inns, and the vast ominous swirl of clouds. The work is an early view, before the carriage road was constructed in 1861. *(ill. 20)*

TOP OF MOUNT WASHINGTON: 6285 FEET ABOVE THE LEVEL OF THE SEA

John Andrew, engraver; published by Evans & Plumer, Printers and Engravers, Boston
1854–1856
Wood engraving
15.3 × 20.4 cm.; 6 × 8 in.
Lent by Douglas Philbrook

John Andrew, the delineator of this work, was a prolific and respected wood engraver in the Boston area. The print can be dated between 1854 and 1856 from the observatory which surmounts the high point of the mountain. The Summit House at the right was the first permanent structure on the mountain, built in 1852 and held down from the fierce winter winds by strong cables. The Tip-Top House was built in 1853, and a second story added in 1862. At the time this view was produced, the only method of ascent was on horseback via the Crawford Path, or on foot. The figures add an interesting commentary to the rugged terrain. *(ill. 135)*

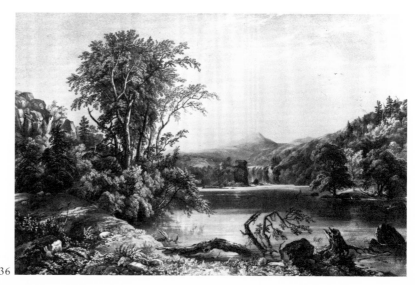

136. *White Mountain Lake Scenery*, W. Gauci, lithographer, after a sketch by Jasper F. Cropsey, January 1, 1859. Lent anonymously

136

WHITE MOUNTAIN LAKE SCENERY

W. Gauci, lithographer, after a sketch by Jasper F. Cropsey; printed by M. and N. Hanhart; published by E. Gambart and Company, London, England
January 1, 1859
Lithograph
30.5 × 47.6 cm.; 12 × 18¾ in.
Lent anonymously

Bibliography:
Talbot, William S. *Jasper F. Cropsey.* Garland, N.Y., 1977.

This lithograph, printed in two tones, was taken from a sketch ordered by Gambart for a projected portfolio of American scenes. Of the 36 views, only 16 were completed, due to Cropsey's ill health.

The original, painted in 1856, was titled *Afternoon in Autumn, White Mountains.* The work is not an actual scene, but a pastiche, with what is probably a view of Goodrich Falls and mill in the center background, backed by Mount Chocorua in the distance. This was a compositional method often used at the time in order to create a romantic, ideal landscape.

This particular lithograph was intended to invoke in the viewer the idea of the bounty of autumn, the grazing sheep, calm water with fisherman, the power of nature harnessed by the mill using the cascade for human good, while, over all, a misty, beneficent sun warms the atmosphere. *(ill. 136)*

WHITE MOUNTAIN SCENERY
(10 views)

Louis Prang, lithographer, after Benjamin Champney; published by L. Prang and Co., Boston
After 1875
Chromolithographs
Each 9.2 × 6 cm.; 3⅝ × 1½ in.
Collection of Dartmouth College Library

Series of views of famous places were popular items produced by Prang. Placed in elegant albums, they graced the parlor tables of myriad Victorian homes, either as mementos of a trip or as armchair travels. This group, taken after Champney's vignettes, appeared after 1875, as the railroad had pierced the stone barrier of the Gate of the Notch. The pictures offer a variety of subjects to please all tastes. The rugged top of Mount Washington and the forbidding Great Gulf are juxtaposed with the serene boating scene on Echo Lake. Berlin Falls and the rocky torrent of Glen Ellis Brook compare to the placid meanderings of the Saco through Conway meadows. *(ill. 137)*

137. *White Mountain Scenery* (10 views), Louis Prang, lithographer, after Benjamin Champney; published by Louis Prang & Co., Boston, after 1875. Collection of the Dartmouth College Library

138. C. G., "Carriage Road, Mount Washington," *Ballou's Pictorial Drawing-Room Companion,* August 9, 1856. Lent by Douglas Philbrook

139. C. P., "Tip-Top House, Summit of Mount Washington, During the Recent Storm," *Harper's Weekly,* February 11, 1871. Lent by Douglas Philbrook

137

138

139

MAGAZINE
ILLUSTRATIONS

BROWN, WALTER FRANCIS

"October in the White Mountains"
Harper's Weekly; October 31, 1874
Wood engraving
Lent by Douglas Philbrook

Brown was a painter and illustrator. This group of humorous incidents indicates a facile pen and a sharp wit. However, Brown must have also done serious work, for he exhibited at the National Academy of Design in 1860. A careful scrutiny of the captions gives an insight into the manners and moral attitudes of the period as seen in a typical cartoon format. *(ill. 141)*

C. G.

"Carriage Road, Mount Washington"
Ballou's Pictorial Drawing-Room Companion; August 9, 1856
Wood engraving
Lent by Douglas Philbrook

This scene is the proposed, but never consummated, dream of a national observatory on top of Mount Washington. The actual carriage road was still five years from completion, and it took more than the two or four horses here shown to drag the coaches with specially built levelers so that passengers would never be discommoded by the steep pitch of the road. The huge fortress-like building was a far cry from the actual tiny Summit House of one-and-a-half stories, bolted to the rocks against the winter gales by cables strung over the roof. *(ill. 138)*

C. P.

"Tip-Top House, Summit of Mount Washington, During the Recent Storm"
Harper's Weekly; February 11, 1871
Wood engraving
Lent by Douglas Philbrook

Mount Washington has the unenviable distinction of recording the highest wind velocity in the world—231 miles per hour. This wood engraving illustrates the tremendous fury of a particularly violent winter storm. A similar scene was recorded in the painting by William Halsall, also in the present exhibit (ill. 113). Samuel Hopkins Drake wrote of such a storm in *The Heart of the White Mountains,* vividly illustrated by W. Hamilton Gibson (ill. 146). Such natural excesses of nature made popular copy for magazines such as *Harper's,* whose patrons drew closer to their cheery fires in their cozy city homes. *(ill. 139)*

GIBSON, WILLIAM HAMILTON

"The Fall of the Bowlder"
Harper's Weekly; July 14, 1883
Wood engraving
Lent anonymously

The great boulder depicted here with such drama, was lodged precariously between the walls of the Flume, above the heads of curious tourists. H. S. Fifield had a photographic studio at the Flume House from 1867 to 1883 and produced hundreds of stereoscopic views of tourists featuring the boulder above or behind them. A violent storm, such as had destroyed the Willey family some sixty years before, swept the boulder into oblivion on June 20, 1883.

Gibson was an illustrator and watercolorist known for his botanical drawings. He frequently exhibited at the Brooklyn Art Association and, in 1881, had a work in the National Academy of Design. His work as illustrator in *The Heart of the White Mountains,* by Samuel Adams Drake (ill. 146), was much admired. *(ill. 140)*

HALSALL, W. F.

"The Signal Service Station, Summit of Mount Washington"
Harper's Weekly; April 22, 1882
Wood engraving
Lent by Douglas Philbrook

The signal station for weather observations, here represented during a violent winter storm, was officially set up in May, 1871. Volunteers had taken observations the winter before and proved the feasibility of such an undertaking. Conditions were extremely difficult as can be seen by the rime ice, like frozen flags, clinging to the telegraph poles which transmitted messages to the base of the mountain. The man taking readings could have been

140. William Hamilton Gibson, "The Fall of the Bowlder," *Harper's Weekly*, July 14, 1883. Lent anonymously

141. Walter Francis Brown, "October in the White Mountains," *Harper's Weekly*, October 31, 1874. Lent by Douglas Philbrook

142. W. F. Halsall, "The Signal Service Station, Summit of Mount Washington," *Harper's Weekly*, April 22, 1882. Lent by Douglas Philbrook

143. Charles Augustus Hoppin, "The White Mountains—The Ride," *Harper's Weekly*, August 13, 1859. Collection of New Hampshire Historical Society

130

141

142

143

131

working in −59° F chill. Ascents in winter were made by walking up the tracks of the cog railway. Two tiny figures can be seen clinging to Jacob's Ladder in the center inset. *(ill. 142)*

HOMER, WINSLOW

"The Coolest Spot in New England— Summit of Mount Washington"
Harper's Bazar; July 23, 1870
Lent anonymously

HOPPIN, CHARLES AUGUSTUS

"The White Mountains—The Ride/The White Mountains—All Aboard!"
Harper's Weekly; August 13, 1859
Wood engraving
Collection of New Hampshire Historical Society

Both of these drawings portray the bustle, preparation, excitement, apprehension, and curiosity of departure on a trip. The bravado of the hiker and the resigned look of the white horse on which the lady is mounted, and other small details such as the gentleman's foot in the stirrup with heel down in best equestrian fashion and the humble stance of the flower seller, attest to the observant eye of the artist. In these views, the mountains and nature are nonexistent. It is the people who count in these images.

Charles Augustus Hoppin, the illustrator, was a graduate of Brown University and Harvard. He practiced law for a short

time, but, after art study in Europe in the 1850s, he turned his attention to illustration, chiefly of a humorous nature. *(ill. 143)*

WARREN, ASA COOLIDGE

"Scenes in New Hampshire—Mount Kearsage and Confluence of Saco and Swift Rivers, Conway"
Appletons' Journal; March 11, 1871
Lent anonymously

Asa Coolidge Warren was primarily an engraver. He studied in Boston under George Girdler Smith and produced bank note engravings and illustrations for Tichnor and Field. It is interesting that in the four bucolic views he chose to depict, he included a railroad track in the foreground of one. The text recalls a bit of naval history referring to Mount Kearsarge as named for the famous naval battle. The mountain's original name was Pequaket, an Indian name. The text is interlaced with bits of homely lore and names of famous people in New Hampshire, a few lines of poetry, together with careful descriptions and accurate information concerning Warren's choice of engravings. *(ill. 144)*

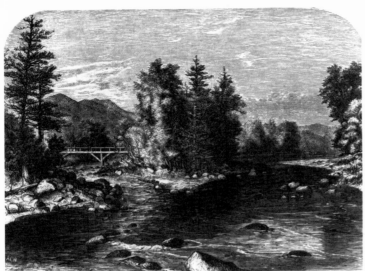

ILLUSTRATED BOOKS

AMERICAN SCENERY

Nathaniel P. Willis
Published by James S. Virtue, London, England
[1838–39]
Letterpress and steel engravings
Illustrations after William H. Bartlett and Thomas Doughty
Collection of Dartmouth College Library

This book, together with Hinton's *History and Topography of the United States,* printed in London eight years earlier, was a source of wonder to the English and Continentals. The vastness and wildness of our country were incomprehensible to those whose landscapes had been domesticated for a thousand years. Titles for the illustrations were printed in English, French, and German in various editions. The text was often completely irrelevant to the accompanying picture. The importance of the White Mountains can be judged by the fact that there were twelve illustrations of the area, the second largest group in the two volumes. Though Bartlett certainly drew his small sepia sketches with romantic fervor and dressed many of his characters as European peasants, he personally visited all the areas he depicted.

There is a great number of copies of these illustrations in a variety of media. At least 69 views were used on Staffordshire pottery. Victor De Grailly, in Paris, turned out a large group of oils of various scenes, and countless artists, both professional and untrained, used the engravings as models for their work, all of which attests to the extreme popularity of the subject matter. *(ill. 80, 145)*

FINAL REPORT ON THE GEOLOGY AND MINERALOGY OF THE STATE OF NEW HAMPSHIRE

Charles T. Jackson, M.D.
Published by order of the Legislature, Concord, N.H.
Printed by Carroll & Baker, State Printers
1844
Lithographs and wood engravings
Illustrated by J. D. Whitney
Lithography by Charles Cook's Lithographers, Boston
Lent by Special Collections, Dimond Library, University of New Hampshire

Full-page, two-tone lithographs after J. D. Whitney illustrate this folio volume together with a large number of wood engravings of diagrams, maps and views by unknown artists. The study was authorized by the State Legislature for the purpose of improving the agriculture and discovering valuable minerals in the state. Whitney's art work was executed in 1841 and illustrates important natural phenomena in the state, such as the Gate of Crawford Notch, the Old Man of the Mountain, and the Willey House slide. *(ill. 34, 79)*

A GAZETTEER OF THE STATE OF NEW HAMPSHIRE

John Farmer and Jacob B. Moore
Published by Jacob B. Moore, Concord, N.H.
1823
Illustrations by J. F. Dana, J. Kidder, A. Bowen
Engravings by Abel Bowen
Lent by Special Collections, Dimond Library, University of New Hampshire

Gazetteers were popular reading in the nineteenth century. Our young country was as fascinated with enumerating its accomplishments and cataloguing itself as the English had been some 800 years before in the Domesday Book. All sorts of fascinating information is to be found in this small book. The history, climate, health and longevity (76 people had lived to be over 100 years old between 1732 and 1822), lakes and rivers, mountains, turnpikes and bridges, geology and mineralogy, government, laws, taxes, and expenses of the state are all set forth. There follows a description of each town, with the names of men of importance printed in capitals. The number of citizens, manufacturies and mills, schools, churches, cattle, and other pertinent information are listed. Town boundaries are clearly noted. Abel Bowen had one third interest in the publication of this gazetteer, the first in New Hampshire to carry illustrations, which he engraved on wood or copper from his own drawings or those of J. F. Dana and John Kidder.

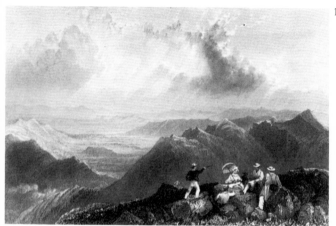

145

146

THE HEART OF THE WHITE MOUNTAINS

Samuel Adams Drake
Published by Harper and Brothers, N.Y.
1882
Illustrations by W. Hamilton Gibson
and others
Collection of Dartmouth College Library

The illustrations in this handsome folio had a variety of engravers, and four artists besides Gibson contributed art work. The author wrote in the manner of a biography of a trip through the White Mountains. The engravings place great emphasis on the minuscule humans and their efforts to survive among the vast and terrifying mountains and hostile nature. *(ill. 146)*

HISTORICAL RELICS OF THE WHITE MOUNTAINS

John H. Spaulding
Published by Nathaniel Noyes, Boston, Mass.
1855
Illustrations by J. Andrew and
W. Roberts
Stereotyped by Hobart and Robbins, Boston, Mass.
Lent by Special Collections, Dimond Library, University of New Hampshire

This slender volume, which was first published in 1855, is not a guidebook in the usual sense, as it consists largely of legends and historical vignettes. It also contains fascinating bits of information such as the fact that George N. Dana counted

his steps from the Glen to the top of Mount Washington and found he had taken 16,925 of them. Alpine plants which are to be found in the White Mountains are listed along with the height above sea level of the various mountain hotels, this last presumably because altitude had a salubrious effect on health. *(ill. 147)*

INCIDENTS IN WHITE MOUNTAIN HISTORY

Benjamin G. Willey
Published by Nathaniel Noyes, Boston, Mass.
1856
Illustrations by C. G.
Wood engravings by N. Orr, O. Wallis, Andrew, and Richardson
Lithography by Benjamin Champney
Lent by Special Collections, Dimond Library, University of New Hampshire

Benjamin Willey was the brother of the ill-fated Samuel Willey who perished in Crawford Notch on the night of August 28, 1826, in a fearful landslide. This dramatic incident caused tremendous interest, and is still a site for curiosity seekers. Willey recounted the occurrence and many other interesting anecdotes in this fascinating volume from first-hand knowledge. Much of the historical material was still vivid in the minds of men and women whose ancestors had settled in the inhospitable country. Consequently, the book has an immediacy seldom found in the flowery utterances of many nineteenth century historians.

PICTURESQUE AMERICA, Vol. I

William Cullen Bryant, editor
Published by D. Appleton and Company, N.Y.
1872
Illustrations by Harry Fenn
Lent anonymously

This compendium appeared in 48 semi-monthly parts, each costing fifty cents. Though carrying the name of William Cullen Bryant, who was famous and respected for his poetry and essays, the text was written by "writers who accompanied the artists, or by those specifically acquainted with the field described." Harry Fenn produced all the illustrations for the section on the White Mountains. One of the founders of the American Watercolor Society, Fenn first came to the United States in 1864, then returned from a sojourn of six years in Italy in 1870 specifically to execute the illustrations for this book.

A second edition "within the reach of the general public" was brought out in 1894 in 30 weekly parts at ten cents each, and, though listed as "new and revised," the Flume boulder was still lodged between the walls of the Flume and described in the text, though it had disappeared in a massive freshet eleven years before. *(ill. 44, 151)*

SCENERY OF THE WHITE MOUNTAINS

William Oakes
Published by Little and Brown, Boston
1848
Illustrations by Isaac Sprague and
G. N. Frankenstein
Lithography by John H. Bufford
Lent by Douglas Philbrook

William Oakes was a botanist who spent many years meticulously collecting and cataloguing the flora of the White Mountains. At the age of 49, he wrote the text for *Scenery of the White Mountains* and engaged Isaac Sprague to produce the paintings which were lighographed and printed by John Henry Bufford. Sprague had been artist-assistant to John James Audubon and was eminently qualified to depict the rock formations and the foreground flora with botanical exactitude. So particular was he about accuracy that he actually used a spy-glass when working on the illustrations for the Profile. Two plates (Nos. XIV and XVI) are taken from paintings by Godfrey Nicholas Frankenstein and are entirely different in character. The book proved extremely popular and went through many editions, the original lithographic plates being taken over, first by Bufford's brother-in-law, Benjamin W. Thayer, who scraped out Bufford's name in the lower right hand corner and inserted his own. Later John Greene Chandler and his brother, Samuel, repeated the process when their firm succeeded Thayer's and appropriated the stones. Some lithographs also carry the name of Oakley. Both the text and illustrations of this remarkable book bear witness to the intense interest, both by men of letters and the general public, in the history and unique natural wonders of our Eastern mountains. *(ill. 54)*

STEREOSCOPIC VIEWS AMONG THE HILLS OF NEW HAMPSHIRE

Bierstadt Brothers
Published by Bierstadt Brothers; New Bedford, Mass.
1862
Collection of Dartmouth College Library

The first edition of stereographs published by Albert Bierstadt and his brothers, Charles and Edward, was ingeniously designed as a tryptich with glass prisms set in the cover with which to view the pictures. This edition contained 48 scenes, and sold for the then large sum of five dollars. However, because of faulty construction of the viewing lenses, it was not a success, and a second edition, which contained 24 views, was published by them in 1875. The original pictures were taken some time in 1860, for they were praised for their beauty and size in *The Crayon* of January 1861. After Bemis's daguerreotypes, they are possibly the first actual photographs of White Mountain scenery and are remarkable feats of photography when one considers the wet plates and cumbersome paraphernalia needed at the time. *(ill. 148)*

VIEWS IN THE WHITE MOUNTAINS

Moses Foster Sweetser
Published by Chisholm Brothers, Portland, Me.
1879
Electrotyped and printed by Rand, Avery, and Company, Boston
Lent by Special Collections, Dimond Library, University of New Hampshire

The stunning photographs, transferred to paper by the heliotype process, which, as the preface says: "represent Nature just as she is without any meretricious additions," are accompanied by a gilded prose which belies the factuality of the illustrations. "The writer . . . on the altar of Agiochook (the Indian name for Mount Washington) ventures to place a daisy, a harebell with a loyal and loving heart." As documents, these pictures are of immense importance, especially as they show the barren land about the hotels, where the forest has been hacked down to provide wood for the many fireplaces. It is interesting to note that the Silver Cascade, once so painted, engraved, and photographed, is not included in Sweetser's *Views. (ill. 91)*

148

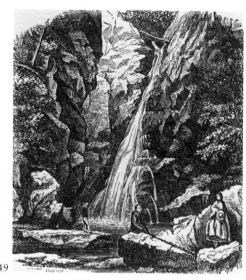

149

THE WHITE MOUNTAIN GUIDE BOOK

Samuel C. Eastman
Published by Edson C. Eastman, Concord, N.H.
Printed by Jones & Cogswell, Concord, N.H.
1864, 4th ed.
Lent by Special Collections, Dimond Library, University of New Hampshire

The frontispiece map of railroad routes in this book indicates their tremendous importance as a method of travel and commerce by the middle of the nineteenth century. Their growth is really phenomenal when one considers that in 1830 the United States had only 23 miles of track. The book, in the first chapter, and again in the back, describes every possible route by the innumerable individually owned railroads or by steamer to the White Mountains. Stages are only suggested when the aforementioned methods are unavailable. Then Eastman launches into descriptions of all the sights found in the White Mountains, for, as he notes in his preface: "Those before issued, (guidebooks) have been rather guides *to* than *through* the Mountains." *(ill. 149)*

THE WHITE MOUNTAINS: HANDBOOK FOR TRAVELLERS

Moses Foster Sweetser, editor
Published by James R. Osgood and Company, Boston
1876
Lent by Special Collections, Dimond Library, University of New Hampshire

Guidebooks such as this one emphasized different aspects of the White Mountains. Unlike the more "coffee-table" types of books such as *Picturesque America,* these were kept up to date with supplements to each publication. Later volumes added information on trails, suggested by the newly-founded Appalachian Mountain Club, conceived in 1876 and incorporated in 1878. Boarding houses are listed with the number of guests, prices, and other useful information. Admixed with this are local points of interest, bits of history, methods of travel, and careful descriptions of the amenities to be found in the large hotels, such as the fact that the halls and parlors are lighted with gas, that there is a barber shop on the premises, a telegraph office, and bathrooms, this last a luxury in the days of the bowl and pitcher. It is indexed in the usual manner with an added special section on biographical allusions, historical material, and quotations. *(ill. 150)*

150. *The Lake Country of New Hampshire,* illustration for Moses Sweetser, ed., *The White Mountains: Handbook for Travellers,* 1876. Lent by Special Collections, Dimond Library, University of New Hampshire

151. *The Descent from Mount Washington,* illustration by Harry Fenn, for William Cullen Bryant, ed., *Picturesque America,* 1872. Lent anonymously

152. *Bird's Eye View of Littleton, Grafton County, N.H.,* Poole and Norris, 1883. Collection of New Hampshire Historical Society

153. *Bird's Eye View of Whitefield, Coös County,* A. F. Poole, 1883. Collection of New Hampshire Historical Society

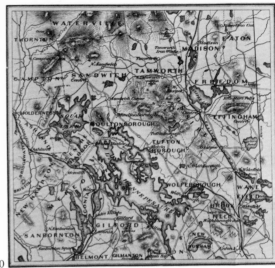

150

136

151

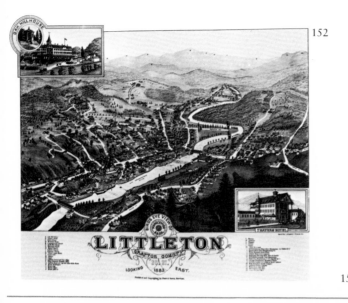

152

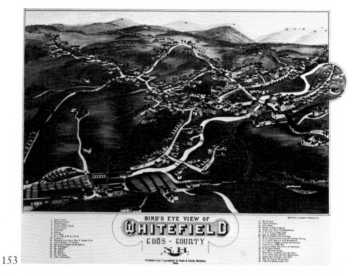

153

MAPS AND TOWN VIEWS

BIRD'S EYE VIEW OF LITTLETON, GRAFTON COUNTY, N.H.

Poole and Norris
1883
Lithographed by Beck and Pauli, Milwaukee, Wis.
50.0 × 65.0 cm.; 19¾ × 25⅝ in. (comp.)
Collection of New Hampshire Historical Society

The widespread use of the bird's-eye town view can be seen by the fact that this work was lithographed by Beck and Pauli of Milwaukee. Here the Ammonoosuc River bisects the scene, and the railroad borders the river, as the grade is generally most level along river banks. Two railroad bridges, three road bridges (all covered to protect them from rotting under rain and winter snows), and a suspension wire from the major factory, all indicate the river's importance to the town. Six churches and an opera house cater to the cultural and spiritual needs of the citizens, and fifteen factories produce a thriving economy. *(ill. 152)*

BIRD'S EYE VIEW OF WHITEFIELD, COÖS COUNTY

A. F. Poole
1883
Beck and Pauli lithographers
43.0 × 56.0 cm.; 17 × 22 in.
Collection of New Hampshire Historical Society

This view of a busy, prosperous town is a far cry from the present-day somnolent settlement of Whitefield. Cultural interests are represented by the bandstand on the green, neatly ringed by trees. Factories smoke prominently in the foreground, and dwellings stretch far up on the hillsides. Churches, schools, and hotels crowd by the river, and a train snakes beside a hill heading toward a trestle. Whitefield has long been known for its salubrious air, free of pollen, and has attracted hordes of hayfever and asthma sufferers for generations. In the 1880s, it was a fashionable summer resort. Views such as this were fairly common in the late nineteenth century as towns grew in importance and their populations became increasingly centralized and permanent. *(ill. 153)*

BOSTON AND MAINE RAILROAD CONNECTIONS

From *Summer Excursions to the White Mountains*
1897
Published by the Passenger Department B. and M.R.R.
Engraved and printed by Rand Avery Supply Company, Boston
58.4 × 78.7 cm.; 23 × 31 in.
Collection of New Hampshire Historical Society

LEAVITT'S MAP WITH VIEWS OF THE WHITE MOUNTAINS

Franklin Leavitt
1854
67.0 × 64.0 cm.; 25¼ × 26½ in.
Collection of New Hampshire Historical Society *(ill. 155)*

LEAVITT'S MAP OF THE WHITE MOUNTAINS

Franklin Leavitt
1878
Published by Franklin Leavitt, Lancaster, N.H.
40.6 × 53.3 cm.; 16 × 21 in.
Collection of New Hampshire Historical Society

Bibliography:
David Tatham. "Franklin Leavitt's White Mountain Verse." *Historical New Hampshire* 33, no. 3 (Fall 1978), pp. 209–231.

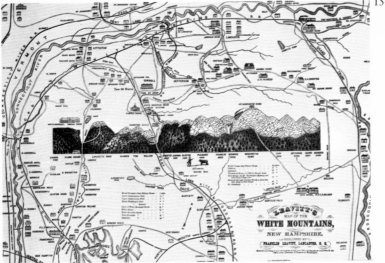

154

154. *Leavitt's Map of the White Mountains,* Franklin Leavitt, 1878. Collection of New Hampshire Historical Society

155. *Leavitt's Map with Views of the White Mountains,* Franklin Leavitt, 1854. Collection of New Hampshire Historical Society

156. *A Map of the White Mountains of New Hampshire,* George P. Bond, 1853. Collection of New Hampshire Historical Society

157. *Mount Washington from North Conway,* illustration by Benjamin Champney, for *A Map of the White Mountains of New Hampshire,* George P. Bond, 1853. Collection of New Hampshire Historical Society

155

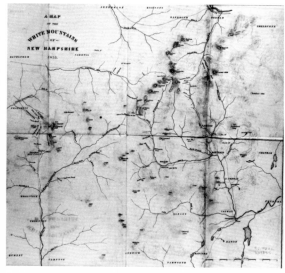

156

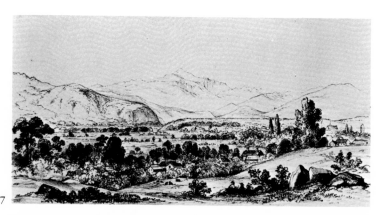

157

Franklin Leavitt was a colorful guide in the White Mountains who produced a variety of ingenious maps over a period of years from 1852 to 1888. Each map is entirely different and naively fascinating. Leavitt was the first person to explore the Devil's Den on the cliff of Mount Willard, being let down on a rope to peer into the cavern, which feat he illustrates on an early map together with a drawing of Ethan Allen Crawford shooting a bear. Roads meander improbably over mountains and most of the drawings are primitive to the extent of childishness, but the cartographer seems to have used engravings at times from which to copy his fantasies, for some views include known drawings, such as the hoped-for but never built observatory on top of Mount Washington which had appeared in Ballou's *Pictorial Drawing Room Companion* in 1856 (ill. 138). *(ill. 154)*

A MAP OF THE MOST INHABITED PART OF NEW ENGLAND

Carington Bowles
1771
Published and printed in London
64.0 × 52.0 cm.; 25 × 20 in.
Lent by Wilbur Collection, University of Vermont Library

This early map indicates that New Hampshire once extended from its Maine border to the Hudson River. Beyond Kusumpe Pond (now Squam Lake) nothing is noted at all beyond Jackoyomays Hill (?) and Kowhas (now Coos), "a French Incroachment (sic)." The King's

Woods are prominently noted around Winipissioket (Winnipesaukee) Lake, used for masts in His Majesty's navy, our pines being considered to last longer than the ones imported from Sweden. *(ill. 1)*

MAP OF THE WHITE MOUNTAINS FROM ORIGINAL SURVEYS

Harvey Boardman; Griswold, Conn.
1858
Engraved by Smith, Knight and Tappan; Boston
58.0 × 66.0 cm.; 23 × 26 in.
Collection of New Hampshire Historical Society

The Atlantic and St. Lawrence Railroad is the only train to have skirted the mountain area by 1858. Vignettes of the principal hotels dot the map, and roads are peppered with tiny squares which denote houses. Those dots which represent hotels include the names of the proprietors with the name of the public house, an important piece of information in days of coach travel. The grave of Abel Crawford is singled out, as well as the site of the Willey Disaster and the ruins of the Fabyan House. *(ill. 23)*

A MAP OF THE WHITE MOUNTAINS OF NEW HAMPSHIRE

George P. Bond
1853
41.0 × 48.0 cm.; 16 × 19 in.
Collection of New Hampshire Historical Society

The particularly important feature of this map lies in the five lithographs printed on its back: Echo Lake, Mount Washington from North Conway, Mounts Jefferson and Adams from the Glen House, Glen Ellis and Crystal Falls, and Pinkham Notch. The choice of subjects is interesting as Crawford Notch, generally so much depicted, is not shown here at all. The work was done by O. Wallis and lithographed by Benjamin Champney, if the usual reading of delineator at the left and lithographer or engraver at the right is followed in this case. These views were the same as those published in Willey's *Incidents in the White Mountains,* 2nd ed. in 1856. *(ill. 156, 157)*

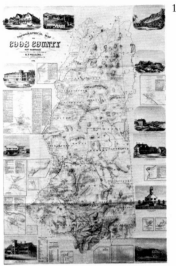

158. *Topographical Map of Coös County,*
H. F. Walling, 1861. Collection of Dartmouth
College Library

159. *Relief Map of the White Mountains,*
1872. Collection of New Hampshire Historical Society

160. *Town View of Conway, N.H.,* George
E. Norris, 1896. Lent by Douglas Philbrook

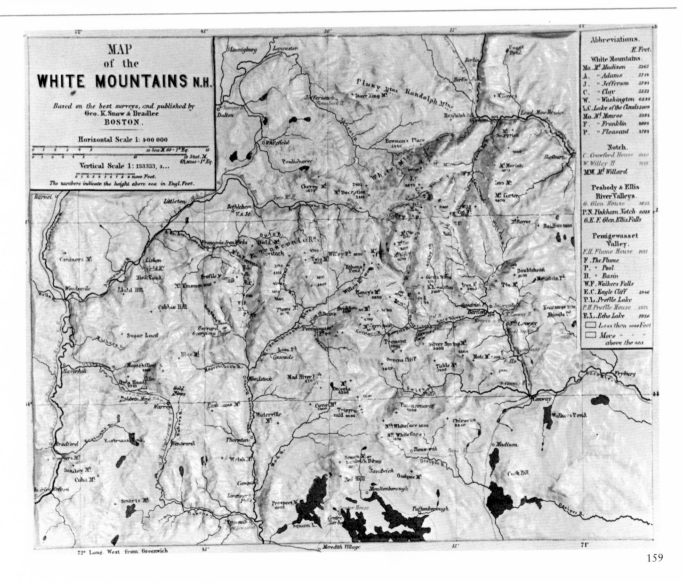

NEW HAMPSHIRE BY RECENT SURVEY

Philip Carrigain
1816
Published in Concord, N.H.
159.0 × 122.0 cm.; 62½ × 48 in.
Collection of Dartmouth College Library

To gather information for this beautifully engraved map, each town in the state had to provide an individual map of its area, which Carrigain then amalgamated. The large title was delineated by J. J. Barralet and shows mountains, coast, and canal; with people fishing, hunting, and farming: all related to New Hampshire commerce. Specific (though unrecognizable) engravings of the White Mountains from Shelburne, Great Boar's Head, and Hampton Beach by John Kidder, and the Gap in the White Mountains by Abel Bowen, are included. These were also used as illustrations in the *Gazetteer of the State of New Hampshire*. The population of the United States is given in a table; New Hampshire at the time was almost as large as Connecticut and New Jersey. *(ill. 47, 69, 70)*

RELIEF MAP OF THE WHITE MOUNTAINS

1872
Published by George K. Snow and Bradlee
24.1 × 59.0 cm.; 9½ × 23¼ in.
Collection of New Hampshire Historical Society

This relief map barely indicates roads and towns, confining itself to the names and heights of the mountains and streams. However, the key at the right gives letters for the Presidential Range, whose steep aclivities do not allow space for printed information. Only five major hotels are singled out, and scenic wonders are arbitrarily chosen. *(ill. 159)*

TOPOGRAPHICAL MAP OF COÖS COUNTY

H. F. Walling
1861
Published by Smith, Mason, and Company
113.0 × 180.3 cm.; 44½ × 71 in.
Collection of Dartmouth College Library

This huge wall map, one of a set of ten representing each county in the state, is embellished with large engravings of hotels and major points of interest. The fact that almost all maps included views of hotels indicates the importance of tourism to the economy of the state. Names of residents of all homes are included, as are roads, mountains, ponds (Mosquito Pond was surely well named), and rivers. *(ill. 158)*

TOWN AND CITY VIEWS OF NEW HAMPSHIRE: BARTLETT, CARROLL CO.

D. H. Hurd and Company
1892
46.0 × 40.0 cm.; 18⅛ × 16 in.
Collection of New Hampshire Historical Society

Hurd's maps are unique documents, presenting invaluable information to the historian and genealogist. Each house and the name of the resident are carefully noted, no mean feat for the cartographer. These views were published in book form, as an atlas, often with two separate parts of the township printed on one page in order to facilitate the minute delineation. *(ill. 38)*

TOWN VIEW OF CONWAY, N.H.

George E. Norris; Brockton, Mass.
1896
Lithograph
50.0 × 69.0 cm.; 19½ × 27 in.
Lent by Douglas Philbrook

This panoramic view with each house neatly and factually drawn in, indicates the prosperity of the town. A train chugs across the intervale, and factories smoke industriously. Tiny numbers refer to a key which lists mountains, hotels, stores, businesses, mills, doctors, and major residences of prominent citizens. *(ill. 160)*

161. C. P. Hibbard, *Profile House, Franconia Notch, N.H.,* ca. 1900. Collection of New Hampshire Historical Society

162. Benjamin West Kilburn, *Mount Washington Railway,* ca. 1870. Collection of New Hampshire Historical Society

142

PHOTOGRAPHS

Bibliography for all photographic material: Darrah, William Culp. *Stereo Views.* Gettysburg, Pa.: Times and News Publishing, 1964.

Adams, Stephen F.; New Bedford, Mass.

CRAWFORD HOUSE, FROM NOTCH, N.H.
Ca. 1860
Stereograph
7.6 × 15.2 cm.; 3 × 6 in. (image)
Lent anonymously

Adams' earliest known work as a photographer was in 1865 when he joined the firm of the Bierstadt Brothers in New Bedford. He took over the business in 1866 and used many of the earlier negatives under his own name, a common practice at the time. His latest known work was in 1876.

This view of the narrow entrance of the notch reveals in the distance the Crawford House, which must have been a welcome sight to the weary traveler. The photograph can be dated with certainty before 1875, as there is no railroad cut. It was probably printed from a negative taken by Albert Bierstadt and his brother, Charles, about 1860.

Aldrich, G. H.; Littleton, N.H.

FROST WORK ON MOUNT WASHINGTON
Ca. 1870
Stereograph
7.7 × 15.6 cm.; 3 × 6⅛ in. (image)
Collection of New Hampshire Historical Society

Aldrich is known to have used F. G. Weller's (active 1867–1873) negatives. Both stereographers lived in Littleton. This view of the striking ice formations on the summit of Mount Washington may possibly have been taken originally by Weller. The first winter ascent of the mountain was in 1858, and another such climb was accomplished in 1862. However, these were the only two successful attempts until after 1870, when ascents became more numerous.

Bemis, Samuel; Boston, Mass.

CRAWFORD NOTCH
Ca. 1840
Whole plate daguerreotype
16.5 × 21.5 cm.; 6½ × 8½ in.
Collection of International Museum of Photography at George Eastman House

Bibliography:
Rudisill, Richard. *Mirror Image, the Influence of the Daguerreotype on American Society.* Albuquerque: University of New Mexico Press, 1971.

Samuel Bemis, a Boston dentist, was one of the first people in the United States to experiment with the photographic process perfected in France by Louis Daguerre. A friend of Abel Crawford, Bemis built a substantial house opposite Crawford's Tavern, or "Old Crawford's" as it was generally known. This view, which is a mirror image of the actual site, as dictated by the medium, is perhaps the first actual landscape ever mechanically recorded in this country, though city views had already been made. The house in the photograph is the front of Crawford's Tavern, and the farm clearing with the dirt track wending its way toward the notch indicates the primitive condition of the Tenth Turnpike Road. *(ill. 17)*

The Hall Studio; Littleton, N.H.

PROFILE HOUSE AND LAKE
Ca. 1885 (?)
Photograph
19.6 × 23.9 cm.; 7¼ × 9⅜ in. (image)
Collection of New Hampshire Historical Society

This view indicates the size, isolation, and self-containment of the Profile House. Only the boat house by Echo Lake and a service house mar the solitude of the mountain tarn on which floats a tiny boat. This is a photographic statement of so many of the early paintings, presenting man's insignificance in the vastness of nature, a photographic comment on Thomas Cole's Visible Hand of God. *(ill. 35)*

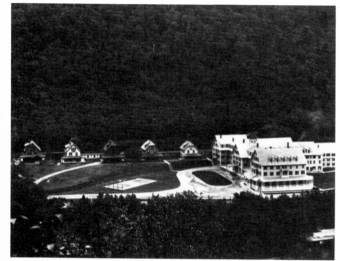

161

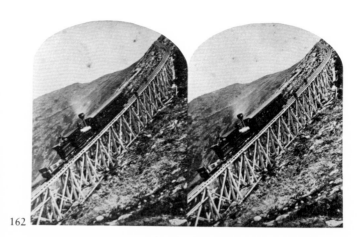

162

Hibbard, C. P.; Lisbon, N.H.

PROFILE HOUSE, FRANCONIA NOTCH, N.H.
Ca. 1900
Large card photograph
18.6 × 24.0 cm.; 7⅜ × 9½ in. (image)
Collection of New Hampshire Historical Society

The Profile House was built in 1852–1853, and enlarged in 1866 and again in 1872. It was considered one of the best hotels in the United States, and was especially popular with New York and Philadelphia families of impeccable social position. It boasted separate villas which were an unusual feature in northern hotels, though common in the south. The Profile House offered billiard halls and bowling alleys, and the dining room was supposed to be one of the largest in the country. As Sweetser noted in 1879: "While midsummer heats are scorching the dry streets of Boston and New York, there ever prevails a delicious coolness in this lofty eyrie . . . and the refreshing odors of the encircling forests drift . . . in the silken parterres of the great parlors." *(ill. 161)*

Hunton, W. C.; Nashua, N.H.

LACONIA BOX FACTORY
Ca. 1880
Photograph
15.9 × 23.9 cm.; 6¼ × 9⅜ in. (image)
Collection of New Hampshire Historical Society

The camaraderie of mid-nineteenth century workers in New Hampshire mills has been well documented. Most of them were women who performed the more routine tasks. They came from the outlying farms, for the wages were good for the period. Though they worked twelve hours a day, six days a week, pleasant rural surroundings can be seen here and working conditions were far better than those of the sweat shops of the cities. Many of the larger factories provided boarding houses which were strictly chaperoned by a housemother, generally a widow. Social life, with hymn sings and lectures, was much more pleasant than on the isolation of a hill farm. A copy of this photograph could be purchased for a dollar and sent home to relatives. *(ill. 39)*

Kilburn, Benjamin West; Littleton, N.H.

MOUNT WASHINGTON RAILWAY
Ca. 1870
Stereograph
10.1 × 15.9 cm.; 4 × 6¼ in. (image)
Collection of New Hampshire Historical Society

Invented by Sylvester Marsh, this remarkable railroad was the first of its kind in the world. Construction was begun in 1865 and completed in 1869. Every piece of material had to be hauled up the mountain by ox teams. The single passenger car was pushed up by "Old Peppersas," a steam locomotive, in an hour and a half. The engine was especially constructed with a pitched boiler which kept horizontal despite the steep grade. The section called Jacob's Ladder took its name from the steepest part of the old Fabyan trail. It has always been the most famous part of the whole extraordinary trip and was one of the most popular subjects for photographers as an almost magical feat of modern engineering. *(ill. 162)*

Kilburn, Benjamin West; Littleton, N.H.

GATES OF THE CRAWFORD NOTCH, AND TRAIN
After 1875
Stereograph
10.2 × 15.9 cm.; 4 × 6¼ in. (image)
Collection of New Hampshire Historical Society

Transportation made New Hampshire a promising place to live. This commonplace stereoscopic view epitomizes the entire nineteenth century history of the White Mountains. One sees the Notch of the White Mountains whose discovery opened commerce between the upper Coos and the sea. The Crawford House indicates the importance of tourism to the state when vast hotels and boarding houses brought guests from all over the Eastern United States and created jobs for the native population. All this travel was accelerated by the advent of the railroad—the Iron Horse extolled by Thoreau—which carried both passengers and freight to every corner of the state with speed and efficiency.

Kilburn, Benjamin West; Littleton, N.H.

FABYAN HOUSE DINING HALL
Ca. 1890
Stereograph
10.1 × 15.9 cm.; 4 × 6¼ in. (image)
Collection of New Hampshire Historical Society

The size of this stereograph indicates that it was produced about 1890. The ferns and festoons add to the sense of festivity promoted by the landlords of these summer vacation haunts. Bare floors, white paint, and crisply ironed tablecloths were featured to enhance a sense of coolness in the summer heat. It must be remembered that guests wore starched high collars, corsets, and serge even in the hottest weather. Tourism was big business. As early as 1873, the New Hampshire Board of Agriculture estimated that the revenues to the state were almost three million dollars. *(ill. 28)*

Kilburn, Benjamin West; Littleton, N.H.

FRANKENSTEIN TRESTLE AND TRAIN
Ca. 1890
Photograph
10.2 × 17.8 cm.; 4 × 7 in. (image)
Collection of New Hampshire Historical Society

This engineering feat over the deep ravine was long thought to be impossible, but by 1871 the Portland and Ogdensburg Railroad had decided to attempt it. The railroad reached North Conway in 1871 and inched its way up the notch until it joined the spur from the Crawford House in 1875. In the days of muscle, dynamite, and pickaxe it was an Herculean task. The steel girders were an innovation, as most trestles were made of wood at the time. *(ill. 30)*

Kilburn Brothers; Littleton, N.H.

LAKE OF THE CLOUDS FROM MOUNT WASHINGTON
1867
Stereograph
7.3 × 15.2 cm.; 2⅞ × 6 in. (image)
Collection of New Hampshire Historical Society

To photograph this view in 1867 demanded skill and perseverance, as the wet plates and equipment used at the time were heavy and awkward. Eastman's *Guidebook* described this gloomy tarn as a "beautiful sheet of water." The pond, which on the hottest summer day makes one gasp at its chill, is the headwater of the Ammonoosuc River. Visitors to the summit of Mount Washington, on seeing this lakelet, have often started down toward it, not realizing that it is over two miles from the summit over very rough terrain.

Kilburn Brothers; Littleton, N.H.

LOG CABIN
Ca. 1870
Stereograph
7.7 × 15.6 cm.; 3 × 6⅛ in. (image)
Collection of New Hampshire Historical Society

This bleak scene should be compared to *Homestead* (ill. 13). The homes of the lumbermen were a far cry from the elegant summer hotels of the wealthy tourists. Here the land has been denuded by lumber teams, using the clear-cut system

of removing every vestige of forest. The one spindly tree is a totem to the destruction of the natural cover and consequent erosion of the thin topsoil.

Kilburn Brothers; Littleton, N.H.

VIEW FROM THE CRAWFORD HOUSE
Ca. 1870
Stereograph
7.7 × 16.8 cm.; 3 × 6⅛ in. (image)
Collection of New Hampshire Historical Society

The narrow entrance to Crawford Notch was one of the most painted and engraved scenes in all the White Mountains. The dramatic cleft, only 22 feet wide, and the rock formation on the left, shaped like the head of an elephant, behind which the looming bulk of Mount Webster further enhances the minute rift in the rocks, was first painted by Thomas Cole in 1838. Bartlett, Currier and Ives, Cabot, Sprague, Bufford, Beckett, Stone, Kensett, Richards, Darrah, Fenn, Gibson, Shapleigh, and Selinger all sketched, painted, and engraved it. Even today the scene is as lonely and awe inspiring as it was a hundred years ago.

Soule, John P.; Boston, Mass.

GOODRICH'S FALLS, BARTLETT, N.H.
Ca. 1870
Stereograph
7.7 × 14.3 cm.; 3 × 5⅛ in. (image)
Collection of New Hampshire Historical Society

These falls offered spectacular scenery for artists. They often were photographed in the nineteenth century, and Frederic Church and Albert Bierstadt probably featured Goodrich's Falls in their large constructed paintings. For a long time, the falls were commercially important. When this view was taken, a lumber mill was situated at the head of the falls.

Soule, John P.; Boston, Mass.

THE FIRST TEAM DRIVEN TO THE SUMMIT OF MOUNT WASHINGTON, JULY 13, 1861
Stereograph
7.7 × 13.5 cm.; 3 × 5¼ in. (image)
Collection of New Hampshire Historical Society

The carriage road to the summit of Mount Washington, begun in 1855, was finally completed after six years of work at tremendous expense. After the first company went bankrupt under the cost, the task was taken over by a second group of businessmen. This team was sent up before the actual opening of the road to the public on August 8, 1861. The driver, J. M. Thompson, was the landlord of the Glen House, from which stages started up the mountain. This trip was accomplished with one weary-looking horse and a high-wheeled wagon. The first passenger vehicle took eight horses to draw it.

Weller, F. G.; Littleton, N.H.

THE OLD MAN ABOVE THE CLOUDS
Ca. 1884
Stereograph
7.9 × 14.6 cm.; 3⅛ × 5⅞ in. (image)
Collection of New Hampshire Historical Society

This stereograph is possibly dated about 1884, and probably was taken from an earlier negative by Weller. It has been retouched to emphasize the classic view of the increasingly popular "Old Man," which had not seemed to capture the interest of many of the earlier painters, perhaps because in actuality it is small and insignificant in the vast mountain landscape.

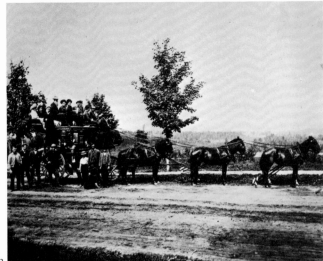

163

Unknown [Kilburn?]

BLUE PRINT SOUVENIERS
1880–1902
Cyanotype album
17.8 × 28.6 cm.; 7 × 11¼ in. (album)
Lent by Stephen T. Rose

This album includes photographs taken in the White Mountains over two decades. A railroad station crowded with horses and coaches, the Flume with its boulder still intact, and the Kilburn stereograph view factory are interspersed with later photographs of Littleton's growth. Cyanotype was an inexpensive process used around the turn of the century; today it is reserved for blueprints.

Unknown

NEW HAMPSHIRE HOMESTEAD
Ca. 1890
Modern print from a glass plate negative
16.6 × 21.6 cm.; 6½ × 8½ in. (image)
Lent anonymously

The muddy dooryard and the dreary cabin starkly contrast the grandeur and beauty depicted by artists from Thomas Cole to Aaron Shattuck. Almost no writers spoke of cold and black flies and driving rain and unrelenting work. The women in this family display no dainty petticoats; the men lean on the tools that keep body and soul together. *(ill. 13)*

Unknown

JACKSON, N.H.
Ca. 1900
Large card photograph
19.4 × 24.5 cm.; 7⅝ × 9⅝ in. (image)
Collection of New Hampshire Historical Society

Cleared fields, stone walls, and the white dots of houses, some of which are the imposing "villas" of summer visitors, seem lost in the expanse of mountain slopes. Farms, a church, a water tower are lonely outposts of civilization. *(ill. 66)*

Unknown photographer; Detroit Publishing Company

LITTLETON, WHITE MOUNTAINS, N.H.
1900
Photograph
42.0 × 99.1 cm.; 16½ × 39 in. (image)
Lent by Stephen T. Rose *(ill. 61)*

Unknown

SILVER CASCADE
Ca. 1900
Photograph
14.7 × 10.2 cm.; 5¾ × 4 in. (image)
Collection of New Hampshire Historical Society

Samuel C. Eastman mentioned in his guidebook (ill. 149), that the upper reaches of the 400-foot cascade could be seen from the piazza of the Crawford House and that "there is, perhaps, no place on this side of the mountain which so enchains one by its loveliness as the Silver Cascade." It was first photographed by Albert Bierstadt and his brother about 1860. *(ill. 5)*

Unknown

STRAWBERRY HILL HOUSE COACH, BETHLEHEM, N.H.
Ca. 1890
Photograph
17.0 × 21.3 cm.; 6⅝ × 8⅜ in. (image)
Collection of New Hampshire Historical Society

This is apparently a view of an excursion to one of the many scenic spots in the White Mountains which were organized for the amusement of hotel guests. The more prominent hotels and boarding houses had their own coaches (undoubtedly Concord coaches). Duplicate photographs would grace the parlor albums of many city homes as mementos of vacation pleasures. *(ill. 163)*

163. Unknown photographer, *Strawberry Hill House Coach*, Bethlehem, N.H., ca. 1890. Collection of New Hampshire Historical Society

164. *Profile House Menu*, 1873. Collection of New Hampshire Historical Society

164

MISCELLANEOUS OBJECTS

AMONG THE CLOUDS
July 20, 1877–September 6, 1879
Burt, Henry M., editor and publisher
Newspaper with wood engravings
Lent by Special Collections, Dimond Library, University of New Hampshire

For more than twenty-five years, this unique paper printed two editions daily, the one issued in the early morning being catapulted down the mountain on slideboards which could negotiate the descent of the cog railroad in as little as three minutes. This early edition was read at breakfast tables in the homes and hotels of the summer visitors. The noon edition listed the names of arrivals to the Summit House, and could be purchased for ten cents as a souvenir. Hotels advertised widely, often with wood engravings of their establishments. Maps were sometimes included, as well as discussion of points of interest, and, of course, the weather. Early editions were small in format and uncut; later ones used the larger newsprint page. *(ill. 165)*

CRAWFORD HOUSE REGISTER BOOK
1872
Collection of New Hampshire Historical Society

The grand hotels claimed with pride that their attraction was national and even international. Careful records were kept at every possible location of the quantity of tourists, who in turn were used to attract even more tourists, all of whom were constantly bombarded with advertisements. This type of register was also found at the summit of Mount Washington.

PROFILE HOUSE MENU
1873

CRAWFORD HOUSE MENU
1879
Collection of New Hampshire Historical Society

These menus give us a clear picture, along with photographs of the hotels' dining rooms (ill. 28), of the sumptuous facilities provided for the tourists' every pleasure. *(ill. 164)*

WHITE MOUNTAINS
Souvenir book
1881
Published by Chisholm Brothers, Portland, Me.
Collection of New Hampshire Historical Society

NEW ALBUM OF WHITE MOUNTAIN VIEWS
Souvenir book
Ca. 1885
Published by Chisholm Brothers, Portland, Me.
Lent by Douglas Philbrook

With the advent of the inexpensive photogravure process, souvenir views of the White Mountains became extremely popular. Accordion fold-outs crammed two to five views on a page. There was no text beyond brief captions. Scenic spots and hotel views predominated.

THE WINNEPISIOGEE AND WHITE MOUNTAIN MAILSTAGE BROADSIDE
1826
Collection of New Hampshire Historical Society

This early broadside contrasts with the later, more elaborate media campaigns when the grand hotels and railroads sank vast sums of money into advertising.

165. *Among the Clouds,* Henry M. Burt, ed.
Lent by Special Collections, Dimond Library,
University of New Hampshire

Among the Clouds.

VOL. III. MOUNT WASHINGTON, N. H., WEDNESDAY, JULY 9, 1879. NO. 1.

THE WEATHER REPORT.

Yesterday's Observations at the Summit.

	7 a. m.	2 p. m.	5 p. m.
Barometer,	30.146	29.997	29.906
Thermometer,	47	50	51
Rel. Humidity,	100	100	100
Wind,	N. W.	N. W.	N. W.
Velocity p'r hour,	25	37	50
Weather,	lt. rain.	lt. rain.	lt. rain.

Maximum temperature, 51 degs.; minimum, 45 degs. Rainfall, .82 inch. Highest velocity of wind, 60 miles per hour.

The above report shows the state of the weather only at the hours of taking the observations. W. S. JEWELL,
Sergt., Signal Corps, U. S. A.

THE TEACHERS AT FABYAN'S.

A Large Gathering,

AND A SUCCESSFUL MEETING.

Webster, master of the Lowell school, and Henry Blake of Nebraska.

Owing to want of room, Tuesday's proceedings are omitted. The issue of Thursday will give the report of the meetings of the two previous days.

PERSONAL NOTES.

Rev. A. D. Mayo of Springfield, Mass., arrived at the Fabyan House, Monday evening. Mr. Mayo is always greatly interested in all educational matters.

Hon. B. F. Tweed, supervisor of Boston schools, is attending the meetings of the Institute. Prof. Tweed has for many years been prominently connected with the schools of Boston and Charlestown.

Miss Mary E. Northrop of the Foster School, Somerville, arrived at the

THE MOUNTAIN HOTELS.

The most important change in the hotel business in the White Mountains this season is the leasing of the Fabyan House to A. T. and O. F. Barron for five years. Mr. Wm. H. Stevens, the landlord of last year, has gone West and the management of the house has fallen upon Mr. Oscar G. Barron, who has made for himself an enviable reputation at the Twin Mountain House. It is safe to say that the Fabyan will not fall behind any of the other hotels in management, so long as Mr. Barron continues as its landlord.

The Glen House is enjoying all its old time popularity and thus early in the season it has a large number of

view from his broad piazzas. He had a very large business last year and he is anticipating as much this season.

The Profile House has already had a large number of arrivals, and its proprietors are anticipating a third greater business than they had last year. The Profile House has always been one of the leading houses in the mountains and each year has added to its well earned popularity. The Franconia Notch, the Great Stone Face and the Flume will always remain objects of interest to White Mountain tourists.

The smiling face of H. L. Thayer of Thayer's Hotel, at Littleton, is worth coming to the White Mountains to see. His cordial and courteous manner have won him many friends. His

Catalogue editor: Shirley Good Ramsay

Photographs: Heidi Faith Kate, ill. 45; George R. Paxton and Robert A. Nakamura, ill. 93; I. Serisawa, ill. 94; Darkrooms, Inc., ill. 4 and 40; Dick Smith, ill. 33, 96, 97, 99, and 124; George M. Cushing, ill. 49 and 98; Kennedy Galleries, Inc. (reproduction rights), ill. 15, 46, 89, 100, and 101; Frank Kelly, ill. 52 and 55; Herbert P. Vose, ill. 105; Franklin Heald, ill. 113; Peter A. Juley & Son, ill. 7, 59, and 60; Scott Hyde, ill. 56; E. Irving Blomstrann, ill. 8, 48, and 121; Michael Marsland, ill. 118; Museum of Fine Arts, Boston (copyright), ill. 37 and 125; Bill Finney, ill. 62, 110, and D; University of New Hampshire Department of Media Services, ill. 66, 104, 143, 144, 147, 149, 150, 154, 163, 165, B, and G; Jerome Drown, ill. 53; Joseph Szaszfai, ill. 76; Helga Photo Studio, ill. 58; Greg Heins, ill. A. All other photographs are provided by and reproduced with permission of the lending institution.

THE WHITE MOUNTAINS:
PLACE AND PERCEPTIONS

Designed by Lisa Douglis
Composed by DEKR Corporation in Sabon,
with cover title words
in Victorian Glorietta
adapted by the book designer
Printed by Mark-Burton, Inc.
on Mohawk Superfine Text
Bound in Strathmore Beau Brilliant